DMZ Crossing

DMZ Crossing

PERFORMING EMOTIONAL CITIZENSHIP
ALONG THE KOREAN BORDER

SUK-YOUNG KIM

COLUMBIA UNIVERSITY PRESS NEW YORK

COLUMBIA UNIVERSITY PRESS

PUBLISHERS SINCE 1893

NEW YORK CHICHESTER, WEST SUSSEX

cup.columbia.edu

Library of Congress Cataloging-in-Publication Data

Kim, Suk-Young, 1970-

DMZ crossing : performing emotional citizenship along the Korean border / Suk-Young Kim.

pages cm

Includes bibliographical references and index.

ISBN 978-0-231-16482-5 (cloth : alk. paper) — ISBN 978-0-231-53726-1 (electronic)

1. Korean Demilitarized Zone (Korea)—In popular culture. 2. Korean Demilitarized Zone (Korea)—In literature. 3. Korean Demilitarized Zone (Korea)—In motion pictures. 4. Borderlands—Social aspects—Korean Demilitarized Zone (Korea) 5. Families—Korean Demilitarized Zone (Korea) 6. Koreans—Ethnic identity. 7. Group identity—Korean Demilitarized Zone (Korea) 8. Korea (South)—Relations—Korea (North) 9. Korea (North)—Relations—Korea (South) I. Title.

DS921.7.K5525 2014

951.9—dc23

2013025643

JACKET IMAGE: A FAMILY FROM THE NORTH ARRIVING AT THE BORDER
CHECK POINT ON THE 38TH PARALLEL, OCTOBER, 1947,
NOONBIT ARCHIVE—U.S. DEPARTMENT OF DEFENSE

For my parents,
YangMyung Kim and Myung-Hee Hong

CONTENTS

ACKNOWLEDGMENTS

JUST AS WE OFTEN HAVE DIFFICULTY PINPOINTING OUR VERY earliest memories, I also find it hard to trace the origins of this project. There must have been multiple points of departure—first living in a divided country and ruminating over that line that could never be crossed, and then moving far away from home to look back into the past with some degree of distance. Among the myriad dimensions that make up the many facets of this book, some places and faces nevertheless emerge clearly from my muddled memory. Sue-Ellen Case's invitation to give a talk on issues of the Korean border at the Center for Performance Studies at UCLA in 2006 must have been the first stepping-stone. Ensuing participation in many other great workshops and conferences—Les interfaces Nord/Sud dans la peninsula coréene, organized by Valerie Gelezeau of EHESS; The Korea Project, co-organized by Victor Cha and David Kang; the Hahn Moo-sook Colloquium at George Washington University, hosted by Young-Key Kim-Reneau; the Leisure and Money Workshop, co-organized by Eugenio Menegon, Robert Weller, and Catherine Yeh at Boston University; the Social Science Research Council Korean Studies Dissertation Workshop, run by Nicole Restrick and Fernando Rojas; and the Columbia University Center for Korean Research Regional Seminar, organized by Charles Armstrong—prompted me to consider the DMZ from diverse disciplinary perspectives.

Grateful acknowledgment is given to the following publications for portions of this book that appeared earlier: "Staging the 'Cartography of Paradox': The DMZ Special Exhibition at the Korean War Memorial, Seoul," *Theatre Journal* (October 2011): 381–402; "Documenting the Flower of Reunification: Lim Su-Kyong and the Memories of Bordercrossing," *Journal of Memory Studies* (March 2013): 204–217. Over the years, I have given presentations based on portions of this book at UC Davis, UC Santa Cruz, UC San Diego, University of Washington, University of Wisconsin, Ohio State University, Stanford University, and the Association for Asian Studies. There I was stimulated by invaluable comments and feedback from colleagues and friends: Nancy Abelmann, Liana Chen, Xiaomei Chen, Laurie Beth Clark, Kathy Foley, Todd Henry, Alex Huang, Ted Hughes, Branislav Jakobljevic, Charles Kim, Jin-kyung Lee, Namhee Lee, Jisha Menon, Stefka Mihaylovna, Viren Murthy, Se-Mi Oh, Peggy Phelan, Chan E. Park, Anna Puga, Michelle Yeh, and Eugene Wang. Special gratitude goes to Clark Sorenson for his thorough feedback on my manuscript; Rudolf Wagner for introducing me to the German border; Jun Yoo for constantly sending me so many great articles and films; and my dear colleagues Risa Brainin and Leo Cabranes-Grant for their kind support. Support from Jennifer Crewe and Leslie Kriesel of Columbia University Press, a Research Fellowship from the Academy of Korean Studies (AKS-2010-R), and a Regents Fellowship from the University of California, Santa Barbara were indispensable for completing this book. My spouse, Michael Berry, lived through every moment of the project, sharing the joys and anxieties that accompanied the formation of this book. Thank you for creating a world for me to live in with your immense love.

Working through this book was not an easy feat, as its evolution paralleled my son's appearance in this world. Intertwined with the intense joy and fatigue of child rearing, many thoughts for the book emerged in the thick of sleepless nights. Often feeling like the only one left to fend for the new life constantly evolving in front of my eyes, I often imagined what my own parents must have gone through when they were young and raising four children. It is unfortunate that our memories do not go back far enough to remember our mothers and fathers as they tended to us when we were infants. But what I do remember well is that, every day for three years while I prepared for the college entrance exam as a high school student in South Korea, my mother packed me three meals to take to school. At times those lunch boxes were bigger than my backpack, each one containing my mother's earnest wishes for my success and health. My father got up at 6 a.m. every day to drive me to early study sessions and went to bed at 1 a.m. after picking me up from extra lessons. What I remember even more clearly is that when I returned home for a summer

break during my graduate studies in the United States, my father drove me to a special library exhibition at the Academy of Korean Studies. When we came out of the exhibition, it was pouring outside, and he took out the only umbrella he had and carefully held it over my head as raindrops dripped off his hair and eyelashes.

We are born and fostered into the world by our parents; with their wrinkled hands and stooped shoulders, they bear our weight. Our knowledge and memories are shaped during sleepless nights, until frustrations and doubts fall away at the brilliant break of dawn.

What I know is not my own. Nor is what I write my own. I am just a temporary repository for those things to pass through the world from yesterday to tomorrow.

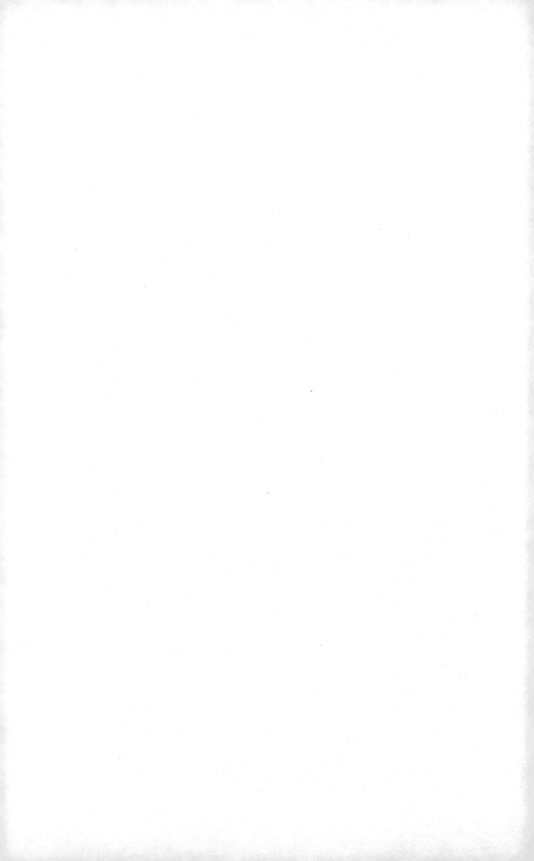

ILLUSTRATIONS

DMZ Crossing

INTRODUCTION
CONTESTING THE BORDER,
REDEFINING CITIZENSHIP

OCTOBER 30, 2010. GEUMGANG MOUNTAIN, NORTH KOREA.

Three elderly South Korean women, Jeong Giyeong, Jeong Giok, and Jeong Giyeon, bow deeply to a North Korean male, Jeong Gihyeong (age seventy-nine), who is seated behind a table laden with rice cakes and seaweed soup—typical dishes for a Korean birthday celebration. Adorned in their best traditional Korean dress, the three women proffer their good wishes to the old man. His actual birthday is still more than a month away, but the women celebrate it in advance since they cannot be together on his real birthday. After honoring him, they present him with two pairs of moccasins and two pairs of leather shoes.

"Brother, you left us barefoot sixty years ago. Our late mother, until the day she died, used to shed tears when she recalled that you were taken away from home without shoes," the three sisters tell the old man, through tears that blur their vision of their dearly missed brother.

In 1950, the brother and sisters of the Jeong family were living a quiet life in the village of Anseong in Gyeonggi Province, South Korea. When the Korean War broke out, the North Korean army marched south and arrived in their town. The North Koreans ordered the villagers to supply hay for the army horses, and when it came time for them to leave, they decided to draft one male villager to transport the hay. Nobody in the village volunteered to leave

their family, so in the end, they drew lots. Unfortunately, the Jeongs' father was chosen. Brother Gihyeong was only nineteen years old then and volunteered to go instead of his frail, elderly father. While his family was wailing in the face of the sudden tragedy that had befallen them, Gihyeong left the house, wearing his tattered shoes. As the army retreated to the North, Gihyeong by chance ran into one of his neighbors and asked him to lend him some money to buy shoes, since he had lost his on the road and was marching barefoot. The neighbor came back to the village and told this story to Gihyeong's family, which made everyone's heart freeze. Gihyeong's parents in particular suffered greatly and mourned the forced separation for a long time. Until the final day of their lives, they longed for their "barefoot son" who had left the family all too suddenly one day, never to return.

"I wanted to go back home after doing everything that the army ordered me to do, but then the road to South Korea was destroyed. You must have worried about me so much. I am sorry." Gihyeong's last words are muffled with deep regret. He takes out three bottles of North Korean wine and sets them on the table. "Bring one bottle to our grandparents' graves and another to our parents' for me. Then give the third bottle to our younger brother who could not join us today," he tells his sisters. They nod silently and accept the gift.

"Mother always used to say: 'I won't live long enough to see Gihyeong, but you girls must do everything to see him again.' Here we are, finally, together after sixty years of separation. It breaks my heart to think about how our brother must have struggled to survive in a strange place far away from his family," one of the sisters says, wiping her tears.[1]

The brother and sisters remembered each other as blossoming youths all through the long years of separation, but at this long-overdue encounter they faced each other with snow-white hair at the dusk of their lives. What happened between that day in 1950 and the day of the temporary reunion in 2010 is the history of contemporary Korea itself—a history marred by strife and tension between North and South that did not allow people on both sides to communicate even on a humanitarian basis. Crossing the border between North and South Korea was, for the most part, a forbidden act, a grave crime that impinged on the national security of both regimes.[2] So severe was the control over this border that even letters written for separated family members could not cross.

The experience of the Jeong family is one of the countless stories that permeate the lives of many Koreans since the country's division in 1945. It is all too familiar for Koreans on both sides who lost their loved ones or were forcibly separated from their families. The family's story captures the absurd trag-

edy of warfare, but it is also a happy story because the lost brother was able to be reunited with his kin, at least for three days. But this type of temporary relief from the permanent state of separation, painfully negotiated between the two Koreas and carefully coordinated by international nongovernmental organizations such as the Red Cross, is rare for most separated families. All too many have passed away without ever seeing the family members who became separated from them during the war. All too many were left in the dark, not even knowing whether their loved ones were still alive on the other side of the border. And all too many came to accept fatalistically the current state of division as their lot of suffering, to be endured in silence.

CROSSING THE FORBIDDEN LINE

The reunion of separated family members is one of the few instances where civilians from both sides are allowed to cross one of the most heavily guarded borders in the world, under the careful surveillance of both Korean states. What is astonishing is not only the scarcity and belatedness of these events but also the rhetorical paradoxes surrounding them, which hinge on the antithetical principles of sameness and differences: while these temporary family reunions are arranged to address the humanitarian principles of allowing kin to see each other and thereby allowing North and South Koreans to be just members of the same family, they are also ridden with high tension between the North and South Korean states, which anxiously attempt to protect the image of their respective statehood by carefully monitoring citizens' behaviors. On the one hand, the recognition of homogeneity—Korea being one nation and Koreans being one people—is at the heart of allowing the separated family members to cross the border, but on the other hand, the alienation between North and South— both stained with dark blood from the Korean War and carrying scars of the ongoing Cold War contestations—make border crossing a precarious act.

What prompted me to write this book is the urge to explore the intriguing set of contradictions that surround border crossing. Border crossing between the two Koreas has always been a contentious act, featuring the draconian control by the state and the varying responses performed by the individual border crossers—from careful compliance to spontaneous resistance. Moreover, the opposing forces created by family kinship and the state, sameness and differences, emotion and constitution that define the complex makeup of the inter-Korean border often collapse and blend together, creating even more convoluted implications for the border-crossing act.

To be clear, separated family members are certainly not the only actors who have crossed the inter-Korean border. Defectors to the other side have secretly done so at the expense of their own lives, while some political activists, in a defiant gesture to protest the Korean division, have openly crossed the line, risking persecution and imprisonment upon their return. And a sizable number of South Korean tourists crossed to visit Geumgang Mountain in North Korea when the thawing inter-Korean relationship allowed for a joint tourism venture from 1996 to 2008.[3] The inter-Korean border has also provided passage for political emissaries from both Koreas and from other countries, whose visits ignited hopes of reconciliation.

What is striking about the wide range of border crossers is that they lay claim to the symbolic significance of the border with their various reasons for crossing, as much as both Korean states exercise authority to control the practice and the rhetoric of border crossing. In his study on U.S.–Mexican border control, Peter Andreas observed that "the escalation of border policing has ultimately been less about deterring the flow of drugs and migrants than about recrafting the image of the border and symbolically reaffirming the state's territorial authority."[4] Andreas's main point is how control over the symbolic implications of border crossing is more important for the states than the actual control of the people and objects that move across. In other words, border control is a significant performance of state authority and legitimacy, as well as a performative gesture of resistance or compliance for individual border crossers in regard to their relationship to the state power.

DMZ Crossing emerged from an attempt to address these ongoing acts of border crossing by focusing on various types of inter-Korean border crossers, who traverse one of the most heavily guarded areas in the world to test the geopolitical limits of the Korean division, which often leads individuals to establish an alternative type of citizenship based on emotional affiliation rather than a constitutional delineation. This book intends to question the persistent legacies of the Cold War in the Korean peninsula from the diverse human perspectives of those who dare to cross the forbidden line; ultimately, it will illuminate how border crossers use their physical bodies and emotions as optimal frontiers to resist the state's conventional right to define citizenship. The book also examines border crossers who do not confront but act as agents of their states, complicating the convenient binary established between the state and the people, top-down control and bottom-up resistance models. In a way, this project is as much about the border crosser's desire to remedy the stultifying reality of division as it is about the state's manipulation of emotional forces that surround border-crossing events for its own ends. The inter-Korean bor-

der was meant to be fiercely protected as well as violated—sustained by both Korean states and their loyal supporters in order to clearly identify the national cogency of each side, while challenged by individual crossers who hope to restore severely violated kinship among one people. What can be gleaned from this unresolved conflict is the visceral impact the border has had in people's actual lives, still an open wound, as seen in the story of the Jeong family.

The System of Division and the DMZ

The deep division between the Koreas that still affects so many lives can be traced to the final days of World War II, when Japan's surrender was imminent. At that crucial moment, the Allies neither knew of nor had a strategic plan for the situation in postcolonial Korea.[5] On August 10, 1945, an all-night meeting took place in Washington, D.C., in the Executive Office Building next to the White House; the participants' goal was to develop a response to the impending Japanese surrender in Korea and elsewhere in Asia. Their process was improvised:

> Around midnight two young officers were sent into an adjoining room to carve out a U.S. occupation zone in Korea. Working in haste and under great pressure, and using a *National Geographic* map for reference, they proposed that U.S. troops occupy the area south of the 38th parallel, which was approximately halfway up the peninsula and north of the capital city of Seoul, and that Soviet troops occupy the area north of the parallel.[6]

Randomly chosen that night as a border between the U.S.- and Soviet-occupied areas, the 38th parallel anticipated the current demilitarized zone (DMZ), which was established at the end of the Korean War. This abrupt decision to divide Korea endures to this day, affecting millions of its inhabitants who were separated arbitrarily and became subjects of two hostile regimes.[7] As former U.S. Foreign Service officer Gregory Henderson noted: "No division of a nation in the present world is so astonishing in its origin as the division of Korea; none is so unrelated to conditions or sentiment within the nation itself at the time the division was effected; none is to this day so unexplained."[8]

One of the most astonishing aspects of the Korean division is that, over the past six decades, it has gained a systemic nature that parades as the natural state of being for both sides. According to renowned South Korean literary

scholar Paik Nak-chung, the current state of divided Korea points to "two governments at each end of the spectrum, the denunciatory and denying, but neither conducing to real clarity on its own status. This particular mix of confrontation and convergence points to the existence of . . . the 'system of division' on the Korean peninsula—a sui generis system that has survived the Cold War."[9] The two Koreas actually count on the divide to justify their legitimacy as nation-states.

This system of division aspires to produce citizenship based on oppositional forces: people's affiliation to the state is defined not by what they support but by what they oppose. Under such circumstances, emotional ties that develop in a community of people who share historical and cultural affinities and cohesion lose their grounding in the formation of citizenship. The Korean people have been tied by familial and cultural kinship throughout a long historical period, but since division they have been systematically alienated to the point that alienation from the other Korea has become a prerequisite for being an ideal citizen in both regimes. According to Paik: "the ways in which the status quo has managed to sustain itself—to an extent that may justify our calling it 'the division system'—is by having enough people accept it as an almost natural feature of life or even forget, in the course of their everyday lives, the very fact of division."[10]

Perhaps no other place embodies the absurd system more viscerally than the DMZ. A small strip of land stretching only 2 miles wide and 155 miles long, it is the spatial legacy of this forced state of division. Conceived as a buffer zone, the DMZ was intended to bring about a temporary cease-fire during the Korean War. Since then, the two Koreas' tumultuous relationship—from reckless surges of hostility to hopeful periods of reconciliation—has been playing out in this space. The result of a violent civil war, the DMZ is still littered with active land mines and the ossified remains of war casualties; paradoxically, however, since the cease-fire this silent no man's land has had an aura of pacifism and environmentalism. Indeed, the DMZ is both a hopeful symbol of peace between the two countries and a heavily guarded border area that nominally divides Korea into two often-hostile nation-states. These contrasting representations shape the unique spatial semiotics of the DMZ, marking certain performative conditions that illuminate the immanent absurdities of the Korean partition.

Described as "the scariest place on Earth" by former U.S. President Bill Clinton,[11] the DMZ is among the most heavily fortified borders in the world, with both sides ready to launch into full-scale war at a moment's notice. Standing as a bitter signifier of the Cold War era, it continues to affect the

lives of millions of arbitrarily separated Korean families. From a contemporary perspective, the zone between the two Koreas stands as a monument to stalemate: an anachronism that memorializes not only the prolonged separation of a once-unified nation but also a longing for the lost other half.

Despite what it represents, the DMZ, for the most part, is today a lush nature preserve in the midst of a crowded, increasingly urbanized Korean Peninsula. Many endangered animal species searching for a pristine ecological sanctuary find it in the DMZ, which has remained free of human development since the 1950s. Impressed by its biodiversity, international environmental activists now argue that the DMZ should become a designated conservation peace park.[12] Justifiable concerns for protecting this unique biosphere motivate the movement; nonetheless, if successful, it would extend the existence of the North–South border, which many citizens of both Koreas wish to eradicate from the geopolitical map as a mnemonic scar of war.[13]

For both South and North Koreans, one of the reasons the DMZ figures so prominently as national trauma is that so few are able to cross it. Those who have, have done so often in highly dramatic ways—as defectors, spies, political emissaries, separated family members, war prisoners, participants in cultural exchanges, environmental activists, and tourists.[14] Crossing the DMZ is never simply a neutral matter of traversing the border between North and South, but instead a high-stakes performative act with consequences for the successful border crosser, such as ideological reorientation, "emotional deterritorialization," and "reterritorialization."[15] Less fortunate would-be crossers have lost their lives in the attempt, while others who survived have been forced to denounce or forget what they left behind. Their acts have transformed this allegedly neutral space into a site for the performative reenactment of death and oblivion, which casts the long shadows of the past upon the present.

The DMZ possesses certain qualities that might cause Marvin Carlson to recognize it as a kind of environmental "haunted stage." According to him, "all theatrical cultures have recognized, in some form or another, this ghostly quality, this sense of something coming back in the theatre, and so the relationship between theatre and cultural memory is deep and complex."[16] Carlson argues that the repetitive citation of the past is an inherent quality of theater, and although the DMZ is not a conventional stage for the performance of plays, it is a space where border crossers perform enduring dramas of life, death, separation, and longing, thereby transforming it into an expansive example of the haunted stage. The DMZ's theatrical roots are located not in constantly shifting geopolitical tensions but in lingering war traumas. At the

local level, the fear of death, involuntary separation of families, and nostalgia for lost hometowns capture the emotional experience of the Korean War much more viscerally than the geopolitical analysis of warfare.

Compounding the theatrical impulse of this contested space even further is the fact that the DMZ is a site largely devoid of the human: both Korean states wish to control it, but neither can; civilians on both sides, especially separated family members, want to cross over it, but few can. Like the theater, the DMZ is a space of temporary passage, not of permanent residence. How does a dramaturgy of war memories unfold in this intractable semiotics of space, this cartography of paradox—an evacuated area defined by ontological temporariness and invaded by so many ghosts from the past?

BODILY KINSHIP AND EMOTIONAL CITIZENSHIP

One effective way to explore the paradoxical nature of the DMZ is to address how citizenship is defined along the border, by the states of South and North Korea as well as by individual border crossers, who add a new dimension to the constitutional stipulations of citizenship. By maintaining the border, the North and South Korean regimes clearly spatialize the boundaries of their respective citizenship, whereas those individuals who cross, often against the prohibitions of the states, directly challenge this citizenship. I am aware that using the term "citizen" or "citizenship" in describing DMZ crossers could be potentially confusing because of the linguistic gap that exists between English and Korean. In Korean, there is no exact conceptual equivalent to designate the definition and implications of the term "citizen" or "citizenship" as used elsewhere, especially in the West.

In Western tradition, citizenship has been articulated through the philosophical framework of the social contract, which emphasizes the dual dimensions of right and duty that bind individuals to a larger community. As Virginia Leary has noted: "Since the time of the Greek and Roman civilizations, the concept of 'citizenship' has defined rights and obligations in the Western world. . . . The concept of 'citizenship' has long acquired the connotation of a bundle of rights—primarily, political participation in the life of the community, the right to vote, and the right to receive certain protection from the community— as well as obligations."[17] In conventional usage, the term denotes a link between an individual and a state, be it an individual's holding a passport issued by the state, paying taxes to the state, or taking advantage of social services provided by the state.

The way I deploy the term "citizenship" in this book, however, does not point to such a reciprocal engagement. In the case of both the North and South Korean states' exercise of power, a more conspicuous emphasis has been placed on the citizen's duty than on their rights vis-à-vis the state. As Seung-sook Moon points out in her study of gendered citizenship in South Korea, "citizenship formally defined as the membership in the modern body politic has been an ideal to strive for, not an actual status for a majority of people in the society,"[18] revealing how in South Korea it has been presented with a heavy-handed, top-down imposition of state ideals. The story is not so different in North Korea, where citizens are seen as perpetual children of the state leaders, whose paternalistic love should provide for the well-being of their children-citizens.[19]

While keeping in mind the long-standing Korean tradition of a state-centered articulation of "citizenship," I frequently use the term to counter such a top-down imposition of people's duties. My usage does not necessarily involve the state; rather, it points to diverse modes of relationship that an individual enters into with a wide range of communities, which may include but are not necessarily equated with the state.

The term "citizen" is roughly translated as *simin* in Korean, which is colloquially associated with a resident of the city (as in Seoul *simin*), or in other cases, with a civic movement (as in *simin undong*). *Simin* as such is a concept that is space-bound and community-based. This is not exactly how "citizen" is used in this book, which addresses communities that are not always space-bound (such as imagined nation or family) as well as more personal types of longing and belonging that do not coincide neatly with organized civic/communal movements.

My use of "citizenship" here is foremost different from how both Korean states use the concept in their constitutions. North and South Korea use *inmin* and *gungmin* respectively to refer to their citizenry. Roughly translated as "people," both words carry varying connotations: if the North Korean *inmin* denotes "workers, peasants, soldiers, and working intelligentsia"[20] under the guidance of "Marx and Leninism,"[21] then the South Korean *gungmin* stands for the "holder of all sovereign power"[22]—a much more vague delineation. In a way, the North Korean term shares much of its genealogy with the Russian word *narod*, whereas the South Korean term carries a vestige of the Japanese colonial bureaucracy.[23]

At any rate, the constitutional definitions of citizenship in both North and South Korea carry heavy burdens of the past, and my usage of "citizenship" is often meant to denounce such implications. Embedded in the term is the notion

of kinship engraved on bodily senses and emotional registers, often accentuating the sameness rather than the differences between North and South. In this sense, perhaps a close—though not exact—Korean term to approach the concept is *minjok* (as in *uri minjok kkiri*, or "Koreans [deal with their matters] on their own"). Often translated as "nation," or at times as "people," the term is used to argue for the uninterrupted oneness of Koreans forged through a long period of history, which many Koreans believe to be the essential reason North and South Korea should be reunited. But as some scholars astutely point out, the word itself is a modern invention devised to sustain a specific brand of nationhood based on ethnic homogeneity.[24] My use of "citizenship" certainly reflects the underproblematized notion of oneness embedded in *minjok*, but it is firmly grounded on the intuitive sense of belonging to a family unit, be it biological or figuratively imagined. To use the powerful rhetoric of family is simultaneously an ontological and ideological act; out of this primal unit of human existence, alternative formations of citizenship can emerge based on emotional affiliation that is distinct from any constitutional definition of citizenship.

Such an approach is indebted to the growing trend in scholarship to understand public/civic life through the study of affect.[25] With the rise of transnational migration and its global impact, there has been a perceivable shift in the way citizenship is viewed vis-à-vis a growing emphasis on realms often located outside the regulatory structures of the state apparatus. The shift from studies of bureaucratic administrative analysis to "how citizenship is experienced, negotiated, and enacted in everyday life"[26] advances the agency of an individual citizen. Marrying human emotion to institutionally understood citizenship is an attempt to restore what the system of national divisions has aggressively eliminated from a more complex human existence. A scholar of human geography, Elaine Lynn-Ee Ho, combines the two notions by coining the term "emotional citizenship":

> Recognizing the relationship between emotion and citizenship, or what I term emotional citizenship, raises two lines of inquiry. . . . First, what are the emotional representations associated with citizenship, and by whom and for what purposes are such discourses constructed? Second, what types of emotional subjectivities emerge in response to citizenship governance, and how do they influence political and social behavior?[27]

Ho here is pointing to the ambivalence of the term consisting of two seemingly incongruent values, which also generates two-pronged questions to ex-

plore, one concerning the purpose and audience of the emotional representa-
tion and the other concerning the subject of such representation and its impact
on sociopolitical life.[28] I view these two aspects as interacting in a dynamic
process in which the efficacy of emotional citizenship depends on its subjectiv-
ity, purpose, and audience, but I also contend that the process requires close
scrutiny of how these variables are performed through human bodies that cap-
ture abstract ideas in a tangible way.

Ho goes on to state that emotional representations may take the form of
"lexicons and metaphors that individuals use to describe and give meaning to
citizenship, such as 'home' and 'belonging.' Such discourses contain an emo-
tional quality that should be critically analyzed to understand its effects." Lexi-
cons and metaphors, as she confirms, are the central ways individual subjectiv-
ity articulates the emotional dimension of citizenship. Moreover, tracing how
language developed along national borders is a visceral way to study the poli-
tics of the borderland. As Sanghamitra Misra remarked about northeastern
India, "the production of linguistic differences and the determination of lin-
guistic hierarchies" make the "sites much privileged for the imagination of
a borderland identity."[29] Exploring language across the border proves to be
crucial for the study of the Korean DMZ as well, since the projection of the
unapproachable "other" side has been expressed primarily through the lan-
guage of either fear of the unknown or nostalgia, which links to the bodily
experience of the prolonged state of separation and contestation.

This book focuses on the significance of the actual body and its capacity to
concretize the linguistic productions, such as lexicons and metaphors, that
are used to ascribe the meaning of citizenship. If individuals are to be seen as
agents of citizenship, emotional citizenship can best be communicated when
the lexicons and metaphors are inscribed onto bodily performance. As Claire
Ramussen and Michael Brown have suggested, body politics plays a signifi-
cant role in shaping the performative repertoire of citizenship:

> The body is used in political theory to represent . . . both the ideal pol-
> ity and to critique its actual manifestations. In doing so, it conveys a
> model citizenship in which the citizen's relationship to and responsibil-
> ity for the rest of the polity is defined. In other words, the metaphor of
> the body politic is a descriptive and normative account of citizenship.[30]

The human body as a primary signifier of emotional citizenship unfolds
the highly controversial nature of border crossing as social performance. My
usage of this term "social performance" takes its conceptual foundation from

Tracy C. Davis's definition of "social dramaturgy" in order to allow for optimal consideration of the border crosser's body in its full dynamic details. According to Davis, the term stands for "a modern day permutation of the *theatrum mundi*, for which the rationale goes like this: all the world's a stage, so if we accept the premise of social constructivism we may as well refer to acting, costumes, scene-shifting, and finales as the language of social interaction."[31] Social dramaturgy in this context highlights the concept of performance, becoming the magnifying glass through which to see the total bodily transgression of crossers through the principles of acting, staging, dramaturgy, scenery, and costuming. Rather than using the notion of "performance" as a mode of fictionalizing the historical circumstances of the DMZ crossings, I use the term to capture the individual agency of the crosser by considering the dynamic network of motion, emotion, visual representation, and spectatorship of border crossing.

The performative registers of crossing are also complicated by the presence of the spectators, who bring various emotive responses to border crossing— whether imagined or actually enacted event—as a way to vicariously participate in the acts of crossing that transforms witnessing into engagement with realities of division. This engagement primarily takes the form of shared bodily experience between the crosser and the witness, which points to a complex physical and emotional network.[32] Geographically signaling a literal transfer of the body from one side to the other, crossing the DMZ is inherently an emotional rearrangement of the crosser's civic affiliations, not from one place or structure of belonging to another, but rather by accumulating layers upon layers of the complex sense of belonging to both sides—which often comes at the price of being labeled a traitor to both sides.

Border crossers, in this respect, not only embody such dualistic layers of transmutation but also test geopolitical boundaries: they use their physical movements to challenge where the nation-state begins and ends, and whether the definitive geographical border is effective. The body politic may be a spatial metaphor in that it is a "particular space" and is "usually bounded and bordered, with the focus being the area within the border."[33] To be sure, for most border crossers, the idea of emotional citizenship is most pronounced when the body is placed on the line in an attempt to cross. The border crossers I scrutinize in this book are special kinds of citizens who use their physical bodies as mobile frontiers to highlight emotional citizenship that either betrays or confirms the constitutional stipulations of citizenship by the state. Crossing the DMZ becomes a crucial performance for these individuals who boldly

claim the state's conventional right to define citizenship, often resisting the state's authority to define the border and the legitimacy of its crossers.

However, it is not only individuals who tap into emotional manifestations of their body to claim alternative citizenship through feelings of belonging and affiliation. According to N. Yuval-Davis, nation-states also quite actively deploy these emotive qualities to establish a collective sense of belonging, loyalty, and being on the inside—the existential makeup of citizenship.[34] It is precisely the matrix of contestations between the state and the individual, emotion and constitution, that makes border crossing a highly performative event—and studying it an important way to untangle the messy history of the Korean division. By transposing the concept of social dramaturgy to DMZ crossing, I hope to show that the DMZ's performative qualities are drawn from the often contentious—and therefore dramatic—interaction between the state and the border crossers as both parties deploy bodily transgression through varying strategies.

Each chapter addresses various modes of border crossing, illustrating how individuals and the state simultaneously tap into the emotive forces of kinship and statehood. With the exception of the final chapter on ethnographic analysis of DMZ tourism, each chapter consists of two case studies—one from South Korea and the other from North Korea—through different cultural outlets, to clearly capture the often conflicting viewpoints between North and South while tracing how various types of media platforms provide distinctive expressions for addressing the contested act of border crossing.

Chapter 1, "Imagined Border Crossers on Stage," showcases a comparative analysis of stage plays by influential dramatists from both Koreas. Sin Go-song's *Ten Years* and Yu Chi-jin's *Thus Flows the Han River* were published in 1958, in Pyongyang and in Seoul respectively. They both feature recent memories of border crossing during the Korean War (1950–53) as a prominent dramatic device to reveal the dangers of emotional ties among family members who are no longer citizens of the same Korea. This chapter shows how individual writers working in the immediate aftermath of the devastating Korean War (1950s) used the stage space to dramatize border crossers as dangerous infiltrators rather than genuine family members to the newly established society.

Chapter 2, "Divided Screen, Divided Paths," presents a double feature, the 1965 South Korean feature film *The DMZ* and the 1975 North Korean feature film *The Fates of Geumhui and Eunhui*. Both films let the tragic separation of families unravel on the haunted stage of the DMZ—which bears a striking resemblance to both a womb and a coffin—where life and death intersect. That immense, uninhabited, and unpredictable space devours life while it creates

new life haunted by the spectral visions from the past. For divided families, having to carry on after being uprooted from their hometown and family network is akin to living an incomplete life in the past continuous, where part of them died upon their separation from the inseparable. Both films feature siblings whose lives and deaths intersect and drift away while crossing that crucial line. This chapter captures shifting rhetoric toward people of the other side as separate from their failed regime, reflecting and anticipating the subtle changes in the political and cultural climate of the inter-Korean relationship in the 1960s and '70s.

Chapter 3, "Twice Crossing and the Price of Emotional Citizenship," looks at a specific kind of political border crossers who transgress the strictly guarded inter-Korean border not once, but twice: the first time to reach the other side, and the second time to return to their place of origin. Two case studies—Lim Su-kyung, a South Korean college student who visited North Korea in 1989, and a group of North Korean "spies" who were imprisoned in South Korea for nearly 30 years—are compared as a way of reading how the act of double crossing creates an alternative community that is not entirely subject to the system of division. This chapter uses the North Korean state documentary *Praise to Lim Su-kyung, the Flower of Unification* (1989) and the South Korean independent documentary *Repatriation* (2003) to explore how the medium can deploy the historical authority embedded in the genre to amplify affective power in restoring the kinship ties among Koreans.

Chapter 4, "Borders on Display in Museum Exhibitions," compares the South Korean state museum's re-creation of the DMZ crossing experience with how its North Korean counterpart imagines the border area and the act of border crossing. While the North Korean museum's reference to wartime border crossing is stunningly lacking when compared to that of its South Korean counterpart, this significant absence symptomatically exposes North Korea's vulnerability in imagining the past. This chapter focuses on how the emotional experience and expression of division is not only a terrain for individual citizens to create spontaneous coalitions but also a powerful resource for both Korean states to claim their validity as agents of reunification—no matter how different their visions of division and reunification might be.

Chapter 5, "Nation and Nature Beyond the Borderland," serves as a conclusion to the book by examining the debate regarding the future of the DMZ, mostly the clashing forces of Korean nationalism and transnational environmentalism. Using my personal observation of Imjingak Peace Park—an expansive memorial park adjacent to the South Korean DMZ—I discuss multiple layers of paradoxes that characterize this contested space: its titillating proxim-

ity to the DMZ and North Korea while functioning as a barrier that stops ci-
vilians' free approach to the zone; its significance as a site of past trauma as
well as of future recreation and leisure. In the process, I take a closer look at the
much-contested perspectives championing the ecological value of the zone
and the local anxiety to remedy national trauma through its eventual aboli-
tion. This section raises questions about hypothetical scenarios concerning
the future of the DMZ—as a tourist attraction, as a nature preserve, and as a
passage—as well as the alternative ways of border crossing that will be affected
by such changes. Because I was not able to visit a memorial space on the north
side of the DMZ—the place that could have been the North Korean counter-
part of Imjingak—this chapter does not make the same degree of immediate
comparison between the North and South Korean cases as other chapters do. I
use my limited access to the North Korean side of the DMZ as a South Korean
tourist to highlight how Korean civilians' lack of mobility across the border
accentuates the absurdly limited field of vision to which they are restricted
when attempting to see the division in its full spectrum.

The chapters are laid out in chronological order, starting at the height of
the Cold War in the 1950s, then moving to the temporary dismantling of the
Cold War-style confrontation at the end of the twentieth century, and finally
ending with the early twenty-first century reversion to the new Cold War con-
flicts in Korea. The chronological exposition of five case studies unravels the
vicissitudes of border crossers and border crossing over six decades. But more
crucially, each chapter introduces a distinctive medium of capturing border
crossing—both actual and imaginary ways of declaring citizenship—in order to
highlight varying degrees of emotional affiliation with the place in which the
border crossers find themselves. While the stage plays in chapter 1 fictionalize
DMZ crossing as a dangerous and almost impossible experience, segregated
from the reality of theater spectators—spatially expressed by the distance be-
tween the proscenium and the auditorium—in chapter 2 the feature films use
various visual techniques to dictate how spectators should empathize with the
bodily pain of the cinematic characters to relive the trauma of separation while
crossing the DMZ. The degree of intimacy between the subject and objects of
the gaze intensifies in chapter 3, where the documentary films use the force of
emotional identification in following actual historical figures who break the
taboo by crossing the DMZ not only once, but twice. The state museum exhi-
bitions featured in chapter 4 manipulate visitors' kinesthetic responses to alienate
them from the "other" Korea beyond the DMZ; in contrast, the ethnographic
observation of South Korean DMZ tourism featured in chapter 5 presents the
individual citizen's discursive experience of border crossing, which cannot

cohesively merge with its representation in the state institutions. All in all, these diverse genres and media—stage productions, feature films, documentary films, museum exhibitions, and tourist ethnography—collectively illustrate varying degrees of emotive-kinesthetic coordination that cannot be reduced to official representations sanctified by the state alone.

In recent years, realistic possibilities for change have emerged along the DMZ, be it triggered by both Koreas' militaristic threats to cross the zone or the sudden elimination of the DMZ by way of Korean unification. The time is clearly ripe to study the Korean border from a fresh perspective, and this book's more visceral understanding of the DMZ as a site of performing emotional citizenship will be crucial to the process.

1
IMAGINED BORDER CROSSERS
ON STAGE

THE YEAR 1958 WAS SIGNIFICANT FOR BOTH KOREAS. EACH HAD been founded only ten years earlier, South Korea on August 15, 1948, and North Korea on September 9, 1948; each nascent state celebrated the anniversary of its respective republic with mixed feelings of anxiety and pomp. North Korea saw 1958 as the year when socialism fully settled in: the Chinese volunteer corps, which had remained in North Korea since the cease-fire in 1953, returned to the PRC and the construction of a socialist society was fully under way. The government launched campaigns to glorify the amazing reconstruction efforts that the country had staged since its founding, with a particular emphasis on the reconstruction of Pyongyang after the devastating demolition and evacuation of the city during the Korean War.[1] South Korea also held numerous celebrations to show the progress it had made during the past decade, from issuing ten-year anniversary stamps to staging various cultural festivals to consolidate a cohesive national image vis-à-vis the outside world.[2]

Although a decade of history was much celebrated internally, both Koreas were tense with uncertainties about the future, especially in regard to the ongoing division. It was unsettling for both to face that the three years of warfare had ended in a temporary cease-fire, not permanent victory over the other side. Both regimes were in a transient phase of domestic power struggle with

many internal enemies to deal with, aggravating the anxiety of the leadership and leading them to suppress potential opposition in domestic politics.

The most sensational political scandal of the year erupted when North Korean agents hijacked a South Korean national airline (Daehan gungmin gongsa) plane to Pyongyang. This resulted in the murder of one passenger, the torture of others, and prolonged negotiations to return the hostages to South Korea. Known as the "Chang-rang Hijack Incident," this traumatic event took place only five years after the 1953 armistice, sustaining the heightened sense of fear and anger about the North. Potential scenarios involving a forced crossing to or an invasion from the other side of the border emerged from the sense of the impermanence of the line just redrawn.

The border region was a terrain where emotional anxiety persisted in various forms: vivid memories and uncertainties about the future. With the legacies of the Korean War still looming large, the reality started to sink in that the 1953 armistice, which had brought a temporary halt to the devastating war, might turn into a prolonged standoff. Under such schizophrenic conditions, simultaneously marked by potential peace and conflict, how were these half nations to envision distinctive identities vis-à-vis each other? The newly formed DMZ area provided the ground for uneasy feelings about the unfinished past and the unknown future: borders are nominally there to maintain control over sovereign territory, but the Korean DMZ as a temporary border dangerously foreshadowed the infiltration of unwanted elements from the other side.

It was under these circumstances that 1958 saw the publication of two plays, written by the representative playwrights of South and North Korea. *Thus Flows the Han River* by Yu Chi-jin and *Ten Years* by Sin Go-song reflect the fear and uncertainties deeply ingrained in the wounded emotional landscape of each nation. Working faithfully with their respective official state ideologies within a broader international Cold War politics, both plays address the necessity to maintain draconian control over the constantly shifting wartime border, which allowed for easy crossing by people from both sides. The DMZ in 1958 was a de facto border that became literally impossible to cross, but both plays revisit crossing the 38th parallel before the DMZ was carved out in 1953—not out of nostalgic longing for mobility across the border, but as a forbidding gesture to alert citizens about the dangers of free crossing.

As different as their ideological orientations might be, *Thus Flows the Han River* and *Ten Years* intersect in their focus on the historical transformation of the region—from a more porous border, the 38th parallel and the military front, to an impenetrable border, the DMZ. With this transition came an

emotional shift in perceptions: the temporary demarcation line consolidated into a permanent fracture. Along with this came the increased need for each state to maintain cohesion. These emotional reflections of changing histori- cal circumstances were manifested most clearly in family relationships. The fear of infiltration by foreign elements into the family—be it a biological family or a community metonymically standing for the nation-state—was dramatized in characters' performance of and allusions to border crossing.

Family life, for that matter, presented the battleground where conflicts be- tween individuals and their choices unfolded. Uneasy feelings about being separated from or not fully integrated into family life allow characters in both plays to explore deeper dimensions of self, ridden with anxiety—a process that often turns individual bodies into battlegrounds. Physical and emotional at- tributes of individual subjects, such as sexuality and jealousy, serve as under- currents of dramatic events surrounded by historic turmoil. Not only the hu- man body and emotion but also the natural landscape embraces the turmoil of this historical moment, as the plays subtly deploy the Han and Daedong rivers to be the sensorial palette of the characters' transformation. *Thus Flows the Han River* and *Ten Years*, which at first glance faithfully uphold diametri- cally opposed ideological traits of the Cold War era, turn out to be very similar. Theodore Hughes claims, "It is time to do away with the notion that the 1950s was a decade of draconian anticommunism and nothing more in South Korea. Certainly the state was authoritarian and anticommunist. But this is only part of the picture."[3] I would like to extend this observation to the case of North Korea through comparative analysis of the two plays. The underexplored part of this period in the history of the Cold War in Korea might well be the subtle potential for each body to cross emotional and corporeal frontiers.

THUS FLOWS THE HAN RIVER (1958)

"A genuine Renaissance man—playwright, actor, director, intellectual, impre- sario, and educator"[4] are only a few attributes used to describe Yu Chi-jin, the father of Korean modern drama. Born in 1905 in the Southern town of Tongyeong to a family of traditional doctors, he studied English literature in Japan. Upon his return to Korea in 1931, he organized Geugyesul yeonguhoe, a troupe that specialized in realist spoken drama, which had a formative influ- ence on the development of modernism in Korea. Yu achieved fame with *The Shack* (1931) and *The Ox* (1930), which realistically portray the devastated lives of peasants under Japanese colonial rule. During World War II, Yu wrote and

performed many pro-Japanese works, which later haunted him in the wake of a campaign to clear up the residue of colonial culture. Following the liberation from the Japanese empire in 1945, Yu wrote many anticommunist plays, but eventually, he cultivated an experimental staging style by incorporating spoken dramas with cinema, music, and dance. In 1958, he established the Korean Drama Research Center (Hanguk yeongeuk yeonguso), which became the foundation of the current Seoul Arts Institute (Seoul yesul daehak). Yu presided over many prestigious institutions, in positions including director of the National Theater and president of the Korean Theater Association (Hanguk yeongeuk hyeophoe).

Many critics argue that *Thus Flows the Han River*, published in the journal *Sasanggye* (World of thoughts) in 1958, effectively ended Yu's career as a dramatist.[5] As the closing chapter to a remarkably productive and influential career, *Thus Flows the Han River* shows many artistic experiments that must have been incorporated as a result of Yu's exposure to film techniques and Western-style dramaturgy.[6] The play consists of twenty-two scenes without curtain and uses film script techniques, such as F.I. (fade in) and F.O. (fade out); the dramatic action moves agilely though the war-torn back streets of Seoul, which has been literally gutted by the violence. Deserted by its own inhabitants, who fled the merciless attacks by both sides during the war, Seoul shows its gory face as a place that hosts the most vulnerable wartime migrants who have no recourse but to entrust their fate to random chance.

The play opens with a long description of a once bustling city that is now devastated by the inescapable death and destruction of wartime:

> Not long ago, the communist army retreated from Seoul. The communists attacked the capital city, which drove away the UN forces. Early April, 1951. Chilly weather still lingers. Seoul has been reduced to rubble and buried in barricades and barbed wire as a result of urban warfare. Cannons and guns are deserted by the communist army; even dead bodies litter the streets. Everyone is still consumed by ongoing warfare and cannot tend to these problems. Most roadside houses have been destroyed; even if they still stand, their exterior is marred by the traces of bombing and gunshots. The Miari hills are located on the outskirts of Seoul. Beyond the hills is the enemy camp. At night the UN forces at times shoot up flares and start a massive bombing campaign. Bombing is carried out in Seoul, which frightens the residents and prompts them to hide underground or cross the Han River. This play takes place near the Eastern Gates Market. Seoul has been entirely evacuated and the

busiest districts, such as Myeongdong and Jongno, are completely empty even in the daytime. But near the Eastern Gates Marketplace, there are some people left because it is where a temporary market has been set up. This makeshift market is the only source of life for the remaining residents, as some make a living selling things and some continue to live on, buying things there.[7]

Seoul is a wasteland, with few traces of life and hope. The play's morbid cityscape is not simply a backdrop to the dramatic action taking place during wartime but is closely tied to the physical and psychological impacts of border crossing. Caught in limbo, Seoul is in effect barricaded so people are unable to get in or out. In this spatial entrapment, how can the characters find their way to cross the inter-Korean border? How does this claustrophobic city reconfigure the meaning of border crossing and mobility at large, which directly engages with the transient nature of emotional community?

Actual border crossing is missing from the dramatic action, which obviously has to do with the devastating war that literally limits the characters' mobility. But crossing the border in this play is not only about physical mobility. More essentially, it is about expressing human desires that cannot be resolved, and border crossing is a moment that intensifies the dramatic conflict rather than resolving it. The only way to get out of Seoul is to perish, highlighting the perilous consequences of crossing.

The main conflict of the play revolves around the twisted fate of two lovers, Cheol and Huisuk, who were engaged before the outbreak of the war. Cheol is an aspiring painter apprenticed under Huisuk's elder brother—his future brother-in-law. When the North Korean army enters Seoul, they arrest Cheol's father. Cheol goes to the enemy headquarters to rescue him, but the communists threaten to kill the father unless Cheol divulges his master's whereabouts. Forced to choose between his father and his future brother-in-law, Cheol gives the latter's hiding place and is forcibly drafted to serve in the North Korean army. His callous visit to the headquarters ends up exposing both himself and Huisuk, who merely accompanied him, to the grave dangers of active participation in warfare. Now separated from Cheol and forced to serve in the enemy's military campaign, Huisuk suffers a bullet wound that leaves indelible scars on her body: her breast has to be amputated and her stomach carries a gunshell particle. Cheol, in contrast, kills the head of the North Korean brigade in which he is forced to serve and marches toward the military front alone to rescue his future brother-in-law, who is rumored to have been sentenced to forced labor in a mining camp. But just before crossing the military

front—the de facto border in wartime—Cheol turns back southward to look for his beloved fiancée instead. The play begins with this crucial delay in Cheol's border crossing, which is replaced by his entering the deserted city of Seoul, where Huisuk also happens to be with her sister-in-law and a young niece, waiting for the return of her brother and her fiancé.

Driven to madness by equally strong feelings of guilt and love, Cheol perches on the paradoxes of being a hero and an antihero at the same time. Haunted by remorse at having betrayed his master, whereby he also exposed his beloved to danger, he enters the city like a possessed man, casting long shadows of devastation over the ruins. In an effort to atone for his sin, Cheol decides to rescue his master, but then suddenly changes his mind and comes back to Seoul in search of his lover instead. This unforeseen shift is not entirely explicable by reason; it is guided by eruptive emotion—hardly predictable and barely controllable—which defines the ontological crisis Cheol confronts.

To cross or not to cross is the question Cheol answers not by rational judgment but by clinging to one emotional attachment (love for Huisuk) over another (loyalty to his master). As irrelevant and absent as it may appear, border crossing in this play is in fact a significant event concerning first the destruction and then the restoration of family relationships. Cheol must cross the border to rehabilitate his loyalty to his master, but this potential crossing also implies the restoration of the family order, of which he will be a part. The man Cheol intends to rescue is both his master and a patriarchal figure for his fiancée. Cheol cannot ask permission to marry from a man whom he has betrayed; hence it is imperative for him to accomplish his rescue mission in order to restore his proper place in the future family. Not having done so makes Cheol's sudden return to Seoul in search of his love already a failure. Crossing the border, in this context, is a prerequisite for the protagonist to redeem himself and emerge as a deserving member of the family; not crossing means Cheol must face the antihero's doom.

Border crossing in this play is a threshold event, but it is literally absent in many different forms, from postponement, as is the case with Cheol, to free imagination, as with Jeongae, Huisuk's sister-in-law. Upon Cheol's betrayal, Jeongae loses her husband to the North Korean army, which drags him beyond the border. Clinging to a futile hope of reuniting with her lost husband, she remains in the deserted city with her young daughter, Dali, barely surviving day to day by collecting unbroken bricks in the ruins and exchanging them for food. They are joined by Huisuk, who narrowly escaped death during the battle and has miraculously returned to Seoul, wounded, in search of Cheol. One day Jeongae returns from work to their hideout and tells Huisuk

about seeing her husband return home from North to South—an event that can only be realized in dreams.

> JEONGAE: It felt just like reality. Dali's father was returning from a forced labor mining camp near Amnok River. I must have been dreaming that Korea was unified and there was a direct train from the North to Seoul. But he was not wearing his hat and looked cold and exhausted. So on my way home, I bought a hat from a second-hand shop.[8]

The image of an inter-Korean train as an agent of free crossing invades the claustrophobic enclosure in which Jeongae and Huisuk hide themselves, setting motion and stagnation in stark contrast. Implausible as this imagined crossing may be, Jeongae's dream plays a crucial role in accentuating the irreconcilable difference between the reality of war and the wishful vision of a united Korea.

Emotional community is broken and restored along the lines of how the actual and imagined crossings are staged in this play. To begin with, the husband's forced crossing to the North breaks up Jeongae's family, and Cheol's decision not to cross erases the possibility of restoring it. Thus, crossings profoundly disturb the family unit and accentuate the futility of any attempt to repair it. Once a character ends up on the other side of the border, the possibility of crossing back to their place of origin is forever foreclosed—which only fuels the desire to return, which is only done in dreams and the imagination.

Creating a variation on this theme of the impossibility of double crossing, the play introduces a character whose steps parallel those of Jeongae's husband. Early on, when the devastated cityscape of Seoul emerges, a character known as Dudeojwi (Mole) appears, seemingly an integral part of the ruined city. He is disabled, and crossed the border from North to South with his wife and child, trying to survive a heavy bombing attack. During this chaotic migration, Dudeojwi lost his wife; he is now left alone to take care of his child, barely able to live from day to day on soup made of food waste leaking from the American military base. Despite extremely harsh circumstances, Dudeojwi persistently seeks opportunities to migrate down to Busan, a city at the southern end of South Korea, where he believes he can be reunited with his wife.

Just like Jeongae, Dudeojwi is separated from a spouse and has a young child to fend for as a single parent in the war zone. But what ties them more tenaciously is their persistent dream of being reunited with their family by crossing various borders: Jeongae dreams of her husband crossing the inter-Korean

border and Dudeojwi seeks to cross the barricades of Seoul and move to Busan. Both crossings imply movement southward, not northward, which would eventually place these characters in North Korea-controlled territory. We can read this as a logical intervention of the South Korean state ideology— its strong desire to prevent its subjects from crossing (read "defecting") to the North. The foreclosure of any chances for its characters to move north is logical if we accept that the playwright is faithfully representing the draconian state policies in 1958. In this light, even Cheol's antiheroic decision not to cross northward to rescue his brother-in-law gains cogency.

However, to conclude that border crossing in this play is a mere reenactment of state ideology is to miss more nuanced implications of the border, especially how body politics conjectures an emotional frontier between the two Koreas that does not neatly coincide with the military frontier. The play deploys a wide range of bodily configurations to anchor the counterintuitive impulse to gain mobility during wartime.

Disfigured bodies appear at the forefront of this traumatized emotional landscape, counterpoising the efficacy of the military front as the de facto inter-Korean border. Dudeojwi's disabled body is an anthropomorphic rendition of the ruined city, as he literally cannot separate his body from the streets. His limping closely resembles crawling and he is anchored to the ground, dragging himself across the streets that are as destroyed as his family life. The resemblance between Dudeojwi's body and the city makes him a native component of wartime Seoul regardless of his origin. Dudeojwi's speech—an extension of his bodily traits—is delivered in a heavy North Korean accent, distinctively marking him as a border crosser from the other side; nonetheless, he is no different from Seoul native Jeongae in his unquenchable longing for the lost family member. Both characters seek home in a place where they can reunite with their family—whether it is physically located in the South or the North is of secondary importance.

Despite all the physical challenges that would cause hardship in moving down to Busan, Dudeojwi is most persistent in his desire to leave the city. A restless migrant who has lost nearly everything—home, spouse, and a part of his body—he creates an unsettling impression at the end of an otherwise completed play. Dudeojwi's disfigured body erases the authority of the wartime military frontier as the true border. Instead, his separation from family and home creates a new set of borders, as anything that lies between him and his lost wife is a barrier to the formation of emotional community. A character who cannot find any sense of belonging in a transient stage, he shares the meager source of life amid the destruction with equally devastated other migrants.

The motley compilation of body politics is deeply interwoven with characters' desires to either cross the border and escape the city of death or stay and reunite with lost family members. In contrast to Dudeojwi's disfigured body, which longs for mobility, there are other kinds of bodies—physically beautiful and healthy—that are also paradoxically immovable. Cheol's bodily presence on stage exudes masculinity, but with all his health and energy, he fails to leave the city. Nor does he successfully cross the inter-Korean military front line, even though that was his intention. As a result, he enters Seoul devastated and guilt-ridden to look for his fiancée and ask her forgiveness. When his sincere efforts to apologize and reunite with Huisuk fail, he becomes bewildered and destroys everything that he finds still intact in the already heavily damaged city. The bestial energy of this vigorous young male, however, strangely resembles the devastation of physically disabled Dudeojwi. While Cheol's wounded mind resides in a healthy body, Dudeojwi's paralyzed body hosts his sober mind obsessed with finding his wife. Despite conspicuous differences in configuration, Dudeojwi and Cheol are alike in that their mindscape and bodyscape asymmetrically merge into chaotic dissonance.

Completely frustrated after being refused by Huisuk, Cheol decides to destroy himself and perish on the streets. His self-abandonment catches the attention of a pair of pickpockets—simply known as Cleopatra and Loach—who want to manipulate his destructive energy toward their gain. In order to make Cheol join their team, Cleopatra and Loach hide the fact that they are lovers and introduce themselves as brother and sister. Cleopatra, as the name suggests, is a seductive young woman who lures Cheol into their business, only to fall for him eventually. She exudes a heightened sense of sexuality, but just like Cheol's, her inner world is drained of emotion. Wry sarcasm and materialism govern her path, later giving way to blind carnal desire for Cheol. Her partner, Loach, is no different, going so far as to lend his lover to Cheol for the sake of business.

What seems to be an entirely despicable portrayal of characters like Cleopatra and Loach, however, gains complexity as the play progresses. The same revelation that transformed Dudeojwi from a weak, crippled stranger to a resilient family man affects Cleopatra and Loach as well. Loach swindles the most devastated people in the most debasing way to provide for his family. During a casual conversation with Cleopatra about their next scheme, he proudly shows off a letter sent by his teenage son, who took refuge in a safer place outside of Seoul. When Loach brags about his son's brightness, he is no longer a swindler but a proud father, just as Dudeojwi is a dedicated husband and Jeongae is a faithful wife. Likewise, Cleopatra's family life is disclosed during this

conversation to deepen the portrait of the character: she is a single mother who had to temporarily abandon her infant in order to survive. When she returned to the foster family to pick up the child a few years later, she faced the harsh reality that one needs financial resources to maintain one's humanity.

> CLEOPATRA: This little child was quite cute, but I could not fend for him. I just couldn't. So I had to let him stay with others. When I returned a few years later, he did not recognize me, his mother. He forgot about his mother for the meager meals the family provided for him. I realized very clearly then that material comfort is more important for human beings than blood ties.
>
> LOACH: So that's why you became a pickpocket?
>
> CLEOPATRA: Yes, without money, just forget about being human.[9]

For Cleopatra, powerful lust settles in to fill the emotional void, directing her toward Cheol. But even this strong attachment has its limitations: primal sexual energy alone cannot attain true union of the two characters, and Cleopatra is eventually abandoned by Cheol. Unable to find solace in human relationships, she reserves her only genuine emotion for an unexpected partner—the ruined Seoul.

In a sleazy dance hall where Loach and Cleopatra hustle to find their victims, Cleopatra contemplates stealing diamonds from an unsuspecting man. As a part of the disarming process, she uses her physical charm to approach her target and strikes up a conversation with him by pouring out her love for the city. She swears that she will never leave Seoul, which she compares to a deserted widow in mourning. What started out as a routine part of the swindling effort elevates into a more serious confession when she suddenly recites poetry from her genuinely melancholic heart:

> Mountains and fields have been wounded beyond recovery,
> But the Han River flows incessantly.
> Although my body is wounded beyond recovery,
> The Han River whispers deep in my heart.
> The Han River is my soul! The stream of life for a lover!
> As long as the Han River flows, we are alive.[10]

Coming from such a nihilistic character, this interlude is a surprise for the audience. Her ripe sexuality, aimlessly devouring the equally aimless energy of Cheol, finds a strange counterpart in her emotional devotion to the city. As

a heartbroken mother who deserted her child and was deserted by the child in turn, she can only love that which is dying. But the peculiar confession of love made by a depraved swindler emanates an enduring, albeit temporary, force that survives the ravages of war and the vicissitudes of people during unsettled times. Her poetry is what gives the title to the play, reinforcing the significance of this rather bizarre digression in Cleopatra's worldview. The image of the city in her poetry overlaps with her body: once lively and beautiful but now emotionally wounded and penetrated, both long for a cure. Could the Han River mend the scars of trauma? As the river flows, it merges with streams and diverts into various rivulets. The Han River stands silently as a metonymy of the resilient continuation of life despite the devastating war.

Cleopatra's beautiful body holds a vacuous mind, but one that allows space for a glimpse of hope that survives rampant death and destruction. Cleopatra in an eccentric way creates a thematic accompaniment to Dudeojwi's persistent hope and search for a cure. By this connection, seemingly antithetical characters—a beautiful female pickpocket from Seoul and a crippled male refugee from North Korea—jointly reaffirm the desire to look for a better existence. But unlike Dudeojwi, Cleopatra does not desire to cross any boundary, not even the city barricade. She already crossed the emotional frontier when she severed her relationship with her child.

Perhaps the most complicated character in terms of bodily configuration is Huisuk, who is trapped between the equally strong emotional forces of love for Cheol and loyalty to her brother's family. One of the major crises that define her life within the play is a physical transformation from a vivacious young woman to a defeated soul with a mutilated body. Audiences learn that the physical attraction between the two lovers is undeniable: as the flashback reminiscence of the days before the war reveals, Huisuk used to pose as a nude model for Cheol. The recollections of the bygone era strongly suggest that their engagement is predicated on a procreative sexual relationship, a union of two healthy bodies. But like Jeongae with her futile dreams of being reunited with her husband, Huisuk cannot restore the physical integrity of her body that bears debilitating wounds; this erases her reproductive potential as Cheol's mate.

The detailed account of how Huisuk lost maternal body parts—a breast and possibly her womb—is revealed, ironically, by a dedicated mother figure in the play. Jeongae, burning with resentment of Cheol, who betrayed her husband, dissuades Huisuk from forgiving her fiancé when he shows up in Seoul. When Huisuk tries to convince Jeongae to accept Cheol's repentance, Jeongae tries to deter her sister-in law by reminding her that her body is not

the same as it used to be. Suddenly aware of the cruel reality that she cannot bear Cheol's child, Huisuk grabs the space where her missing breast was and her abdomen, where the shell fragment is still buried. With a piercing shriek, Huisuk evokes the painful physical wound as well as deep emotional despair; she does not want her union with Cheol to deprive him of fatherhood, so despite her true feelings, she denies his proposal to reunite. Although Huisuk ends up in this precarious situation not by her own will but due to the uncontrollable forces of history, she takes the scars of her body and mind as a personal burden and keeps them secret from her lover. The loss of a procreative female body for Huisuk becomes an impetus to draw an emotional boundary between herself and her lover.

In a rare moment of fleeting optimism, however, Huisuk contemplates letting the past settle by accepting Cheol's suggestion to leave Seoul and go to Busan to start a new life together. Upon seeing this evanescent vision of hope, even embittered Jeongae pities Huisuk and forgives Cheol for his betrayal. Before their departure, Huisuk and Cheol promise to dedicate their future to each other, in a makeshift wedding ceremony in front of the refugees assembled to see the couple off to their unknown future. But just as a glimpse of hope and salvation seems to emerge, Huisuk's frail body is violently penetrated once again by a gunshot. Jealousy-ridden Cleopatra has fired at Huisuk, and the couple's attempt to reunite by leaving the city ends with their ultimate separation. The unfulfilled reunion of Cheol and Huisuk reaffirms the impossibility of crossing the physical and emotional border, as the couple's physical union would have been possible only after the emotional wounds of others had been healed. Although Jeongae's blessing lifted Cheol from his guilt, Cleopatra, who feels betrayed by Cheol, acts as a messenger of vengeance. Witnessing the end of his quest for love, Cheol goes mad, exploding with grief and anger, while Cleopatra is taken away by the security forces. Deep grief and chaos descend upon all the characters in the form of profound silence, with one remarkable exception. Dudeojwi, still sober and planning to reunite his family, appears at center stage and asks the crucial question: "When are we crossing the Han River to look for my wife? When? When?"[11]

REVISING HISTORY, REVISING MEMORY

In this raw portrayal of bottomless despair, the state seems to have almost no place in settling the losses of individuals. But at the same time, through subtly crafted bodily configurations, the state lays claim to the meaning of border

crossing and the fatal consequences it carries. Deeply steeped in the Cold War politics of contestation and fear, this play reinforces the norm of only heterosexual coupling that will result in reproduction. Not able to consider alternative forms of desire and relationships, the play never upsets the tenet that nonreproductive bodies are forever excluded from family life. Family, which signifies the ultimate utopian unit of human existence in this play, is not possible when individuals are swept away by uncontrolled border crossings—even if involuntarily, as was the case with Dudeojwi and Jeongae's husband.

Cold War politics in South Korea in 1958, no doubt, was oppressive in its binary worldview that divided the "free democratic us" from the "oppressive communist other"; but more dubious and perhaps more curious aspects of this binary raise questions about whether the democratic world was truly liberating when it only accepted the heterosexually policed procreative body. This rigorous guarding of its citizens by the state, as the play shows, is an inherent way of controlling their psychological borders. No matter what the circumstances, nonprocreative bodies, especially those of women like Huisuk and Cleopatra, have no place in the future of proper citizenship.

Not surprisingly, this regimented ideological and corporeal practice was sustained for well over three decades, into the late 1980s, in the theatrical imagination that closely mirrored the military state's draconian policing of everyday life. Although the play was published in 1958, it did not premiere until December 8, 1987, in the last days of military dictatorship in South Korea. Mounted on the main stage of the National Theater under the direction of Kim Woo Ok, the 1987 production showed even more disciplined visions of citizens' bodies as extensions of the state. The first act was based on Yu's original script as published in 1958. But the dramaturge Yun Daesung added a second part that extended the timeline to the early 1980s, thirty years after the dramatic action of the original play takes place. Yun took the liberty of arranging reunions of ravaged wartime characters in order to show their spectacular transformation. Under the new South Korean society of the 1980s, children who were beggars and pickpockets during the war in the original play have turned into healthy, constructive pillars of the new society.

As forthright a piece of political propaganda as the 1987 production was, the play nevertheless drew much attention to the meaning of border crossing, loaded with contested desires. In a dramatic moment showcasing the robust youth of contemporary South Korea in the second act, young people shout "Unification" in unison to open a fantasy sequence on stage. In darkness, barbed-wire walls standing for the national division between the two Koreas disappear, and separated family members are reunited in an ardent embrace.

The state ideology makes a heightened emotional claim through the imagined erasure of the border, which results in the fluid crossing of people from both sides—an utterly utopian vision that the 1958 original script did not have. However, by claiming uncontested power to open up the border, the 1987 production loses the dramatic agony of frustrated border crossers or would-be border crossers, which staunchly embraced the tragedy of countless separated family members.

Although Yu Chi-jin's play seems to faithfully follow the official anticommunist line of the South Korean government of 1958, it also touches a nerve of truth, capturing the chaos and inhumanity of wartime existence. Scratch the surface of the anticommunist play, and we find a convoluted maze of the unresolvable angst and frustrated desire that have characterized the daily existence of people living in a state of forced separation. For this reason, it would be a gross simplification to call this play mere anticommunist propaganda, as it probes deeply into uncertainties about why people first draw lines and then agonize over crossing them.

SIN GO-SONG'S *TEN YEARS* (1958) AND CROSSING DRAMATIC CONVENTIONS

It is difficult to dispute the widely circulated claim that the most representative theater works in North Korea consist of revolutionary operas (*hyeongmyeong gageuk*) and revolutionary plays (*hyeongmyeong yeongeuk*).[12] Supposedly inspired by the life of Kim Il-sung during the Japanese colonial period and later produced under the directorial gaze of Kim Jong-il in the 1960s and 1970s, these cycles of productions collectively capture a wide range of themes and dramatic structures that unfold typical visions of North Korean revolutionary life, ranging from the heroic anti-Japanese resistance movement to anti-American battles during the Korean War to the postwar reconstruction efforts. However, this conventional theater historiography accentuating the artistic genius of the North Korean leadership overlooks a crucial stage in the development of North Korean drama, namely the 1950s, which laid the foundation for the revolutionary operas and plays to emerge.

North Korean dramas of the 1950s occupy a unique place in the overall cultural history of that country because their artistic expression is less restricted. *Ten Years* (1958), written by Sin Go-song, one of the most prominent figures of the early North Korean theater world, illustrates what has been largely neglected in the current genealogy of North Korean drama as articu-

lated by both the official North Korean perspective and the critics. Subtitled a "heroic chronicle" by the author, the play follows a North Korean family over a thirteen-year span (1945–1958) while featuring many aspects unconventional in other plays of the period: the frequent use of subplots and metanarratives as well as the exploration of unusual themes such as romance and jealousy. These aspects might not be striking to today's readers of world dramatic literature, but they surprise those familiar with the rigid dramatic conventions of the revolutionary opera and play cycles that emerged in North Korea in the 1960s and 1970s. Although researchers cannot gather extensive information about how plays and performances were written, censored, published, and circulated in the late 1950s from the North Korean sources, based on the available North Korean periodicals that published extensively on dramatic literature and theater productions, such as *Joseon Yesul* (North Korean art), *Geuk Munhak* (Dramatic literature), and *Sseokeulwon* (Circle members), it can be inferred that during the 1950s there was a greater degree of artistic freedom compared to the subsequent decades.

It appears that the stringent control of the arts in North Korea began in the early 1960s with the launching of Kim Il-sung's personality cult. Before then, censorship by the party may have been less developed and more loosely exercised. The 1950s was also a culturally exciting time period that saw plenty of media coverage on international culture.[13] The more open artistic expressions of the 1950s are indebted not only to the more relaxed sociocultural environment in North Korea but also to the particular artistic and political vision Sin cultivated, as an individual who crossed the 38th parallel from the South to the North to find an ideal environment for his artistic creations. To be clear, Sin was not the only artist to have crossed the 38th parallel to the North; many others, such as Song Yeong, Hwang Cheol, and Sim Yeong, left indelible traces in the dramatic landscape of North Korea. In the 1950s, crossing the border to the other side was entirely forbidden, but for most Koreans it still lingered as a relatively recent memory that vividly captured the traumas of war and separation from the native hometown. To imagine the life they left behind and could no longer access on the South side of the border became crucial in embracing North Korea as their newly adopted homeland.

In Sin's tumultuous life, perhaps his experience of crossing the border from South Korea to North Korea was the most crucial event. Such a life-altering choice most likely would have left salient features in dramatizing the lives of characters who appear in his works of the 1950s. This is not to suggest that the border-crossing experience for Sin directly translates into the experience of his characters, but to emphasize that border crossing for both the

dramatist and his characters stands not only for the geographic migration from one side of the 38th parallel to the other but also for the psychological relocation of their political and artistic affiliation. Crossing here signifies a double transgression: the physical crossing is commensurate with transgressing dramatic genres and conventions on a metatextual level as a way to embody internal struggles of the border crossers. These two registers create a more complex notion of the self and the other for the border-crossing subject, revealing a perceivable gap between the external struggles of history, which fail to reconcile the two Korean nation-state systems along the border, and the internal perceptions of two systems as coexisting and intermingling in the mind of the border crosser. As Louis Althusser noted, ideology represents not "the system of the real relations which govern the existence of individuals, but the imaginary relation of those individuals to the real relations in which they live."[14] Imaginary border crossing for Koreans in the post–Korean War era, in a way, is an ideological struggle quite akin to what Althusser describes (i.e., partition as a historical condition of life). The unique aesthetics of 1950s North Korean drama arguably stem from the recent memories of border crossing between North and South, which produced haunting legacies of division that linger today in the form of ideological and aesthetic struggle.

Ten Years That Crossed Many Borders

Sin Go-song was born in the southeastern province of Korea in 1907 and grew up in a poor farming household with a single mother. Due to difficult financial circumstances, he was not able to obtain higher education; instead he worked as a clerk in a local financial institution. He eventually managed to attend Daegu Teacher's College and taught in an elementary school for two years, until he was dismissed for having been involved in the leftist political movement. He then went to Japan to pursue an education in theater; there he encountered a flourishing leftist cultural movement.[15]

Upon returning to Korea in the early 1930s, he published children's poems and dramas imbued with antiwar sentiments in children's magazines, which the Japanese colonial government saw as a dangerous challenge to the regime. Subsequently he was arrested and imprisoned. After liberation in 1945, Sin was active in leftist drama circles and ended up crossing the border to North Korea in 1946 in order to find a more accommodating environment for his literary works. There he enjoyed a successful artistic and political career,

occupying key positions such as the head of the Pyongyang Institute of Theater and Cinema, the director of the National Theater, and the head of the North Korea–Soviet Friendship Society. In 1962 he was even elected to the Supreme People's Council—the most powerful political position a North Korean citizen could assume at the time. However, after the early 1960s, little was recorded about Sin's activities, and one can only speculate that he might have been purged by the political opposition. *Ten Years*, which was published in 1958 by the leading North Korean arts magazine *Joseon Yesul*, is one of his last publications. This playwright-cum-politician had a formative influence on the North Korean dramatic tradition, and yet, his artistic legacy is practically forgotten by North and South Koreans alike.

Ten Years was written during the height of Sin's success as a political and dramatic leader in North Korea, to celebrate the ten-year anniversary of the founding of his adopted country. The epic scale of the play references historical events across the tumultuous decade, from the liberation from the Japanese colonial government to 1958, when postwar reconstruction efforts were fully under way.

The play, consisting of three acts,[16] is arranged as a family chronicle of the Kim clansmen unfolding amid the sweeping forces of historical events, such as land reform, the Korean War, and the reconstruction of the revolutionary society in the new People's Republic. The Kim family's three sons—Hyeonju, Hyeongi, and Hyeoncheol—in the course of the play transform from impoverished peasants into liberated revolutionary workers of the new socialist state. In contrast to the heroic Kim brothers, a slew of antirevolutionary characters, such as a former landlord's family, their lackeys, and South Korean and American military forces, interfere with the protagonists, only to be defeated by the inevitable tide of history that welcomes the advent of a socialist world order.

Although the characters come across as pale incarnations of ideology and the plot as typical North Korean propaganda—unfolding the liberation of the Korean people by the Soviet Army, epic battles against the South Korean and American forces during the Korean War, and the internal struggle against the remnants of the antirevolutionary elements within North Korean society— *Ten Years* nevertheless features unusual aspects that are rare in other contemporary North Korean plays. Perhaps the most prominent is the presence of a narrator, Hyeoncheol, the youngest of the three brothers, who is described as a fourteen-year-old boy in 1945 when the play begins. Before the first act even opens, he appears on stage and directly addresses the audience:

You might be wondering why a character in a play like myself is making an appearance even before the curtain rises. The playwright wants to show various events spanning ten years in a single play. This may be a futile attempt, and even a reckless attempt, but I see it as my role to assist the playwright and help him capture the details of things as they occurred. This is why you will encounter me not only during interludes but also throughout the action of the play.[17]

Here the audience members are faced with a young narrator whose voice sets out the course of events to follow, "assisting" the playwright in depicting historical junctures that will mark the birth of a new nation. At first glance, it might be natural to assume that a nascent nation like North Korea is analogous to a childlike character such as Hyeoncheol. But in later North Korean drama, there are no other examples where such a young narrator determines the overall structure of a play. After all, what can really be achieved by having a fourteen-year-old guide the audience through the first decade of a newborn nation? The innocent viewpoint of the child narrator might effect what Russian formalist Viktor Shklovsky termed "defamiliarization" (*ostranenie*), or making familiar things strange. A child can see society and history from a refreshing, unconventional point of view that might be easily overlooked by an adult.

To be sure, a child is a figure who belongs both inside and outside society: an honest observer of the world he lives in, but not a full-fledged participant in the actions that take place there. He may be marginal to the revolutionary efforts, but at the same time, he is able to present trustworthy viewpoints that have not been tainted by the world of grownups. The liminal position of the teenage narrator thus is caught between childhood and adulthood, between observation and action, and most significantly, between stage and reality. This allows Hyeoncheol to even cast doubt on what the playwright is setting out to accomplish. When the narrator comments that to document ten years of history in a single play "may be a futile attempt, and even a reckless attempt," he calls into question the goal of the play itself. Such a self-referential statement is quite unusual in the North Korean dramatic tradition, without parallels even in the other plays written and produced in the 1950s.

The narrator throughout the play keeps alerting his audience to various metanarrative registers, linking theatrical action to historic events and thereby providing an authentic aura to this otherwise typical North Korean political propaganda. Hyeoncheol steps out of the dramatic action and reminds the spectators of the sequence of actual historic events that must have been a recent memory for readers and audience members in 1958.[18] Before the curtain

rises in act 1, scene 2, Hyeoncheol appears on stage wearing his junior high school student's cap. He frames the political significance of the subsequent events to be staged.

> The Soviet Army liberated us from the half-century-long slavery under the Japanese colonial regime! What a historic event! What a glorious liberation! How enormously moving this is! As a young person, I can hardly express all these events in words.[19]

Here, Hyeoncheol's stepping out of the events in the play is not a metanarrative gesture to draw attention to the boundary between stage and reality (as a Brechtian reminder that what the audience is watching is nothing but a play). Quite the contrary, it collapses that boundary, obfuscating realities on stage and off stage by having a dramatic character cross the line between the proscenium and the auditorium.

To be sure, crossing the boundary between the reality on stage and the historic reality is nothing new in North Korean theater; it urges the viewers to believe that what they see on stage spills out of dramatic confines to shape perceptions of real events. In fact, it is one of the most salient features of theatricality in the North Korean tradition. What marks this play as different, however, is the fact that its dramatization of border crossing, which weaves the action into the recent historic past, seamlessly merges with the imagined psychological border crossing between the two diametrically opposed regimes. In the prelude to act 1, scene 2, Hyeoncheol further states:

> But there are events that worry even a young person like myself. That south of the 38th parallel, the completely opposite situation [in comparison to the North] is taking place. Antirevolutionary forces headed by Rhee Syngman and American imperialists are against the Moscow Resolution to support the unification of Korea. Even for a young person like myself, these events cause quite a concern.[20]

Hyeoncheol's narration, delivered in an accusatory tone, no doubt resonates with the typical North Korean perspective on partition. At the same time, he reminds the audience of the particular historical stage in which North Korea finds itself, heavily reliant on the Soviet Union for political, military, and economic guidance.[21]

But despite its obvious political tilting, the true significance of this narration is that it prompts the audience to imagine crossing the border virtually

when it is forbidden in reality. Border crossing in 1958 could only have been an imagined event, and it takes imagination to recall the experience when it can no longer be carried out. In this light, it is natural that Hyeoncheol is presented as someone who possesses the ability to envision and verbalize what he is able only to imagine, not to experience. His eloquence and vision are what entitle him, despite his young age, to step closer to the events unfolding in his country.[22] His talent with language is what allows him to transform from an observing child to an acting adult. Before he can fully participate in actions around him, he is able to articulate the meaning of those actions through rhetorical means. This is his way of making a transition from childhood to adulthood.

Upon the outbreak of the Korean War, Hyeoncheol appears on stage as a young soldier who joins the North Korean Army and devotes himself to defending his homeland. From a boyish character of fourteen to a burgeoning youth of nineteen, he makes a leap as historical forces drive the nation to crisis. Even while on a battlefield, where the line between life and death seems to blur, Hyeoncheol, the all-seeing narrator, does not lose sight of his surroundings and is profoundly moved by the beautiful landscape of the fatherland. At this reflective moment, Hyeoncheol's comrade draws attention to his literary talents: "Hyeoncheol, you are a poet and therefore you can feel this urge better. We cannot give even an inch of this beautiful land of ours."[23] Hyeoncheol's clairvoyance reaffirms his quality as a narrator, establishing his authority as the one who can correctly report on the events in South Korea, to which the audience members no longer have access.

Hyeoncheol eventually crosses the border to the other side to reflect on the futility of the division unfolding from the national conflict. By doing so, he brings the imagined border crossing closer to the actual geographic crossing, making the two indistinguishable. A fearless fighter, Hyeoncheol crosses with his brigade to enter the enemy camp. In another direct address to the audience, he notes:

> You are listening to the gunshots of the enemy. Our men successfully diverted their attention and marched forward into their camp. But what awaits the attack brigade is a dangerous challenge. The brigade had to cross numerous barbed-wire fences and enemy checkpoints. No matter how dangerous, they passed them all and secretly marched toward the enemy camp.[24]

Geographic border crossing to confront the enemy is for Hyeoncheol a prerequisite for becoming a hero who can truly differentiate the righteous North

Korean regime from its opposite. Crossing to the other side becomes a performative act that also qualifies him to be a veracious chronicler of history. In addition to his conspicuous military achievements, Hyeoncheol here showcases a new type of dramatic narration that simulates live reportage from a wartime journalist who broadcasts the events as they unfold in front of his eyes. The sense of liveliness of the reported events crosses the time gap between the Korean War and the spectators/readers of the play, who are distantly removed from the real conflict. Hyeoncheol's crossing spurs their imagination, which re-creates the aura of the past events as if they were taking place at this narrative moment. As a central commentator on all the historical turmoil and vicissitudes, he is able to embody figurative and literal border crossing simultaneously, and thereby generate a unique aesthetics that pertain to this particular stage in Korean history.

Dangerous Crossings

However, not all border crossings are heroic acts in this play. Crossing the 38th parallel signifies something entirely different for antirevolutionaries. The playwright shows how the remnants of the bourgeois society still taint the newborn republic and warns the audience that border crossings allow undesirable elements to filter into North Korea—a primary danger that impedes the construction of the newly revolutionized society, which also becomes the focal point of a particular dramatic convention of the late 1950s. For instance, the former landlord's family members represent the lingering residue of the prerevolutionary feudal Korea, as they stand for the typical "enemy within" in North Korean literary and dramatic tradition.

When the play begins, the landlord's family is shown distraught in the aftermath of what they perceive as the devastating land reform. The family used to exploit many landless peasants, including the narrator Hyeoncheol's family, but now that their land has been confiscated and distributed to former peasants, they secretly plot to sabotage the efforts of the Worker's Party in the hope of reclaiming their property. The landlord's two nephews, Jaegu and Jaegeun, respond somewhat differently. The older one, Jaegu, allies himself with the South Koreans in seeking revenge, whereas the younger, Jaegeun, does his best to cope with changing realities even though there are conspicuous conflicts between himself as an individual and himself as a member of the persecuted family. In act 1, scene 2, on the brink of the outbreak of the Korean War, Jaegu comes from the South to persuade his younger brother to spy for the

South Korean military, for he sees no future for his brother in the North. Jaegu urges him to reconsider his prospects: "Jaegeun, you are the nephew of a landlord whose property has been confiscated. Do not think that you can exist in this society. You will not go too far here under the rule of communists. What is there to strive for under such circumstances?"[25] Upon seeing his brother, who he believed was in the South, Jaegeun asks how and when he arrived in North Korea. Jaegu replies, "I can come anytime I want. The Daedong River merges with the Han River. Don't you know that one can even cross through the sky if one's determined enough?"[26]

The sudden appearance of a family member who does not belong to the new social order and its ideal citizenry complicates the meaning of border crossing as an ambivalent act that can generate undesirable consequences, creating a sharp contrast to Hyeoncheol's heroic border crossing. It also becomes a device to complicate the main plot, since the unwelcome border crosser, Jaegu, reveals to the audience that his younger brother, Jaegeun, is in love with Seonsuk—a woman who is mutually in love with Hyeoncheol's elder brother, Hyeonju. Hyeongi, in turn, is admired by a female factory worker, Gilryeon, but just like Jaegeun, she suffers from unrequited love. The two heartbroken lovers, Gilryeon and Jaegeun, eventually end up marrying each other. Compromised by jealousy and frustration, the romantic interests in the play acquire multiple layers of attractions that are not always reciprocated. These complicated human connections are first unveiled to the audience by Jaegu, who has been spying on his brother's private affairs and using personal frustration to motivate Jaegeun to turn against North Korea. Hence, the dangerous border crossing of undesired members of society ignites a chain reaction of unrequited love and betrayal, adding a negative dimension to the meaning of border crossing and opening up new subplots that hinge on taboo subjects in the later North Korean dramatic tradition.

The romantic rivalry in this play primarily intensifies the political strife between the sympathizer of the corrupt past society and the new worker of the communist regime, members of the ideal body of citizens and those who are not. But more broadly, it became a signature of the dramas of the 1950s, distinguishing them from the works emerging out of North Korea in subsequent years. I have noted elsewhere that the amateur dramas written by collective farm workers in the late 1950s place an unusual emphasis on vivid images of healthy female bodies, which signify the dual desires for sex and procreation.[27] Quite the contrary, romance that borders on carnal desire is neither central nor conventional in the canonical revolutionary operas and plays that were produced in later decades. In the late 1950s, however, it seems to have

been one of the very crucial points through which human relations, and by extension, revolutionary missions became staged and resolved. While *Ten Years* does not directly reference any carnal longings that might exist between lovers or between secret admirers and their objects of love, it nevertheless presents a highly unusual dramatic tension built on a very basic human desire and feeling that are foundational to emotional citizenship.

One can argue that the elements of bodily desire in Sin's play may be attributed to the lingering legacies of the leftist writing of the earlier modern Korean literary tradition. In discussing the emergence of proletarian writing in Korea in the 1930s, such as Gang Gyeongae's short stories "Sogeum" (Salt) (1934) and "Jihachon" (Underground village) (1936), Theodore Hughes notes that the "bodily sensation goes hand in hand with the coming to awareness of the proletarian subject,"[28] especially for female characters. Although Sin's play does not explicitly reference somatic sensations as the harbingers of political awakening, it surreptitiously links the rejected romantic desire to the surge of violent political retaliation. In a way, the thesis proposed by Hughes finds its antithetical application in Sin's play and becomes even more complicated by the issues of border crossing.

Ten Years features two instances where the sexual frustration of male characters who are border crossers ignites outright violence against women as a way of condemning the antirevolutionary project. Two female characters— Hyeonju's wife, Seongnyeo, and Gilryeon—are shot to death in the play, designed to invite strong emotional reactions from the audience. In act 1, scene 11, which features how the North Korean people resisted the American forces during the war, Seongnyeo is beaten by an American officer, O'Connell, who pressures her to divulge the hiding place of the North Korean partisans. But just moments earlier in the same scene, we see O'Connell amorously gazing at a framed photo of his wife, calling her tenderly, "my better half, my beloved wife."[29] His contrasting manners in regard to women juxtaposed so closely in one short scene are no doubt intended to reveal the bestial nature and hypocrisy of the American imperialists. However, upon a closer look, this episode unfolds a much more foundational frustration of human desire, manifesting on a barely conscious level. O'Connell's masculinity is accentuated by his amorous gaze at his wife's photo, as he cannot have access to her physically but nonetheless desires her presence. At this moment, he is physically located in North Korea, having crossed the 38th parallel with the American military forces, literally having penetrated the border between the two Koreas. Then, having torturously interrogated Seongnyeo, O'Connell executes her by shooting. The bullet enters Seongnyeo's body—a brutal masculine force literally penetrating the

flesh of a North Korean woman. O'Connell's enamored gaze toward his wife and violent execution of a North Korean woman show that male desire can manifest in two extreme forms hinging on negative duplicity. But it is nevertheless the female body that becomes the foil for unfolding male sexuality as a dangerous antithesis to revolution.

Gilryeon, in contrast, is shot to death by her own husband, Jaegeun, while carrying his baby, which makes the violence even more appalling than the scene with O'Connell. When Gilryeon discovers that Jaegeun, now secretly working for the South Korean military, has been sabotaging the party's work and swindling money from the party, she urges him to confess his wrongdoings and start afresh. When his true identity is discovered, Jaegeun pleads with his wife to leave North Korea with him (implying that they will defect to the South), but when he fails to persuade her, he shoots her mercilessly. Jaegeun's downfall from a potential citizen of North Korean society to the most despicable enemy within the newly revolutionized society occurs after his brother secretly crosses the border from the South and infiltrates North Korea. This undesirable border crosser could have created another undesirable border crosser, but like all North Korean dramas show, no evil escapes punishment in the end. Jaegeun's crime is no exception.

Harboring a criminal turns out to be fatal for Gilryeon; the price is not only her death but also the death of her unborn child. She and the baby are painful reminders of Jaegeun's unrequited love, and perhaps it is only natural for him to see them as signs of his failure, of which he must unburden himself. The marriage to Gilryeon and her pregnancy, the result of their not-so-ideal carnal union, are a pale substitute for Jaegeun's unfulfilled desire for his true love, Sangsuk, who ends up choosing a proper (read "typical") North Korean hero, Hyeongi.

Ten Years entangles primal human instincts and their frustration with more outward political actions against the background of history when border crossing was still a very prominent memory for North Koreans. It uses body politics to carve out the true boundaries of ideal citizenship, and thereby began a tradition of imagining the other in North Korean dramatic writing. Although pretty much everything we know as North Korean drama is attributed to Kim Il-sung's creative force in one way or another, it is actually the dramatic works of the 1950s, such as *Ten Years*, that laid the foundation for many years to come. At the same time, these works feature what could be labeled as risqué elements from a contemporary North Korean perspective, and invite theater historians to reconsider why those elements did not survive in the following decades.

The diversity and liveliness that characterized the 1950s came to an end in the early 1960s, with the first turning point on November 27, 1960, when Kim Il-sung instructed writers and artists to reflect on the realities of the time and to present a new era and a new people. Similar instructions were issued in 1961 and 1962, and the 4th Party Assembly Report on Literature and Arts reaffirmed these principles, which expedited the implementation of Kim's idea. It was around this time that rural drama troupes began to disappear, for they were unable to reflect the new reality.[30] By the mid-1960s only the National Theater Troupe (Gungnip yeongeukdan) remained intact to perform a handful of chosen plays from the repertoire. The dramatic world started to yield most of its resources to the rapidly emerging genre of cinema, which fueled the downturn of the spoken dramas on stage.

These changes inevitably eclipsed the legacy of one of the most vibrant periods in North Korean history, seldom remembered and studied now. Contemporary readers of North Korean dramatic literature have the disadvantage of hindsight—of focusing too much on the works of the 1960s and onward. This limits our understanding of the North Korean dramatic tradition in a holistic sense. Therefore, various levels of border crossing in this play challenge the historiographic limitations of what we conventionally perceive as the North Korean dramatic tradition. In this respect, *Ten Years* is a play that has crossed many borders and opened up many alternative readings of North Korean theater history.

2

DIVIDED SCREEN, DIVIDED PATHS

THE 1960S AND '70S WERE DECADES MARKED BY EQUALLY STRONG forces of hope and fear in inter-Korean relations. Although they vacillated between partial reconciliations and ever-growing animosity toward each other, both Koreas thrived in the division system, in which one side's legitimacy is predicated on the negation of the other. Now that the traumatizing partition and gory warfare were entering the repository of memory, a sense of normalcy began to define everyday life. The political and social stabilization, quite ironically and unfortunately, was achieved by draconian institutions of dictatorship in both Koreas. North Korea consolidated Kim Il-sung's dictatorship under the guiding principles of *juche* ideology;[1] South Korea, in an eerie resemblance to its sworn enemy, opened the era with a military coup by Park Chung-hee on May 16, 1961, which resulted in an eighteen-year dictatorship until Park's assassination by his trusted security aide in 1979. The pinnacle of Park's regime came in 1973, when the People's Assembly was forced to reform the constitution to enable Park to serve as president for life, using a system known as *Yushin*,[2] the annihilation of democratic election procedures. South Korea and its northern counterpart both pursued centripetal concentration of state power at the expense of democracy and political freedom.

One more significant development detrimental to already hostile inter-Korean relations was the discovery of three underground tunnels in the southern

part of the DMZ—the first on November 23, 1974, the second on March 29, 1975, and the last on October 28, 1978—by the South Korean DMZ patrol. The South Korean government claimed that these tunnels had been dug by the North Korean military for a stealthy underground invasion. The sequence of discoveries raised South Korea's anxiety about undesirable border crossing, intentionally designed to escape the scrutiny of watchful border guards. According to a report by Daehan News—the official news agency of the South Korean government—released on November 23, 1974 (installment number 1010), the discovery of the first underground tunnel marked "not only the violation of the armistice agreement but also a de facto invasion of South Korean territory by the North Korean military forces." Likewise, according to the 1208th installment of the same news series (released on October 28, 1978), which reported on the discovery of the third tunnel, the South Korean Minister of Defense warned North Korea "to halt all preparations for war and that the South Korean armed forces will not allow any type of military adventures by the North." These accusations were met with adamant denials by North Korea, which claimed that the underground tunnels were dug by the South Koreans and that the allegations were blunt propaganda to prevent any positive development of inter-Korean relations.[3]

In spite of the grim political reality, doubly marred by the lack of democratic freedom and the threat of war with the discovery of the tunnels, this era also witnessed hopeful moments of possible reconciliation, propelled by rapidly changing Cold War dynamics in East Asia. In 1971, U.S. Secretary of State Henry Kissinger visited China and paved the way for President Richard Nixon to follow in 1972. A series of U.S.–China exchanges, known as "Ping pong diplomacy," ensued, resulting in a sudden thaw of the long-standing Cold War confrontation that had reached its high point during the Korean War.

In a parallel process to China's partial opening toward the West, the two Koreas also enjoyed a temporary thaw, most notably on August 20, 1971, when Red Cross delegations from both Koreas met in Panmunjeom in the DMZ for preliminary discussions about hosting a meeting to address pressing humanitarian issues, such as temporary reunions of separated families. This was the first time the two Koreas had officially met face to face in twenty-six years, since partition in 1946.[4] The following year also saw improvement in inter-Korean relations, culminating in the declaration of a joint communiqué between the two governments (7.4 Nambuk gongdong seongmyeong ui tongil samdae wonchik) on July 4, 1972. The communiqué consisted of three major

principles: 1) Korean unification should be carried out autonomously by the Korean people without the interference of foreign powers; 2) unification should be carried out in a peaceful manner without the use of armed forces; 3) unification should pursue the unity of the people, which transcends differences between ideologies and systems. Although these principles remained abstract ideals rather than actual practices to change the course of inter-Korean relations,[5] they were nevertheless groundbreaking in the bold imagination that separated people from the political system, as apparently expressed in the third principle. This is crucial, as it projects a unique vision of the "other" Korea as made of two constituents inherently at odds: the always-evil regime and the people, who want to and should join in kinship/citizenship with the other side once they are freed from the yoke of their miserably failed government. The projections of the other Korea became much more convoluted and discursive, compared to the unilaterally negative representations in the previous decades.

On a cultural register, the process of extricating people from their state was enacted most imaginatively, allowing fissures and gaps to appear in the astringently controlled representations about the other Korea. While the two plays in chapter 1 cast individual characters and the Korean nation they stand for in the same derogatory light, the two films analyzed in this chapter—the South Korean film *The DMZ* (1965) and the North Korea film *The Fates of Geumhui and Eunhui* (1975)—illustrate very different notions of citizenship as much more complex than simply individual subjects' membership in the other failed Korean state. As both films show, whether a person is from the North or the South is not the determining factor; rather, citizenship is defined as familial relations strengthened by intuitive bonding between lost kin.

The existential question of belonging raised in both films, despite their conspicuous defense of their own political regime, is presented through the innate bonding between siblings as they inhabit the same maternal body, both literally and figuratively. In a striking parallel, the two films use the contested spatial semiotics of the DMZ to illustrate the tragic, yet hopeful dimensions of family ties, metonymically standing for the splintered citizenship in Korea. The South Korean film imagines two strangers eventually coming together as brother and sister while crossing the DMZ from North to South in search of home; the North Korean film, which came out a decade later, shows twin sisters living as strangers after they are separated while crossing the DMZ from South to North. Bearing an astonishing resemblance to both a womb and a coffin—where life and death are determined by cruel

chance—that immense, uninhabited, and unpredictable space called the DMZ devours life while it creates new life interwoven with dark shadows from the past. For divided families, the new life they find after crossing the DMZ is incomplete, trapped in the past, where part of them died upon their separation.

This chapter captures each Korea's shifting rhetoric toward people on the other side of the border, reflecting and anticipating the subtle changes in the political and cultural climate of the inter-Korean relationship in the 1960s and '70s. Both films were made when increasing political stability, albeit through dictatorship, allowed for a growing number of cultural productions. The film industry started to grow exponentially in both Koreas, and nationwide spectatorship exploded: without qualifications, cinema was *the* rising genre, serving the needs of education and entertainment.

In North Korea, where film was seen as the primary means of political indoctrination, state intervention in and support of the thriving film industry was far from surprising. In fact, the cultivation of North Korean film had a very clear purpose: to liberate the South Korean people from political oppression. In his address to a group of "literary and cultural workers (*munhak yesul bumun ilgundeul*)" on November 7, 1964, Kim Il-sung praised the progress made in screenwriting, but also directed that "the party must put an emphasis on liberating 20 million people in the South. Their liberation [from the American imperialist oppression] is not only in the hands of South Koreans, but also in our hands."[6] The shifting notions about the people under the other regime are well reflected in the speech, which solidified the political profile of the state-groomed film industry.

In South Korea, where film competed with many other forms of entertainment, it nonetheless enjoyed unrivaled success as the industry grew tremendously in the 1960s. This was indeed the Golden Age of South Korean cinema. For instance, in the early 1960s, only 87 films were produced and released, but by 1969 there were over 200. The number of moviegoers sharply rose, from 58 million in 1961 to 170.4 million in 1969.[7] However, the 1970s saw a noticeable decline due to the rising popularity and accessibility of television. This was not quite the case in North Korea, where the first pinnacle in cinema history was reached in the 1970s, when Kim Jong-il emerged as a prominent figure in the propaganda bureau and dedicated his political clout to making film the dominant form of national culture. The two films addressed in this chapter were produced and circulated in the heyday of each Korea's cinematic glory; both testify to how the DMZ figured significantly in the moment of each nation's coming of age.

THE *DMZ* IN THE DMZ

The black-and-white screen is illuminated by the living images of the dead and the dying images of the living. A lone girl, no more than age five, walks endlessly on the dusty ground in open wilderness. She is wearing only a sleeveless summer dress and simple flat shoes, and appears vulnerable and frail. Exhausted by the long walk along the dusty road, she clings to an empty tin can as if it is the only familial object she has left. As she stumbles upon abandoned train tracks along the barbed wire, a tall rifle, fixed in the ground like a tombstone, enters the film's frame. Then the camera moves closer to the ground to show a human skull. The little traveler's gait stops with a gasp at the naked image of death.

The spectral matrix weaving life and death into a scenic incongruity is the work of South Korean director Park Sang-ho, whose films tackle the realities of Korean division. Arguably, his most notable cinematic achievement is *The DMZ* (1965), whose memorable moments arise from the poignant portrayal of fragile children who face death every minute of their lives during the war.

The film follows an unusual journey of children, completely abandoned in the DMZ during the war, left to cross the two-mile-wide wilderness to find their mothers. The girl who enters in the opening sequence falls into a stream in the DMZ. She is rescued by a boy who looks three or four years older than she; he is also crossing from North to South in search of his family, from whom he was separated during the Korean War. Wearing a tattered military uniform of unknown origin and carrying weapons, he presents a grotesque figure, exuding both severe fatigue from the long walk and mischievous excitement from engaging in a war game with actual war machines strewn across the DMZ. On their southbound journey in search of home, the boy and girl eventually become like brother and sister, at times indulging in playful oblivion of their circumstances: a deadly land mine turns into a fire pit for them to bake potatoes, and a discarded military tank becomes an iron horse for them to ride for amusement. But no matter how surprisingly the children transform the DMZ into a space for play with their innocent spirit, their route is littered with death: heavily bombarded buildings that stand like ghosts, military tanks and land mines still lurking as killing machines, and skeletons of fallen soldiers. In the end, the boy is murdered by a North Korean soldier who is fleeing from South to North and the girl is left alone to continue her journey through a minefield. The film ends with a panoramic shot of the landscape of the DMZ accompanied by narration deploring the tragic realities of division.

The emotional truth of the film, captured without the excessive high melodrama so popular in the 1960s, is strengthened by the purity of the children's perspective. As the only means through which spectators see the vacuous space of the DMZ, the rendition of the children's viewpoints transforms the familiar scars of war into playthings. Such distinctive choices were the results of Park's long battle with the prevailing cinematic style.

In the South Korean film industry in the 1960s, distinctive genres emerged as the nation entered a new phase of social stability and economic growth. Demand for popular entertainment and an ongoing need to sustain the rigid ideological purity of the nation meant melodramatic and anticommunist films equally enjoyed their heyday. The latter, in particular, were produced en masse, to the point that they constituted a genre of their own quite distinctive to South Korea. As different as these two cinematic genres might appear at first glance—the former mercilessly pursuing popularity at the box office and the latter molding the state's ideological mission to antagonize North Korea—in practice, they shared foundational similarities. Both genres, according to Park, were exaggerated and false, eliding truth and reality. In an interview featured in a documentary commemorating his cinematic legacy, Park claims that South Korean filmmakers of the 1960s did not study the realities of the society and produced films oversaturated with impulse: "There was too much fiction. As a result, all films looked similar and filmgoers were jaded. Once something came into fashion, everyone jumped on the bandwagon. [. . .] I had a strong urge to make cinema grounded on realism and kept searching for the right subject that would allow me to create [a new vision of reality]."[8]

"Semidocumentary," the subgenre for the film, was a natural choice for the director's vision of validating truthfulness in cinema. Clearly distinguished from the trendy films of the time, the unique genre, half documentary and half feature film, allowed for a mellifluous confluence of free-spirited poetic imagination and authoritative documentary footage. To augment the realistic profile of the division, the film did something that most regarded as impossible—entered the DMZ itself. Director Park's tenacious mission to capture visions of history as lived by real people led him to the actual grounds of the DMZ, still heavily littered with explosives and dead bodies from the Korean War, which had temporarily halted just over a decade earlier. As Park reminisces in an interview:

> There were just too many land mines. Since nobody really knew where they were, it was necessary to clear them up first before shooting. The U.S. military asked me where I wanted to shoot my scenes in the DMZ. But I really did not have a clear idea about the detailed landscape of the

DMZ, so I simply listed some iconic sites, such as Panmunjeom and the train that was abandoned in the DMZ like a ghost shell after it had been bombarded during the war. When the U.S. military cleared a certain area of land mines, they demarcated that place and allowed me to shoot within the confines. But whenever I saw proper scenery for my film, I wanted to shoot there impromptu, and this caused conflict between the film crew and the military. We even had heated arguments about to whom the DMZ really belongs.[9]

Director Park's persistence qualified the film as a site-specific performance in the most visceral sense of the word, but *The DMZ* achieves yet another symbolic level of truth in addition to its documentarian precision. As the characters traverse breathtakingly beautiful, yet hauntingly desolate landscape, their playful view of the world scarred by the ravages of war emerges in equally poetic and compelling measures. Setting the children's perspective as the main viewpoint to illuminate the scars of war at first makes the elements of free-spirited play utterly incongruous with the tragedies. But eventually the seemingly incompatible forces of joy and trauma fuse into the landscape of the DMZ. As viewers travel along, the children's innocence enlivens the zone under the guilt of war.

After the boy rescues the girl from drowning, they sit by the stream and have a conversation evocative of both uncanny fables and absurdist drama.

BOY: What is your name?
GIRL: Yong-Ah.
BOY: Yong-Ah? It's my sister's name.
GIRL: No, it's my name.
BOY: No, it's my sister's name.
GIRL: No, it's my name.
BOY: I said it's my sister's name.
GIRL: Where is she then?
BOY: She took refuge with mother.
GIRL: I am real Yong-Ah. Uncle Bawoo told me so.
BOY: Bawoo is my real uncle.
GIRL: No, he is my uncle.
BOY: Yong-Ah is my real sister, too.
GIRL: No, Yong-Ah is my name.
BOY: If you are Yong-Ah, you should call me brother.
GIRL: All right, brother.[10]

Bordering simultaneously on the preposterousness of Eugene Ionesco's *Bald Soprano* and the cinematic void of René Clément's *Forbidden Games*,[11] the conversation shows the young strangers eventually coming to accept the terms of kinship as they join in crossing the DMZ. Their lively exchange, punctuated by repetition and imitation of each other, turns the focal point of the dialogue from content to form—from semantics to the playful deployment of language itself. Kinship is established through spontaneous wordplay, obliquely obfuscating the questions of who they really are.

But because the dialogue successfully evades any finite meaning, any singular interpretation of their relations, paradoxically, it opens the way for a darker truth to emerge: it is the children's innocence and playful spirit that can potentially excavate the horrors of war. The fact that some names are identical might be fortuitous, but could it be that the boy and girl are a real brother and sister who fail to recognize each other due to amnesia stemming from war trauma? Could it be that the dialogue's ontological weight is defined by a graver dimension of what is not explicitly said and shown in the film?

The cinematic subtext of this impish exchange raises a possibility that the boy and girl might be siblings who lost their memory during the harrowing course of separation from their families and the ensuing journey. Such a reading, in turn, entails what could be a futile effort to reconcile oblivion with the tenacious nature of memory. Amnesia may be comforting and even necessary to enable survivors to move beyond traumatic events, but it does not secure the survivors a perpetual refuge where oblivion becomes an all-curing remedy. Although lying in the silent shadows of the past, the children's immediate memories, which are not directly presented in the film, creep into the cinematic text through the recurring tropes of separation and nightmares.

The children's dialogue sets up an allegorical universe in which kinship is established and dismantled throughout the film. It is not entirely clear how many days and nights these children walk in the DMZ, but throughout their journey, they go through multiple cycles of separation and reunion, first initiated by playful exchange and then forced upon them by violent surroundings. As the uncanny bonding through naming illustrates, play gains a serious dimension where the symbolically sublimated pain raises its persistent profile. In a similar duel of danger and pleasure, trauma and play, the young travelers survive a near-death experience following their fairy tale-like encounter: when the boy finds potatoes in the open field, he starts a fire on a metal plate covering a land mine. Not knowing the fatal consequences of such an action, the boy and girl chatter with delight at the prospect of killing their hunger. But their merriment is shattered when the plate explodes violently, and the poetic

scene is immediately interrupted by actual documentary footage of military delegations from both Koreas as they come face to face in Panmunjeom and each blames the other side for the provocative incident.

Nonetheless, this experience does not dispel the allure of play for the children. As the boy and girl, now brother and sister, continue their walk through the unpredictable grounds of the DMZ, they come across a strange line, marked by a simple white ribbon that runs over weeds and open fields. The camera captures the signage of the Military Demarcation Line, the ultimate frontier that separates North from South. But the children regard this encumbered symbol of national tragedy as simply another prop for playful engagement with the strange universe they inhabit. When the girl asks her brother what the line is for, the boy casually brushes off her question and says: "It's for dividing the land." Prompted by her question, he suggests that they occupy each side of the line and not talk at all as sworn enemies. The girl is intrigued by the unusual game and delightfully accepts the invitation. They each take one side along the border and set out to mark their territory—the boy urinating over his side of the land and Yong-Ah drawing additional lines to mark her side.

But what starts out as merry play soon begins to cast dark shadows. When the boy and girl sit down in their respective territory, the boy pulls out a rifle and aims at his sister as he reinforces the rules of the game once more: "If you break the rules, I will shoot you." The sudden outburst from an otherwise kind little boy exposes the violent heart of war, where so many lives were lost just to keep the line from moving northward or southward. Now sitting across the ultimate frontier, the children are separated by deadening silence, and the camera captures a close-up of both children with their backs turned toward each other (fig. 2.1). Only wind crosses the field, making the flimsy line flutter.

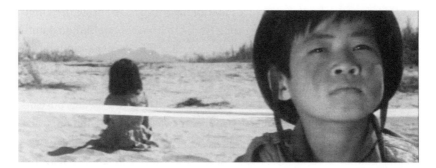

FIGURE 2.1 Two young travelers play an allegorical game of being alienated from each other while they sit on each side of the border in *The DMZ*.

Amid thick silence, the camera moves to feature a different register of emotional kinship: the potential reconciliation between North and South Korean soldiers. A South Korean radio broadcast aimed at North Korean listeners breaks the silent equilibrium. The speaker on the South side of the DMZ sends a heartfelt message to North Korean soldiers and starts to play a song appealing to the emotions of the separated brethren.

> Does a mountain keep you from coming here?
> Does a river keep you from coming here?
> The land in the north, the land in the south
> They all belong to our Fatherland.
> But why can't we see you even in dream?
> We only regret [sic] the 38th parallel.

As the lyrics play over shots of the serious faces of soldiers from both sides, fully armed in camouflage and ready to launch an attack at any moment, they also overlap with the stern face of the boy and the frustrated face of the girl as they sit still across the line. With time, what started out as play turns into a serious contemplation on the rigidity of division. The forced alienation of the boy and girl is foundational to this ludicrous game, but by exposing its artificial rules, this seminal scene unravels the absurdity of the reality in which North and South Koreans must live—arbitrarily divided and forcibly silenced. Painfully bearing the burden of silence, Yong-Ah finally breaks down in tears, pleading with the boy to quit the game; the boy, equally frustrated at this point, knocks down the barrier and embraces his sister in an emotional outburst.

As the children's play unfolds the real dimensions of war more and more viscerally, the film reminds viewers that the siblings' coming together is still a precarious engagement. Their struggle to cross the DMZ leads them to the fact that, in order for their newly established kinship to be viable, they must find their common mother—the crucial force that gave them life and created their kinship. The mother never appears in the film, but the hollow landscape of the DMZ reveals itself as an ominous simulacrum of the missing mother. As the film progresses, that vacuous space slowly gives way to various passages reminiscent of mazes and dead-end roads. The two siblings continue on their journey to a crossroads where life and death literally intersect. The landscapes captured in haunting black-and-white scenes interweave flowing streams and rivers to cleanse the emotional wounds suffered by sojourners, and dark, cavelike ruins and a gloomy forest encircle the two vulnerable creatures (fig. 2.2).

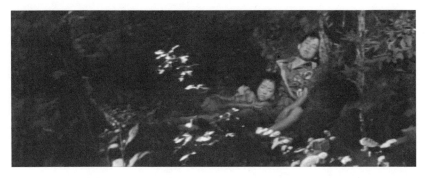

FIGURE 2.2 Boy and Yong-Ah find a shelter to rest their tired legs at night in *The DMZ*.

FIGURE 2.3 Yong-Ah chases the phantom of the soon-to-be-dead boy in a nightmarish scene in *The DMZ*.

To rest their legs, the boy and girl curl up in a shadowy nook of the forest, looking like stillborn babies. This womblike space cannot sustain their lives, like a dying mother who can only expel her ill-fated creation to the cold, ruthless world of death. The DMZ devours life but also creates life out of sheer whim, knotting one relationship as it breaks another.

Literally like a perilous crossroads, this scene is a crucial turning point in the film: the separation of the siblings, earlier as a game, degenerates into violence. In an effort to nourish their feeble bodies, the boy looks for C rations left behind by the American army. During his search for food, he involuntarily becomes separated from the girl and they make desperate efforts to reunite. Yong-Ah crosses the open bridge of a demolished structure, anxiously calling her brother's name (fig. 2.3). Like a spectral vision in a nightmarish dream, she appears in the scene as the sole living figure in the entire world. As if entering the mouth of death, her tiny frame is about to be devoured by the merciless sky and desolate earth.

The lingering impact of this scene is accentuated by the angle of the camera, which shows Yong-Ah's crossing from below. As an allegorical dead mother who cannot give life to her children, the DMZ itself seems to be looking at Yong-Ah, her dying child, as she crosses the bridge connecting life and death. That crucial bridge leads to a large demolished structure where corpses of war casualties have decayed into harrowing skulls. Chasing the phantoms of each other while encountering the physical image of death, the brother and sister now step closer to an inevitable death to come.

REAL DREAMS OF REUNION, DREAMY REALITY OF SEPARATION

Stepping over decaying corpses and skulls strewn over the steps of the ruined building, the boy and girl enter the maze. Unable to find each other, they only hear the fading echoes of their voices calling out desperately. Their trails overlap, but they miss each other, as if they are walking through complete darkness in the belly of death.

When the boy and girl are finally reunited in the building, they cannot rejoice too long, since they soon encounter a North Korean soldier who is crossing the DMZ from South to North. Suspecting that the children are running away from North Korea, he forcefully drags them with him. In defiant resistance, the boy aims what he thinks is an unloaded rifle at the soldier, but accidentally pulls the trigger and brings down the North Korean. Surprised by this unforeseen turn of events, the boy runs to the wounded soldier, who now stabs the boy to death. The young traveler meets his end, to be separated from his sister and fall onto the gloomy ground of the DMZ—his dead mother—who now embraces him as she did so many other unfortunate crossers before.

Yong-Ah's predicament, foreshadowed in the previous bridge scene, now becomes reality, and she is back to where she was at the beginning of the film—the absolute loneliness of a solo traveler. Forever lost and in deep grief, she finds shelter in a demolished shack at night when rain pours down, as if to mourn the death of the young boy. Soaked and shivering from high fever, she covers herself with a straw mat and falls asleep, only to continue the nightmare she has been living while awake. In her dream, she sees a clear, sunny sky sending brilliant rays to the courtyard of the shack. When she runs out toward the sun, she sees the radiant smile of the dead brother, who stands there with two kind-looking South Korean soldiers. Delighted, she runs to

embrace him, and the soldiers promise to take her to her mother in South Korea. When she goes back to the shack to retrieve her tin can and comes out again to join the company, she sees nobody. Yong-Ah calls out for them, desperately running through the fields and mountains as she tries to catch up. She runs and runs, frantically trying to find the others, but she misses a step and falls off a cliff. Yong-Ah wakes up with a shriek, delirious with fever, only to realize that she was sleeping with death. The film shows that during the night she was literally embracing a skull that had been lying under the straw mat (fig. 2.4).

The director's relentless pursuit of psychological truth culminates in this most disturbing nightmare, audaciously juxtaposing the quintessential image of death with a very young girl who is just starting her life. The weight of war she must carry crushes her frail figure, but she continues on her journey. Deeply wounded by the loss of her brother, she finds temporary relief when she encounters a baby goat to play with in an open field. The immaculately pure animal and innocent little girl soon become close travel companions. But when the goat runs playfully into the bushes, it steps on a land mine and explodes into dust. The allegorical parallel between an innocent sacrificial animal and a young child invites viewers to accept the goat's death as the girl's own end. Although the ensuing scene simply captures a close-up shot of her bloody face, her aimless gaze staring at the void in front of her foreshadows that she is bidding farewell to her life. On her way to join the friends and family who left her alone in this world, her empty gaze eventually merges with the void of the sky.

The memories of war implode in symbolic expressivity because the DMZ, the very space that those memories inhabit, explodes. With its lush, beautiful landscape, crystal-clear streams, and rain, it is supposed to be the maternal

FIGURE 2.4 Yong-Ah wakes from a nightmare of dying to find that she was sleeping among the dead in *The DMZ*.

womb where life is conceived and delivered to this world. But all too paradoxically, this land also consumes life with its wrathful explosives and deep gashes from recent battles. This ambivalence is highlighted in the closing scene of the film (fig. 2.5), in which the camera follows the dying gaze of the girl toward a distant horizon. The grave voice of the narrator resounds over the panoramic bird's-eye view of the beautiful DMZ landscape:

> The mountains and rivers are always the same
> but the Demarcation line is still dividing our land.
> Just imagine that so many people shed their blood
> —the blood of same people—the blood of same nation.
> That's not for the Line, but for freedom.
> Oh Heavens, what will you do about the fate of the nation?
> Oh Heavens, when will you answer the cry of the Korean people?[12]

Facing the burden of history at a place where the legacies of the past still vividly ignite new violence, the closing scene accomplishes a task that most filmmakers wanted to evade at the time—to get to the bleeding heart of the unresolved Korean tragedy. "It was too close to the viewers' painful memory," director Park reminisces in an interview. *The DMZ* was neglected by the domestic audience, who found it an agonizing reminder of a still recent experience, and it did not do well at the box office. As one critic noted at the time: "I am not sure about the fans of melodrama and action flicks, but intelligent filmgoers will have a stimulating conversation with the film."[13] However, *The DMZ* was well received overseas; it was exported to India and Hong Kong and even won the Best Film Award in the category of tragedy at the Asian Film Festival.

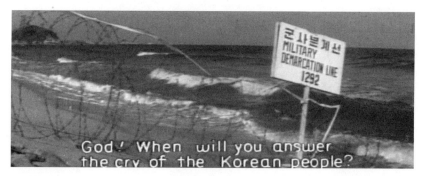

FIGURE 2.5 The ending sequence of *The DMZ*, where the narrator deplores the tragic fate of divided Korea.

Deliberately filtering emotional expression in pithy cinematic frames, the film explores the psychological underworld against the backdrop of the vacuous DMZ—a landscape that has become an emotional playing field where imminent death looms large behind the temporary spurts of life. Through vicissitudes of separation and reunion, alienation and identification, family kinship is formed and dissolved just as nature blossoms and dies with seasonal changes. But forever unchanging in that process are the emotions that the DMZ conjures up, a strange concoction of fear and hope for the future, desire and abomination for the other side, and eternal longing for the separated who have gone to the netherworld of the borderland. The DMZ is marked by these emotional land mines, constantly ready to ignite in the open field.

THE FATES OF GEUMHUI AND EUNHUI (1975)

The question of South Korea must have presented itself as a two-pronged project, first of the people and then of the state, after Kim Il-sung declared in a speech to a group of "literary and cultural workers" on November 7, 1964: "Our literary and cultural fields have achieved so much but still have one fatal deficiency—the lack of any representation of South Korean people's lives and political struggle."[14] To North Koreans, the state of South Korea represents an undeniable failure: in the crucial aftermath of World War II, when the nascent Korean nation was at a crossroads, South Korea turned its back on the benevolent leadership of Kim Il-sung and forfeited the Korean people's dignity and sovereignty, most noticeably by accepting the continued presence of the U.S. Army. But the people of South Korea were not inherently complicit in the state's failure. Quite the contrary, they were the primary victims, because the burden of harboring the evil American imperialists fell upon their frail shoulders. Such a convoluted symbiosis of hatred and compassion, directed respectively at the South Korean state and its people, shaped distinctive dimensions of how inter-Korean citizenship was imagined in North Korean cultural works in the 1960s and '70s.

The North Korean film *The Fates of Geumhui and Eunhui* (hereafter referred to as *Fates*) illustrates a world of *discordia concors*—harmonious discord—hinging on the opposing emotional forces of love and hatred, sameness and differences. It follows the lives of twin sisters who are separated early in their childhood—Geumhui growing up to be a happy and accomplished dancer in North Korea while Eunhui is forced into a life of depravity, selling her body and musical talent in order to survive in South Korea. The doubling of a single

inseparable entity,[15] figured in the trope of twins in this film, is of course a protest against the aberrant separation of the Korean people into North and South Koreans.

The Korean border—first the 38th parallel and later the DMZ—plays an important role in determining the fate of those who dare to cross it. The DMZ in the film is that crucial dividing line where the future is determined not by sheer chance, but by the intentional choice of those who consider crossing it. Rather than leaving individual fates in doubt, this positivist North Korean film advances individual determination as a primary force deciding whether one ends up in socialist utopia or capitalist dystopia: those who have the courage to cross from South to North end up in paradise, whereas those either too devious to become North Korean citizens or too feeble to cross the border remain in the dystopian South. The borderland is a space of choice for life in *Fates*, and in this respect, the film presents a stark contrast to *The DMZ*, where the border is a fatalistic space of death. The films' diverging outlooks hark back to the directors' intentions: *The DMZ* was motivated by Director Park's obsession with capturing a living piece of historical truth, and *Fates* became the primary channel to broadcast the teleological vision of Korean history in which South Koreans must be liberated by the national father, Kim Il-sung.

The film's opening scene brings viewers to a well-illuminated exhibition hall in Pyongyang. Sanguine citizens of North Korea are enjoying a rich cultural night out. The camera immediately zooms in to a conversation between two young men who stare at a painting of a beautiful young dancer in a traditional costume. The man who purchased the painting tells his comrade that the girl in the painting must be Eunhui, his lost sister, who would be around age twenty-seven if she were alive today. He further recalls how Eunhui loved to sing and dance since early childhood. Geumhui, the actual model for the dancing girl in the painting, overhears this conversation with astonishment. She realizes that the strange man believes that the girl depicted is someone other than herself, about whom she has never heard until this point. When shell-shocked Geumhui returns home, she asks her father about her past. She urges him to reveal her true identity, which he has kept veiled in mystery, questioning whether she is his biological daughter. This leads Hyeonsan, Geumhui's father, who painted the dancing girl, to reminisce about the fateful event that took place more than twenty years ago.

An ensuing scene marked as Hyeonsan's flashback memory unfolds on the dark and gloomy screen. Viewers are now brought to a wild open field near the 38th parallel in South Korea. The time is shortly after Korea's liberation

from Japanese colonial rule in 1945. Overgrown with unkempt weeds and marked by random passageways, this space brings people from various walks of life together where their lots are changed forever. Hyeonsan enters the field as a young artist who has just been expelled from a South Korean art school for being unable to afford tuition. He is northbound, on his way to his hometown; he dreams of living in an equal society liberated by General Kim Il-sung. On the road, he runs into Byeongho, an impoverished but kind-hearted South Korean fisherman who is returning home after an unsuccessful fishing trip. The two take refuge in a small shack when a rainstorm starts to pour down.

Soon they spot another man, holding two little girls in his arms, barely managing to walk through the muddy field. When they rescue the man and children and bring them to rest under the straw roof of the shack, the young father of the twin girls barely finds the strength to tell them the devastating story of his life. His wife recently passed away, leaving him with young children to look after, but he is hardly able to look after himself: a music teacher continuously persecuted by the South Korean police for having praised "the shining star over Baekdu Mountain," an obvious moniker for the North Korean leader Kim Il-sung, he realizes that he has no future in South Korea and decides to cross the 38th parallel to live under the leader's loving care. But he breathes his last while pitifully holding one of the twins in a tight embrace. In grief for his untimely death, the desolate song whose lyrics gave the young father so much trouble resounds lachrymosely.

> Good night baby, my loving baby
> The night is thick, good night baby.
> The shining star over Baekdu Mountain is bright,
> He protects you, my loving baby.

The song bridges many separated entities, such as dead parents who departed from their children and siblings who are soon to face separation for good. But more crucially, it marks the transfer of paternal authority; as sudden tragedy befalls the young twins, it prompts Hyeonsan to feel deep sympathy and take the girls to North Korea with him. Byeongho is moved by Hyeonsan's selfless act and deplores the precarious fate of the orphans, to the point that he volunteers to take one of the girls in an effort to relieve Hyeonsan of some of the burden. In a twist of fate, Geumhui ends up in North Korea with her artist father, Hyeonsan, and Eunhui ends up in South Korea with her poor fisherman father, Byeongho. But regardless of how loving and ideal the adoptive

fathers might be, the lyrics advance the notion that ultimately the children are the protégées of Kim Il-sung, whose significance is elevated to the realm of eternal nature—the shining star of Baekdu Mountain. The allegorical reference to fatherhood, as illustrated in this song—from biological father to foster fathers, and then finally to the national/natural father—is not simply an arbitrary unfolding of artistic imagination but a political directive.

That the people of both Koreas are legitimate children of the North Korean leader Kim Il-sung is a deeply rooted conviction that allows North Koreans to regard South Koreans as unfortunate brothers and sisters rather than enemies. The random fates of Geumhui and Eunhui tellingly assert the oneness of the people, who are not the root cause of their own misfortune. The identical looks of the twins—Geumhui and Eunhui are played by the same actress—proclaim the kinesthetic connection of the people whose lives are marked by irreconcilable differences between peerless glory and endless misery. Camera angles fully participate in shaping the diametrically opposed lives of the twin sisters while accentuating their resemblance. In the separate scenes where Geumhui asks her father about the truth of her birth and Eunhui pleads for mercy from her tormentor, the sisters are captured by the exact same camera frame in order to accentuate their undeniable bodily resemblance. But their circumstances as represented in these identical shots cannot be more different. Looking up to father Hyeonsan on the left, Geumhui sheds tears of joy as she realizes her fortunate circumstances and bemoans that she cannot share her happiness with her unfortunate sister. Eunhui, stripped of human dignity and forced to sell her body and her musical talent to survive extreme poverty, pleads with her tormentor to let her see her father, Byeongho, who has come to the city in a desperate search for his daughter.

By capturing the diverging fates of the twins in an identical cinematic frame, the film evokes the critical moment in their lives. What makes such a difference for sisters born of the same parents in the same time and space? What illustrates such a remarkable chiaroscuro for the lives of North and South Koreans? That crucial moment of choice, when Byeongho decides to take care of Eunhui, seals her unfortunate fate forever. "Siblings are not supposed to be separated," Hyeonsan warns when Byeongho volunteers to take her. The essential truth about the division in this film is encapsulated in Hyeonsan's line, which regrettably haunts the travelers whose paths intersected in the wild open field some twenty years ago.

Memory and Oblivion at a Crossroads

The space where the sisters' fates become twisted by conflicting choices is the borderland on the South side of the 38th parallel—the future site of the DMZ. In a rendering similar to a crossroads, like the one in the South Korean film *The DMZ*, the place where Geumhui and Eunhui are parted is a simulacrum of a mother's womb. But as in *The DMZ*, it is a moribund one at best. Revealingly, the biological mother of Geumhui and Eunhui is dead and never enters the film, but the small dark hut where the twins take temporary refuge and meet their foster fathers figuratively lends itself as a site where the second chapters of their lives are conceived. A place where birth and death wrestle closely, this simulated womb expels Eunhui into a life worse than death, whereas it pushes Geumhui on to a life of honor and glory. The role of the two foster fathers, in this crucial moment, becomes closely aligned with that of midwives who deliver their respective babies in drastically different circumstances. If Hyeonsan leads Geumhui to the righteous father, Kim Il-sung, and hence makes it possible for her to live, then Byeongho fails to do so for Eunhui, which eventually deprives her of a chance to live.

At this crucial juncture, the borderland becomes a place where memory is erased. When Geumhui and Eunhui first enter the film with their dying father in the open field, they appear to be approximately age three or four—a stage in life when fragmented memories could potentially survive into adulthood. But Geumhui does not seem to retain any memories, not even vague traces or impressions. Rather, she has to rely on others to recoup the past and reveal the mysteries of her lost twin sister. Her adoptive father, Hyeonsan, knowingly participates in silencing her earliest possible memories by keeping secret the story of her separation from her twin, only to open up when Geumhiu starts demanding the truth. In a way, the film is structured along Geumhui's recovery from involuntary amnesia. As Geumhui gets closer to fully uncovering her secrets, the film shows that not having known her past is not only a personal loss but also a national loss. By focusing on the story of twins, the film metonymically speaks for the misery of lost brothers and sisters of North Koreans who might not even know of their separated siblings' existence.

But the erasure of memory for Geumhui is not an eternal loss, only a temporary eclipse, as she eventually pieces together her origins with the help of other characters. Byeongho's son, who purchased the painting at the beginning of the film, plays a crucial role in the process, since Geumhui is only

able to find the missing information at the end of the film, when she reads a memoir written by him. This memoir resurrects the memories of yet another border crossing from the graves of the past. Before coming to North Korea, he lived an impoverished, yet happy life together with their family, embracing adopted Eunhui as his own sister and helping his fisherman father get by day to day. But misfortune descended upon them when they failed to repay a hefty debt to their landlord, who, in lieu of payment, took away Eunhui with the promise of finding her work in the city but ended up selling her into prostitution. When Byeongho learned about this and lashed out at the vile man, the landlord took out a knife and threatened the father. His two young sons soon came to his rescue, and the younger son ended up killing the landlord. As the police came to arrest the father and his sons, they had no choice but to flee to North Korea, leaving Eunhui, her mother, and younger siblings behind.

When Geumhui's perfect universe is cracked by knowledge of an identical twin sister trapped in the South, other characters' dormant memories about the past are also revived and come back to haunt the present world. Learning that a strange young man purchased his painting of Geumhui because he considered it a depiction of yet another person, Hyeonseok sets out to reconnect with the past, which eventually leads him to Byeongho. When the two men meet again, this time in North Korea, it becomes clear that they have never attempted to make connections in the twenty years since their fatal encounter in the borderland in the South. Rather than attributing this to lack of interest in seeing each other, the film points out the precarious nature of border crossing as the culprit: given the grave danger, Byeongho could not have simply assumed that Hyeonsan successfully crossed the 38th parallel to North Korea with Geumhui, and in fact, Hyeonsan and baby Geumhui narrowly escaped being shot by South Korean border guards when doing so. On the other hand, Hyeonsan could not have known that Byeongho crossed the DMZ with his two sons, leaving a grown-up Eunhui behind in South Korea. Like Geumhui, they cannot fully recover their memories—not because they lack the desire to do so, but because the circumstances do not allow them to have complete knowledge of the past. Eventually, they all come to understand the full circle of their intertwined fates, which leaves them grateful for their fortune in North Korea while remorseful for those whom they left behind in the South.

The film proposes that having full access to memories of the past is a privilege—a treasured right exercised only by those who find themselves in North Korea. South Koreans, however, are perpetually trapped in the darkness of amnesia, which casts a shadow on the lives of those who know it all. Arguably the most memorable passage of the film is found in what seems to

be a depiction of an ordinary day in the life of North Koreans. Byeongho's son, who now lives an ideal life as a father and husband in North Korea, tells Hyeonsan: "A grandson does not know his grandmother and a grandmother does not even know that a grandson exists." Referencing the tragedy that his mother is left behind in South Korea, the young father deplores the broken link in the family lineage, which casts gloom on the happy continuation of everybody's life. People enjoying the normalcy of North Korea, as it appears on the surface, cannot be oblivious to the miserable lives of brothers and sisters, mothers and fathers left behind in South Korea. Geumhui's perfect life starts to shatter when she learns about the past and the irreversible course of separation from her other self—her now forever lost twin, Eunhui.

The film is a testament to the inevitable duality of any viable subjectivity living in a divided nation: for Geumhui's accomplished life, there is Eunhui's misery. For utopian bliss enjoyed by the North Koreans, there is abysmal despair endured by the South Koreans. If events in North Korea are illuminated by sunshine or brilliant lighting, as in the film's opening scene or on the brightly lit stage of People's Palace, where Geumhui dances, then events in South Korea, as seen in the wild borderland or the sleazy bar where Eunhui sings against her will, are marked by disconsolate darkness. The chiaroscuro is so stark that it impressionistically turns a color film into a black-and-white film.

The contrast, however, lies not just in illumination but more crucially, in ideology. The darkness of the South Korean world even devours people living in it, literally mangling their bodies. The fact that Eunhui cannot lead a dignified life manifests itself in her disfigurement: being sold to the world of prostitution, she is sexually violated; later, when she tries to escape, her legs are crushed by a car. Her injured limbs literally bring her closer to the ground, pinned to the damp soil where illness and misery prevail. The last image of Eunhui in the film is of her reunion with her adopted family—her famished young siblings and her gravely ill mother, Byeongho's wife. Overwhelmed by the misery they have endured during her absence, she can hardly support her body in a crouch and crawls to embrace her mother, who also cannot even rise due to her exhausting illness.

The violated woman's body stands as a quintessential metonymy for desecrated Korean nationhood in the North Korean cultural imagination. Ripe with potential to direct viewers' rage against the inhumanity of the perpetrators, the woman's deformed body ignites a visceral sense of injustice. While Eunhui becomes part and parcel of this cultural tradition, what distinguishes this film from many other well-known examples, such as *Flower Girl* (the young sister of the protagonist is blinded by an evil landlord) and *Choe Haksin Family*

(an American soldier makes sexual advances on a North Korean woman and ends up shooting her), is the characters' sharing the pain of others through bodily connection. Viewers cannot escape Geumhui's pain upon facing Eunhui's despair, nor can they avoid imagining the two sisters in each other's places. It may be a jaded metaphor for sameness, but the twins nevertheless capture the kinesthetic connection between North and South Korea. After all, doubles inhabiting one subject, as the film shows, is exactly what Koreans on both sides have come to perform in reality—at times self-consciously, but for the most part, even without knowing it. Performance of oblivion has become a defining condition of life in a divided country.

Stories Never End in the DMZ

The epic chronicle of the family finally comes to an end when a broader perspective on the fate of the nation itself is introduced in the concluding narration. Against the panoramic background, across which images of prosperous North Korea are interspersed with those of the borderland, the male narrator in a grave voice brings viewers to a perspective that transcends the individual stories of Geumhui and Eunhui. Assuming the bird's-eye view of history itself, the narrator seems to speak in the voice of the nation. *Fates* ends with an exalted tone quite similar to that marking the ending of *The DMZ*. The soundscape is almost identical to that of the South Korean film, with its outburst of national tragedy and the visual accompaniment of the quintessential image of the DMZ as no man's land—barbed wire and overgrown weeds dancing freely in the open field.

> This story not only retells the tragedy of two sisters and the tale of individuals' fate trampled, but is the story of the national suffering of millions of Koreans. And thus it is not difficult to see who has drawn a wall of barbed wire—a wall even more cruel than that which lies between most national boundaries—across our beautiful land. And who has stuck a signpost of national division into our people's hearts? We the Korean people have a long history and rich culture; we have always been a unified nationality. Our people are hardworking, brave, and ever striving for a better life. We only ask, can this national tragedy that has been forced upon us since the 1940s not be stopped? Let us allow the public opinion of the world to have its say!

In an uncanny parallel, this narration marking the end of *Fates* closely revives the lamenting tone of *The DMZ*. Although the two films are set apart by a decade, their structural doubling is unmistakable. It is not clear whether the North Korean filmmakers were cognizant of *The DMZ*, but I propose that any story about the DMZ is faced with the problem of having to come to a conclusion while the DMZ remains a conundrum that cannot be easily resolved. That impassable line is absurdity materialized by irreconcilable forces; how can there ever be a clear ending? Both films' finales, in a way, work toward the impossible, racing toward an end in a space where one does not exist. At least not yet.

But despite the resemblance in the narrative conclusion, the ending of *Fates* departs from that of *The DMZ* significantly. The South Korean film openly deplores that the future of the Korean people is unknowable, but the narrator in *Fates* clearly states that the blame lies with Americans, as the film captures a devious face of an American soldier guarding the border from the South. Just like *The DMZ*, *Fates* does not present any way to free the Korean people, but it does clearly present the culprit for their ongoing suffering.

A familiar trope, the North Korean vision of the DMZ created in this scene was later revised as a symbol of tragic division. The iconic portrayal of the DMZ with Americans as the evil gatekeepers preventing peaceful reunification recurs in the 1989 documentary film *Praise to Lim-Su-kyong, Flower of Unification*, which will be analyzed in the following chapter. A barricade perpetuating the separation of family members, the DMZ is the property of the evil empire whose demise is the responsibility of the heroic republic on the North side. Until this is accomplished, the poor brethren in the South will remain in captivity, and the chapter on division in the book of history remains unfinished.

3

TWICE CROSSING AND THE PRICE OF EMOTIONAL CITIZENSHIP

When the Berlin Wall came down in November 1989, many around the world saw it as a harbinger of inevitable changes to come, which would eventually challenge the long and embittered standoff between the two Koreas. The year saw a series of transformative events that unsettled over four decades of Cold War politics in the Korean peninsula. Diplomatic relationships were established with communist countries such as Hungary, Poland, and the former Yugoslavia as South Korea's first step toward joining the political thaw around the globe. This eventually led to normalizing relations with the Soviet Union in 1990,[1] unthinkable only a decade earlier.

In a New Year's editorial, many South Korean newspapers projected an optimistic outlook on Korean integration:

> If the 1980s ended with the reconciliation epitomized by the downfall of the Berlin Wall, then the 1990s must begin with the unification of Korea. Division is the tragedy that impedes people's progress and prosperity. Unification is our long-standing dream. As the last stronghold of the Cold War in a rapidly changing world, we must find a path to unification via opening and dialogue.[2]

North Korea, in contrast, responded to the dramatic events unfolding on the global stage through its usual channel—the voice of its highest commander. In his 1990 New Year's speech, Kim Il-sung declared to the nation that the concrete wall on the South side of the DMZ should be demolished as a way to unburden Korea of the legacies of division (in reality, no such concrete wall exists in the DMZ at its Northern or Southern limit). While the Soviet Union expressed its support for Kim's resolution, international press, such as *Le Monde*, saw it as North Korea's inevitable necessity to admit and respond to the rapidly changing world order. Most South Korean media were quick to criticize the fallacy of Kim's demand: they pointed out that pressing South Korea to dismantle an imagined concrete wall while most North Koreans lacked very basic freedom of mobility was an utter paradox:[3] a *Hankook Ilbo* editorial noted, "He [Kim Il-sung] must have been quite alarmed to witness the historical downfall of the Berlin Wall. Hence he came up with the stultifying proposition to demolish the [nonexistent] concrete wall in the DMZ."[4]

The reconciliatory mood was often interlaced with the familiar rhetoric of contestation. Daehan News reports produced in the 1980s and 1990s reflected such polarized sentiments of hope and fear toward the North and the oscillating outlook on the DMZ as a place of reconciliation as well as conflict. For instance, installment number 1575 (released on January 11, 1986) features South Korean soldiers defending the DMZ area despite severe cold, as they carry out rigorous training in a mission to defend the homeland and the people. As the news states, "they [the South Korean soldiers] defend the border so that not a single drop of water can permeate it." In a similar challenging tone toward North Korea, installment 1791 (released on March 9, 1990) breaks the alarming news that the fourth underground tunnel was discovered in the DMZ area. The male news anchor, in an agitated tone, states that the discovery of the tunnel presents "an obvious violation of the MLD and the armistice agreement," testifying to the incessant threat North Korea poses to peaceful coexistence. And yet, other installments of Daehan News feature a more pacific outlook: as installment 1649 (released on June 17, 1987) announces, the DMZ is a tremendous natural preserve that "presents the wish of the people who look back on the war experience and hope never to have to experience such tragedy again." Installment 2002 (released on March 21, 1994) likewise introduces a serene image of wildflowers blossoming in the DMZ, as if signaling the advent of peace in the Korean peninsula. The dramatic shift of tone and sentiment toward the North is quite symptomatic of how the thaw, rather than creating unilaterally reconciliatory responses, uncovered deeply contesting visions among South Koreans.

North Korea must have felt an urgency to respond to these rapidly changing global circumstances and reinvent itself as the stronghold of a newly emerging socialist world order. Regardless of daunting financial challenges, Pyongyang hosted the 13th World Festival of Youth and Students (Segye cheongnyeon haksaeng chukjeon; referred to as the Festival hereafter) in 1989, an event celebrated by college students in the socialist bloc.[5] North Korea's decision to host stemmed from its desire to parallel the 1988 Seoul Olympic Games while also asserting its steady adherence to socialism in the face of rapid changes in the world order.

Despite persistent challenges, the 1990s were marked by a set of monumental events that brought North and South Korea closer to each other, culminating in the 2000 summit meeting between the two leaders. Hopes for unification grew out of stale rhetorical cliché and morphed into realistic possibility, slowly but gradually: the 1992 declaration of the Agreement on Reconciliation, Nonaggression and Exchange and Cooperation between the South and the North eventually led to the "Sunshine Policy."[6] Launched coevally with Kim Daejung's presidency in 1998, this pro-North Korean policy enabled many events—previously unthinkable to Koreans of both sides—to take place.

Amid this transformation were unique forces stemming from grassroots-level student movements. Students have never been bystanders of social change throughout South Korean history. But especially in the 1980s, they were fully riding the shifting geopolitical dynamics and functioned as the harbingers of thaw. As Namhee Lee points out, "In the late 1980s, the South Korean student movement was considered one of the most important political actors next to the military."[7] Many influential student organizations were launched, such as the National Students' Alliance (Jeonhangnyeon, organized in 1985) and the National University Students' Committee (Jeondaehyeop, organized in 1987). These groups not only played a crucial role in bringing down the military government in the 1980s but also evolved into various activist organizations in the 1990s and 2000s, such as the Association of Families of Political Prisoners for Democracy (Mingahyeop) and various civic alliances (*jumin yeon-dae*), which were concerned with ongoing human rights violations of political prisoners and activists by the South Korean National Security Law. The grassroots movements by these organizations helped bring about the Kim Dae-jung administration's Sunshine Policy and the 2000 summit meeting in Pyongyang. All in all, in these decades, hopes for reconciliation reignited long-standing fears in the North, and the contrast between the anachronistic stalemate and the rapidly changing world generated momentum to go forward.

The North and South Korean documentary films about crossing the DMZ discussed in this chapter both capture the rapid pulse of changing inter-Korean relations of the 1980s and '90s, but they showcase quite different relationships between the individual border crosser and the state: the North Korean state documentary on Lim Su-kyung rests on the limitations of challenging the sacrosanct role of the state as the guardian of reunification while never failing to accuse South Korea as the main culprit in division; the South Korean independent documentary about North Korean political prisoners daringly unsettles both Korean states' manipulative stance toward grassroots-level humanitarian exchange. The acute difference in these films' willingness to challenge the state's role no doubt stems from the incongruity between their producers—the North Korean state and a South Korean independent documentary filmmaker. As different as these filmmakers are, they meet at a certain point of absolute agreement that border crossing is an event where Koreans from both sides can revalidate their undeniable kinship. Whether it is motivated by manipulative state propaganda machinery or the rebellious impulse of an individual filmmaker to disclose corrosive state intervention in efforts to build true inter-Korean rapport, the border crossing reverts to palpable emotional kinship. This chapter shows how family rhetoric continues to exercise tremendous power on imagining various registers of border crossing.

Documenting the "Flower of Unification": Lim Su-kyung and the Memories of Korean Border Crossing

"Korea is one, Korea is one!" shouts a chorus of agitated North Koreans, waving their arms at a young woman who is turning away from them to face the other side of the border between North and South Korea. Wearing a plain cotton T-shirt and jeans, she is standing by a white line drawn on the ground, where all eyes are concentrated. The sky is grey and no breeze is to be found. Her short, wavy hair sways as the highly anticipated moment of crossing approaches. Her face becomes tense with agony and confusion, her body shivering with the gravity of the event. Soon, judgment will descend upon her like rapacious vultures closing in on their prey.

On August 15, 1989, a twenty-year-old South Korean college student, Lim Su-kyung, crossed the Military Demarcation Line (MDL) in the DMZ while thousands of spectators around the world witnessed this controversial act. As she stepped forward from the North side of the border to the South side, she

became the first Korean civilian from either side to openly cross the MDL since the cease-fire on July 27, 1953. To this day, citizens of both Koreas cannot cross the border freely without both Korean governments' permission, which is nearly impossible to obtain. Hence, when Lim visited North Korea in 1989, unbeknownst to the South Korean government, to participate in the Festival as the one-person delegation representing the League of South Korean University Students (Jeonguk daehaksaeng hyeophoe), she shocked many with her daring decision. Dozens of South Korean policemen waiting for her to enter South Korean territory immediately arrested her on the charge of violating the South Korean National Security Law.[8] She was initially sentenced to twelve years in prison, which was later commuted to five years. Lim in the end served three years, until a special amnesty was granted for an early release.[9]

Vilified for breaching the National Security Law and therefore causing a huge embarrassment to the South Korean intelligence community, Lim enjoyed a completely opposite reception in the North. Dubbed the "Flower of Unification," she was hailed by the North Korean government as a heroic martyr who sacrificed herself on the altar of Korean unification. The forty-five days she spent in North Korea was a series of festivities marked by sumptuous welcoming ceremonies and press conferences, which culminated in a warm reception by Kim Il-sung. Every step of the journey of this unusual South Korean sojourner was memorialized in the North Korean documentary film *Hail to Lim Su-kyung, the Flower of Unification* (Janghada tongil ui kkot Lim Su-kyung, Naenara video jejakso, Pyongyang 1989), which challenges viewers accustomed to equating the North Korean brand of heroism almost entirely with the canonization of Kim leadership. How does this young South Korean female citizen figure in the long-standing North Korean tradition of identifying national heroism almost exclusively with the accomplishments of male leaders?[10] This question is intricately linked to the nature of the North Korean documentary film: how did the genre, usually reserved for the glorification of male leaders and heroes, come to center on a female figure in this unprecedented manner? While considering the specific features of the North Korean documentary film and gender politics in tandem, what can be gleaned about the North Korean politics of forging national memory in relation to the trauma of partition, as embodied in Lim's performance of forbidden border crossing?

I trace the journey of Lim Su-kyung, one of the most controversial South Koreans to have visited North Korea, to explore how the North Korean state articulates the trauma-ridden war legacy and its national memory through the medium of documentary film, which is an indispensable constituent of the North Korean state media. To be clear, every nation has a particular strategy

of reconstructing its past through national rituals; in the case of North Korea, however, special attention should be paid to the state-owned media's formative influence on the nation's memory-making process. The North Korean media by definition is an apparatus monopolized by the state, faces no alternative counter-visions that might shape public opinion, and therefore plays an unparalleled role in archiving and propagating the nation's past. All documentary films are produced by Joseon Documentary Film Studio (Joseon girogyeonghwa chwaryeongso) and later distributed by various video production companies, all under the control of the Korean Workers' Party Propaganda Bureau. Since the establishment of the first North Korean film studio in 1946,[11] film productions have emphasized North Korea as the legitimate heir of the Korean national essence and its male leaders as unassailable agents of Korean unification.

In this respect, the North Korean documentary of Lim's political journey presents an intriguing case study: it suggests not only how the North Korean media attempted to capitalize on this unusual visitor to prove the state's political legitimacy but also, more crucially, how Lim's visit might have inadvertently challenged the North Korean people's perception of the other Korea south of the border. A close analysis of the production will reveal the way the North Korean state envisions gender politics and the utopian notion of inter-Korean citizenship; it will also pose challenges to academia's overwhelming tendency to focus on Kim Il-sung as the centripetal force of the national personality cult in North Korean media.

FLOWER BLOOMS ON THE FORBIDDEN FRONT

Lim's visit to North Korea in 1989 came at a time when the Cold War dynamics was undergoing a major transformation with the fall of the Berlin Wall and the imminent dismantling of the Soviet bloc. In February 1989, South Korea established a diplomatic relationship with Hungary, a country that belonged to the Soviet bloc; this would have been unthinkable only a decade earlier. As the "Cold War-based geography of fear and competition" was rapidly deconstructed,[12] South Koreans started to rethink the question of Korea's future without faulting North Korea as responsible for the tragic division. Instead of asserting, in a Cold War fashion, that South Korea was the only legitimate representative of the Korean nation, South Koreans began to reconsider their society as a fractured community whose identity was in formation and flux, composing only half of the entire Korean nationhood that had been lost.

For the first time since the division, it became possible for South Koreans to openly express their perception of the North as it began to change from an archenemy to a neighbor, with whom South Korea must find ways to communicate and coexist.

South Korea in 1989 witnessed attempts to make inroads into the rigid inter-Korean relations—a couple of its citizens visited North Korea without obtaining permission from their government. On March 20, 1989, South Korean novelist Hwang Seokyeong went to Pyongyang upon receiving an invitation from the North Korean Union of Literature and Arts (Joseon munhagyesul chongdongmaeng); five days later, on the invitation of the North Korean Committee on the Peaceful Unification of the Fatherland (Jogukpyeonghwatongil wiwonhoe), Pastor Mun Ik-hwan went to Pyongyang and met Kim Il-sung twice, which resulted in a joint declaration reaffirming the three principles on unification previously agreed upon by the two Korean governments on July 4, 1972.[13] These visitors embarrassed the South Korean government, which halted its efforts improve relations in the Korean peninsula. The government declared that it would not permit any South Korean students to attend the Festival in the North.

Despite the prohibition, the League of South Korean University Students responded by sending a South Korean delegation to the Festival, with the hope that it would open up grassroots-level discussion on Korean unification. As the chosen one-person delegation making the officially forbidden trip to Pyongyang, Lim took a long detour. The North Korean documentary captures the irony of her journey through exalted narration: "What could have taken four hours of driving between Seoul and Pyongyang took her ten days, including twenty-six hours of flight time," as there were no direct flights between the two capitals and she spent some time in Japan and Germany in obscurity, to avoid any suspicions of traveling to the "homeland" turned forbidden territory by the absurdity of international politics.

The moment she landed in Sunan Airport in Pyongyang was marked by a national welcome that would have suited a presidential visit. Lim was treated as a state visitor during the following forty-five days in North Korea. The two-part documentary starts with a high-strung tone, praising Lim, and ends with a lament deploring the tragedy of the Korean partition. This shift, joyful exuberance descending into somber grief, coincides with the shifting locations Lim visits—from the sacred capital city of Pyongyang to the revolutionary countryside, and finally to the DMZ itself.

Wherever Lim went, various North Korean hosts introduced her as a courageous warrior who embodied the South Korean people's collective will to

unify Korea as one nation. The film captures not only the defiant tone of Lim's speeches against South Korea but also their unusual format: improvised. "Korea is one! Korea is one! Away with the South Korean military dictators and the American imperialists who want to perpetuate the division!" In North Korea, unscripted speeches are rarely given, because they could contain inadvertent mistakes that could bring punishment to the speaker. For this reason, only the highest leaders, such as Kim Il-sung and Kim Jong-il, are known to improvise. Given this context, North Korean viewers could have been quite surprised to see a young South Korean female student speak so freely through improvised speeches, which potentially endowed her with the same degree of political prestige enjoyed exclusively by the Kim leadership. North Korean documentaries are carefully filtered productions, with editors eliminating many undesirable and accidental elements before reaching the final cut. So the fact that Lim's speeches are intentionally featured raises questions about how the documentary aims to memorialize her visit, which would have an inevitable influence on its national image vis-à-vis the outside world. To be sure, the documentary must have been intended to highlight Lim's strong anti-South Korean and anti-American stance, but in the process of doing so, it also documents her uninhibited way of displaying the traits of South Korean society, relatively less restricted than North Korea in regard to the freedom of speech, giving North Korean citizens a glimpse beyond the façade of government propaganda. The unexpected element of surprise in this film hence stems not only from the empowerment of the young female whose age and gender contrasted sharply to the conventional male icons of power in North Korea, but also from Lim's uninhibited manner of self-presentation, which inspired North Koreans to rethink the South Korean society that they had been led to believe was oppressive and lacking freedom. Intentionally or not, the documentary film alters these risky moments with more conventional aesthetics of its long-standing tradition—presenting revolutionary citizens whose presence does not supersede the importance of the Kim leadership. Such a multivocal narrative leads viewers through Lim's duplicitous journey that straddles the high revolutionary road and the subtle side ways of traditional femininity. In fact, nowhere does the documentary capture this salient feature better than in the two encounters between Lim and the Kim leaders.

The early highlight of the documentary comes when Lim makes an entrance at the opening ceremony of the Festival, arousing the entire May Day Stadium audience into delirious frenzy by her mere presence. The ecstatic atmosphere is even more escalated when Kim Il-sung and Kim Jong-il greet her from their high podium seats, transforming this young South Korean visi-

tor into a chosen hero of the occasion, staged to rival the 1988 Seoul Olympic Games hosted by South Korea. Indeed, the documentary captures the Olympic-style grand opening, with delegations marching under their national flags from the streets of Pyongyang into the sports stadium, where Kim Il-sung and Kim Jong-il greet them. But unlike delegations from other countries, whose participants marched in groups, Lim enters the stadium alone, turning her sole presence into a powerful focal point of the gaze. This moment presents a highly unusual aesthetics in North Korean media practice, where the focus is conventionally reserved for the male leadership. When Lim enters, both Kim Il-sung and Kim Jong-il provide a standing ovation—an action echoed by the international dignitaries surrounding them. The documentary captures this unusual gesture of total acceptance, which makes Lim the center of attention for everyone in the stadium. The camera zooms in on her as if assuming the perspective of the leaders, on the podium looking down on the marchers: the elevated view turns her into a glorified hero for the documentary audience as well. As she waves a red flower and marches freely in her T-shirt and jeans, Lim's unbridled movements presented a sharp contrast to the orderly applause performed by the North Korean spectators. Whether intentionally or by accident, the documentary film continues to show Lim on par with the leaders in their ability to act in an improvised manner—a freedom not bestowed on the North Korean people.

However, following the opening ceremony, the documentary quickly departs from the visual logic of equating Lim with the Kim leadership when it shows how Lim is presented to Kim Il-sung at the conference. The most anticipated student participant, Lim appears in modified traditional Korean dress—white *jeogori* (blouse) and black *chima* (skirt)—and bows her head deeply upon encountering Kim Il-sung, who greets her with fatherly warmth and authority. Her previous outfit of short-sleeved cotton T-shirt and jeans— typical clothing for many South Korean college students—had shocked many North Koreans but is nowhere to be found in this moment. With the exception of her unusual hairstyle, short curls barely reaching her shoulders, Lim appears as a typical North Korean female citizen. Needless to say, the modified traditional dress could be seen as a carefully chosen sartorial code for the occasion; this transformation tames the body of the unbridled visitor to fit the North Korean sensibility, in the usual way of reducing the stature of outside visitors who face the sacrosanct leadership. The presence and physical proximity of Kim Il-sung must have necessitated this: quite different from an unruly individual who dared to breach her country's national law and criticize its regime openly, Lim in the modified traditional dress looks like a docile North

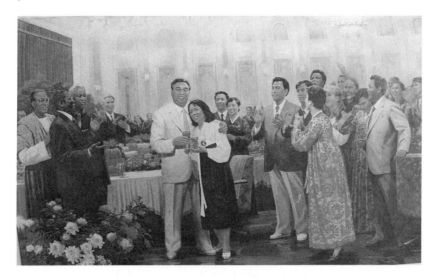

FIGURE 3.1 The North Korean magazine *Joseon Yesul* captures the encounter between Kim Il-sung and Lim Su-kyung. Note the familial intimacy between the two. *Joseon Yesul* 10 (1991)

Korean female citizen who should never lose sight of her femininity and modesty vis-à-vis the North Korean state fathers (fig. 3.1).[14]

Thus displayed, Lim's public persona is diminished from a rebellious border crosser to a model female. At this moment, she is subsumed doubly by the gender politics of North Korea, which places a critical importance on the hierarchal distribution of power between male and female, and by the sacred hierarchy of father and children that has come to characterize the relationship between the leader and the citizens of North Korea.

The North Korean media's framing the leaders as benevolent and almighty subjects is not by any means surprising, but the fact that Lim in certain moments enjoys critical acclaim as much as the leaders do is worthy of careful scrutiny when grappling with how ideal inter-Korean citizenship is imagined in the eyes of the documentary filmmaker. With the exception of the aforementioned moment when she becomes a docile female subject in the presence of the North Korean leader, Lim, for most of the film, is presented as an autonomous subject with an individual will to decide her own fate. What is achieved by empowering a young South Korean woman like her in the eyes of the North Korean state media? Are there potential dangers? Soon after the meeting with the head of the state is over, Lim is back to her previous self, wearing the South Korean clothing she had when she entered Pyongyang. At the meeting of the International Students Union (Gukje haksaeng dong-

maeng), at the dance celebration on Gwangbok Street, and on visits to Pyongyang's numerous universities,[15] she audaciously criticizes the South Korean–U.S. joint military exercises and chants slogans such as "Unification of our nation" and "Abolish [South Korean] National Security Law!" Before attending the closing ceremony of the Festival on July 8, 1989, Lim continues her high-profile activities in Pyongyang by issuing a joint declaration of Students of North and South and takes part in a one-mile marathon. In the absence of the Kim leadership in these moments, the documentary captures Lim as the only subject of national glory; she assumes the role of a visionary fighter whose courage and defiance qualify her as a proper revolutionary. In an effort to present Lim as the prophet of unification, the documentary resorts to various cultural tropes, such as her propitious visionary dream, that are widely recognized in North Korea. During the tour of the Pyongyang metro station, the documentary narrator claims: "Her father works for the [Seoul] metro system. She dreamed of having South Korean trains reach here."[16]

But once again, this triumphant tone shifts dramatically when the Festival concludes and the scene changes from Pyongyang to the countryside. Lim's ensuing activities closely resemble those of a tourist and eventually of a political martyr. The documentary captures how Lim was taken to major North Korean tourist sites, such as Geumgang Mountain and various revolutionary sites and memorials, including Baekdu Mountain, where Kim Il-sung and other North Korean leaders supposedly spent their days of revolutionary struggle. Her tour was organized as a long march from Baekdu Mountain to the DMZ, from the northernmost reaches of the country to its southern border. This itinerary undoubtedly resembled Kim Il-sung's legendary marches when he was a young revolutionary. For him, the long marches were an important aspect of building his hagiography, presenting him as a fighter entirely dedicated to the cause of the nation. As the biography of the great leader suggests, without hardship and struggle, one is not inducted into the pantheon of great revolutionaries; following this tradition, the documentary models Lim Su-kyung's tour of North Korea on these sacred marches and thereby reflects the same teleological trait, which meticulously prepared her for what North Koreans saw as her inevitable persecution by the South Korean authorities. The documentary gradually transforms her tour into a religious pilgrimage, paying homage to other North Korean national saints at revolutionary sites and preparing Lim for the impending self-sacrifice for the greater cause of Korean unification. On July 23, 1989, she enters Pyongyang again, shouting out loud the slogan that would perpetually memorialize her in the minds of North Koreans: "Unification!"

DARE TO CROSS

The date for Lim's border crossing, July 27, was not chosen by accident. Quite the contrary, it was selected because of the symbolic weight it carries in the inter-Korean relationship. On July 27, 1953, both Koreas signed the armistice, which brought three years of devastating warfare to a temporary cease-fire. The documentary clearly captures the impending border crossing as the pinnacle of Lim's visit, the ultimate sacrifice she has to make in order to become the true "Flower of Unification." The physical act of border crossing may appear as simple as stepping over the MLD that divides the DMZ into two halves, but the act itself turns into the most controversial political gesture ever performed by a Korean civilian. Would it be used by the North Korean government to accuse South Korea? Or would it be remembered as a harbinger of a grassroots movement that could potentially lead to thaw and reconciliation in the Korean peninsula? As if having contemplated the legacy the event might entail for future generations, the documentary film consecrates Lim's act as a peace-making performance, with the narrator, in a high-pitched voice, reporting the opening of the World Peace Conference at the Panmun Pavilion in the DMZ under the auspices of the UN Secretary General.

Once the pacific context of Lim's border crossing has been established, the exalted tone of the documentary narrator peters out, letting the historic moment speak for itself. The camera focuses on Lim as she leaves Panmun Pavilion and approaches the MDL with resolute steps. A large South Korean national flag is placed around her neck, and a badge showing the symbol of Korea as one nation hangs on her shirt. There she stands, hand in hand with Mun Gyuhyeon, a South Korean Catholic priest dispatched by the South Korean Union of Catholic Priests in Search of Social Justice (Jeongui guhyeon jeonguk sajedan) to accompany Lim back to the South.[17] On the other side of the border, however, stand U.S. soldiers and South Korean authorities in full anticipation of the scandal Lim's action might cause, since it would turn them into passive witnesses of a performance that embodies the violation of the South Korean National Security Law. Ironically, it is not the South Korean soldiers who block Lim's border crossing but the U.S. soldiers, which allows Lim and the North Korean viewers to form a unified front to resist the evils of American imperialism.

"The hell with Yankees!" Lim's furious protest is captured and enhanced by the documentary narrator's exhortation that she will cross the border to South Korea despite the challenges presented by the outside forces. The film

shows Lim's fervid resolution as a call to all Koreans, who should take inter-Korean matters in their own hands: "I will fight with a hunger strike until I can return through this land. Why do I have to turn away from my own home, just steps away?" This performance of defiance, as the documentary presents it, has an infectious impact: the following moments in the film feature Lim and Father Mun embarking on a hunger strike to protest the U.S. and South Korea's decision to block Lim's border crossing. A hundred participants in the Festival join them to create a spectacle that is broadcast to all of North Korea. The longer the strike extends, the more defiant the tone of the documentary film becomes, building the dramatic tension before the border-crossing event. On the sixth day of the strike, the North Korean military representatives in the DMZ summon their American military counterparts to state once again Lim's resolution to cross the border. In emphasizing her determination, the documentary reports Father Mun's declaration that "Lim will cross the border, even in death."

Lim's whereabouts are not entirely clear during the first half of August, between the end of her hunger strike and the second attempt to cross the border on August 15, 1989. The documentary shows her hospitalized in Pyongyang, being treated for the effects of the hunger strike, and then attending a Catholic service. It also shows her in a car parade along the streets of Pyongyang, riding on a train, and visiting the city of Gaeseong, where she also appears in a car parade. But curiously enough, on her visit to Gaeseong, she is greeted by the same children who greeted her during her participation in the Festival in Pyongyang, earlier in her stay in North Korea. On a closer look, it turns out that Lim's reception in Gaeseong is represented by the same footage used for her reception in Pyongyang, which took place about a month earlier. This recycling makes viewers naturally doubt the veracity of the events presented in the film, but more importantly, it reveals the necessity for the documentary to build the celebratory mood toward Lim's culminating performance—the fated border crossing that would seal her identity forever as the martyr of unification.

The second attempt to cross the border was carried out on August 15. This is no less historically significant than the first chosen date, for it is the day Korea was liberated from the yoke of Japanese colonial rule in 1945—a national holiday celebrated by both sides. Presenting Lim's border crossing as the highlight of the journey to perform the unification of the two Koreas, the narrator of the documentary escalates her tone and thereby intensifies the gravity of the event to come. In the parching heat of mid-August, Lim, Father Mun, and their North Korean supporters once again stand by the MLD and prepare themselves for the historic act. Lim makes a short address to the North Koreans who have

hosted her for the past forty-five days, and by extension, to the rest of the country: "Dear fellow students, dear thirty million fellow Koreans, until we achieve unity, let us march toward our goal. Be well!" Father Mun echoes the historic gravity of Lim's speech in terms of religious significance as he looks up and speaks to the overcast sky: "We want to cross the division today. God, do you see the tragedy of our people today?" The documentary captures the voices of these soon-to-be border crossers without filtering them through the narrator's dramatic voice, which raises the question of how the religious implications of Mun's speech might have come across to North Korean viewers.

In this respect, one of the most intriguing moments in the documentary materializes when Lim spends her final moments in North Korea offering a Franciscan Peace Prayer with Father Mun. Just before she crosses the border, the documentary captures Lim with her eyes closed as she offers the sacred words to God:

> Lord, make me an instrument of Thy peace;
> Where there is hatred, let me sow love;
> Where there is injury, pardon;
> Where there is error, the truth;
> Where there is doubt, faith;
> Where there is despair, hope;
> Where there is darkness, light;
> And where there is sadness, joy.

Why did the North Korean filmmakers decide to keep this prayer in the film? Performed by Lim, whom they have been decorating as the revolutionary martyr ready to give her life for the cause of Korean unification, would it not have presented a contradiction in a country where religion is denigrated as a remnant of the prerevolutionary culture? How do religion and revolution go hand in hand at this strange historic juncture marked by the impending border crossing? Whatever the intentions behind such a choice, it is a very strange one, since it must have had quite an impact on the North Korean people, who are instructed to dismiss religion as idolatry. Ju Seongha, a North Korean defector-cum-journalist in South Korea, recalled watching the North Korean television broadcast of this event and seeing the viewers touched by every word of the prayer: "Religion is opium, we were taught. But every word of Lim's prayer rang the bell of truth. They were all good words!"[18] In a country where free religious practice is not openly sanctioned, to represent religious ritual so thoroughly overlapping with the revolutionary mission would

have been a huge risk. Even more puzzling, Lim's prayers were shown in an official documentary film, which, unlike live television broadcasting, has to go though a multistep editing process before the final cut reaches viewers.

To add to the oxymoronic nature of this religious/revolutionary performance, the film's narration dubs Lim's crossing with exclamatory statements hailing her as "Cinderella of Unification" and "Jeanne d'Arc of the twentieth century"—an interesting array of modifiers borrowed from the culture and history of the West. Just like the Franciscan prayer, does Lim's status as an outsider—originally from South Korea and destined to return there—qualify her to be compared to those nonindigenous figures? Is it not strange to juxtapose these alien modifiers with familiar metaphors of kinship, which cast Lim as a family member for North Koreans? To be sure, the revolutionary ethos that marked the Festival is eclipsed by the national ethos to project an ideal Korean citizenship that traverses the distinction between South and North. The North Korean documentary incessantly emphasizes the fact that Lim came to visit North Korea to meet the separated fellow students and fellow countrymen who are members of an extended family unit. Her journey was motivated by a very basic human desire to meet her kin. Her border-crossing moment as a nationally televised performance embodies nothing less than the unified national identity of two Koreas—at least, that is how the documentary presents it. But the film leaves too many ambiguities and paradoxes in capturing Lim's journey, which betrays many doctrines and formulas that define the political and aesthetic principles of North Korean documentaries. Between religion and revolution, South and North, the legacies of Lim's journey are highlighted and memorialized in the mire of contradictions that still invite heated debate.

Amid the cacophony of vociferous praises from the North and condemnations from the South, Lim crossed the MLD while holding hands with Father Mun. Technically, they crossed the border together and jointly became the first civilians to do so since July 27, 1953. However, Father Mun's whereabouts since his return to South Korea are not mentioned at all in the following segments of the documentary film. Only Lim's arrest and trials are documented in the loud, accusatory tone of the narrator, building up North Korean viewers' anticipation of the South Korean government's inevitable persecution of Lim, which would prove the political lessons they learned from the North Korean government—that the South not only is disinterested in Korean unification but also actively persecutes those who struggle for the cause. But the main question here lies within the fact that only Lim, a young female college student, not Mun, a forty-year-old Catholic priest, became the consecrated hero. Why only focus on Lim while Mun also risked his personal safety by

crossing the border? Given the cultural context in North Korea, one can specu-
late that Lim's gender, more than anything else, played an important role: in the
North Korean cultural tradition, women figure doubly as the victims of historic
violence and the bearers of national continuity—both literally and symbolically.
For instance, many North Korean female icons, whether figures from revolu-
tionary history or fictional characters from theater and film productions, signify
suffering inflicted by social injustice while functioning as the core of the family
and nation in the absence of male counterparts.[19] Therefore, Father Mun had
to become invisible in order to accentuate Lim's suffering and endurance.
Anyway, why would North Koreans need a fatherly chaperon for Lim when
she has been already confirmed as beloved daughter and revolutionary fighter
by the Great Leader Kim Il-sung himself?

What Happened to the Flower?

When Lim returned to the South, she ended up spending three years in prison
for violating the National Security Law, which was a shockingly light sentence
in the eyes of the North Koreans. But the complicated legacies of her visit to
the North were not easily settled. Even after her rehabilitation in 1999, she was
ostracized by the majority of South Koreans for more than a decade for having
let herself serve as a propagandistic tool for the North Korean government.[20]
Was she the "Flower of Unification" trying to symbolically reenact the tragic
realities of division, as the North Korean documentary dubbed her, or simply a
puppet used by the North Korean propagandists to blackmail the South, as the
South Korean government claimed? She represents an intriguing amalgama-
tion of various types of border crossers: a North Korean spy, a South Korean
dissident, a national martyr, a religious pilgrim, a political whore, a tourist, and
a member of the family perpetually longing for her kin.

North Korean documentaries have a consistent way of transforming a com-
plicated person into a cohesive icon that fits into the existing mold, which
upholds the nationally circulated narratives about how a citizen should behave
in the political system. The North Korean documentary that captured the
"Flower of Unification" does its best to reduce the often conflicting multiple
identities of Lim Su-kyung by taming her to fit the ideal body of North Korean
citizenry.

However, despite such striving for a cohesive representation, Lim Su-kyung
elides certain typology often found in the North Korean rhetoric. Document-
ing a real person with so many conflicting identities is not an easy feat. Before

her visit to North Korea in 1989, she was completely unknown in both Koreas, which must have posed some challenges to the North Korean documentary filmmakers in grappling with how to tame her multiple personas and represent her in a way congenial to the North Korean sensibility. As a result, the documentary captures her as a docile female citizen vis-à-vis the national leaders Kim Il-sung and Kim Jong-il. But the constant allusions to her fragility as a young female, always in familial expressions of daughter and sister, often collide with more conventional "masculine" narratives to describe well-known national heroes, most notably the Kim leaders; at the same time, the film shows her as the comrade of the socialist revolution, sharing her path with other male North Korean revolutionaries. The fluctuation between masculine and feminine personas illustrates only one facet of this complicated border crosser, who defies a single definition.

But amid all the confusing narratives and claims reflecting on the significance of Lim's trip, perhaps the most surprising one comes from North Koreans who have settled in South Korea. They claim that the North Korean government wanted to use Lim's visit to publicize criticism of South Korea through the voice of a South Korean student and thereby demonstrate the superiority of its own regime—the point the documentary captures in many places. However, the North Korean government did not foresee the unexpected impact Lim's visit would have on North Korean citizens, who had their eyes fixed on Lim during the forty-five days of her stay and followed news of her even after she returned to South Korea—all diligently brought to them by the state media (fig. 3.2).

Her liberal speech and uninhibited manners made North Koreans rethink South Korea as a place that might be much more unrestricted than they had imagined; also surprising for them was the fact that Lim was given only five years in prison for violating the National Security Law, and served only three thanks to the special amnesty. This incredibly light sentence in the eyes of North Koreans might have alerted them to the alternative understanding of the South as much less oppressive state they were made to believe by their North Korean education. According to a North Korean defector who simply identifies himself as Sim, watching Lim's free manners altered his ideas about the South side of the border and became the major reason for his defecting to South Korea.[21]

Ju Seongha states that Lim truly crossed the forbidden line not by literally crossing the DMZ, but by stepping into the North Korean people's hearts and minds, stealing their thoughts and making them doubt the official knowledge their government has been feeding them for so long. Ju argues that the North

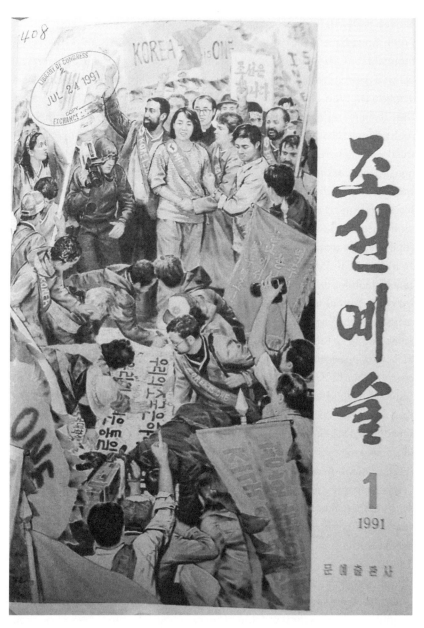

FIGURE 3.2 A painting depicting Lim Su-kyung's activities in North Korea. Lim is wearing a band that displays the slogan "Korea Is One." Cover of *Joseon Yesul* 1 (1990)

Korean government itself realized the dangers of idolizing Lim; as a result, North Korean media reportage on her diminished as viewers became more and more curious about South Korean society through Lim's visit and trial.[22] This claim is more convincing if we consider that Lim's second visit to Pyongyang on August 15, 2001, under the initiative of a more pro-North Korean government in the South, was hardly reported and memorialized by the North Korean media.[23] As Ju claims, the fact that an outspoken critic of her own government had the freedom to visit the enemy state again could have been shocking to North Koreans; and yet, still another factor may have played a role in the North Korean media's silent reaction to Lim's second visit, a huge contrast to the first visit so feverishly embraced by the entire nation twelve years before.

In 1989, Lim was a twenty-year-old student, too young to have experienced the Korean War firsthand. Her generation represented a fresh start and was free from the guilt of the war generation. Lim stood as a powerful symbol of hope upon which Korea's new future as a unified nation could be built. In 2001, however, that symbolism had already withered away and she had become one of the established figures representing the South Korean dissident group. Moreover, Lim's border crossing in 1989, as a performance embodying the desire to unify Korea, carried a special aura since it was sure to be met with a grave punishment, turning her into a pure sacrificial figure who was not culpable for the division of Korea but who nevertheless placed herself on the altar of unification. Also significant was the fact that Lim returned from North to South by literally crossing the MDL in the DMZ. She thus became the embodiment of the space she crossed, standing for the tragic Korean division itself. Forever etched as the "Flower of Unification" in the minds of North Koreans, she became the same symbol for some South Koreans. As one South Korean eyewitness testified, Lim's border crossing "was a spectacle! A great spectacle! I do not mean to use the word in a derogatory sense. Although Lim's crossing only meant acting out the desire to unify Korea, it was a grand and wise gesture."[24] In 2001, however, Lim was in a different place: she received permission from both Koreas and flew directly in and out of North Korea, at no risk. In the eyes of the North Korean authorities, she was no longer a martyr. She had ceased to be one when she was released from the South Korean prison in 1992.

Although the North Korean state seemed to have changed its mind about Lim, she was still very much adored as a national hero by the North Korean people. This could have figured into the low-profile coverage in 2001, since her return could have potentially attracted huge attention from viewers, if not presented a dangerous rivalry to the North Korean leadership. The 1989 documentary enhanced Lim's special profile by juxtaposing her political activism

with religious martyrdom, captured in the narrator's dubbing Lim "Jeanne d'Arc"—a kind of provocative gesture never used to present the Kim leadership. Kim's special ability has been presented in an implicit way; he is the savior whose devotion to the people closely resembles that of a deity, but the parallel has never been openly stated in the public media. Lim's aura in the memory of North Koreans stems from a unique religious framework that the documentary film created to immortalize her, whether by a careful calculation or, more likely, by sheer accident, which backfired on the North Korean state.

Epilogue from the Future

It has been more than two decades since Lim performed the controversial act of border crossing. She may have been forgotten by many South Koreans and be unknown to the younger generation, but her name still reverberates strongly in North Korea as the symbol of unification. Many North Korean defectors with whom I have had contact mention that my first name reminds them of Lim's (the similarity between Suk-Young and Su-kyung). Perhaps the most recent testimony about her significance to North Koreans comes from journalist Euna Lee, who was arrested in June 2009 by the North Korean border patrol when covering the stories of North Korean escapees around the North Korea–China border region. Together with her colleague Laura Ling, she was detained in North Korea for 142 days and was sentenced to 12 years of forced labor in a correction facility. Eventually she and Ling were released after former U.S. President Bill Clinton visited North Korea as a special envoy on their behalf. Lee recently gave an interview with the South Korean press, during which she revealed that the first question the North Korean judge asked her during the trial was whether she knew Lim Su-kyung, the "Flower of Unification." Lee recalls that the judge, having asked this, went on to berate her: "Lim Su-kyung struggled so much for the unification of Korea. But how dare you, being Korean yourself, commit such a crime?"[25]

As this episode shows, Lim continues to hold an enormous place in the minds of North Koreans, which deserves careful scrutiny in efforts to illuminate the politics of national memory in North Korea. However, scholarly examination of ways the state commemorates the national past has for the most part focused on the figure of the founding father, Kim Il-sung (Breen, 2004; Buzo, 1999; Martin, 2004; Suh, 1988), be it his resistance to the Japanese imperial forces in Manchuria or the recurring celebration of his birthday beyond his death. This limited approach stems from the fact that the most widely

available sources are official propaganda produced by the state. These performances elevate the cult of the leaders to underline the nation's imperative to see its historical trajectory as solely shaped by the political leadership. While studies of official propaganda about the leaders may yield fruitful results in illustrating how and why they are remembered, it is necessary to look beyond the obvious official claims of the North Korean state for much more discursive voices of often neglected subjects, which may potentially complicate the seemingly cohesive façade of that nation-state. Included among such voices may be sojourners to North Korea, whose uniquely liminal position of being both outsider and insider of that country enables them to bring an alternative perspective to what is being remembered, to what end.

Careful analysis of *Praise to Lim Su-kyung* sheds new light on the North Korean personality cult as being more complex and discursive than simply a domain monopolized by Kim Il-sung and Kim Jong-il. The responses of the North Korean people who remember Lim's visit with a sense of refreshing alarm prove the unconventional nature of the documentary film, which also captures Lim with a sense of shock and awe. By deviating from the normative documentary film practice of focusing on the male leadership, *Praise to Lim Su-kyung* might have opened up the North Korean people's rigid perceptions about South Korea. To be sure, Lim's unique place in the memories of North Korean citizens was carved out by the possibility that there might be an alternative way of perceiving South Korea, different from the version presented in other official North Korean propaganda productions. The film, in this respect, was like an engram where secret memories, alternative to intended official memories, were stored. But all too unfortunately for many North Koreans, that memory of discovery based on the civilian's border-crossing performance had to be hidden behind the officially sanctioned, state-approved propagandistic rhetoric. This is the real tragedy of the Korean division and the legacies of war: that true revelation cannot be shared in the public forum and become a part of official national memory, but must be concealed in the private realm, where it is destined to remain unheard.

REPATRIATION, OR CROSSING THE EMOTIONAL BORDER

To my late father
and to all the unconverted North Korean political prisoners
who suffered long-term imprisonment for their faith in
reunification,

I dedicate this film.
An ardent anticommunist,
my father would have been infuriated had he seen this film.
Neither would the North Korean political prisoners
have been entirely pleased with it.

The South Korean independent documentary film *Repatriation* (Songhwan, 2003) opens with a somber appearance of white letters on a dark screen, marking the dedication of the director Kim Dongwon. It is addressed to two parties, unlikely to have joined company were it not for an oxymoronic juxtaposition: the director's fiercely anticommunist father and the "spies" who were dispatched by the North Korean government during the Cold War to infiltrate South Korean society, many of whom were captured and served over thirty years in prison for not having denounced their political faith in North Korea. This peculiar kinship connecting North and South Korea foreshadows how the documentary will bring together more incompatible opposites, such as communists and their opponents, the young and the old generations, and even the world of the living and the dead. Young and vigorous in their twenties and thirties when captured but frail and hunched when released after three decades of physical and psychological torture, many unconverted North Korean political prisoners have spent as much time in jail, if not more, as they have spent outside. The documentary follows their unusual journey, from their secretive arrival in South Korea as "spies" to their return home as the world's longest-serving political prisoners. It uses their journey to unfold how DMZ crossing transforms the notion of the border from an ideological demarcation line between two competing states into a discursive space where individuals' emotional affiliation creates an alternative community that is not entirely subject to the system of division.

For a documentary that features unconverted long-term North Korean prisoners who became disreputable evidence of the South Korean state's human rights infringement, it is nearly impossible to avoid the acerbic history of the political confrontations between the two Koreas; and yet, the opening of the film eschews the accusatory tone of the official media from both sides and adopts an intimate voice that claims the documentary to be independent of the conventional narrative patterns. The narration by the director in a subdued voice gives an unsettling aura to one of the most vitriolic chapters of inter-Korean conflict in the Cold War era: the ideological war launched by both Korean governments vis-à-vis their own people as well as those on the other

side of the border. The film starts with the narrator sharing a personal account of how he first met his documentary subjects:

> I first saw them in the spring of 1992. Although the "age of resistance" had already passed, the military dictatorship still remained in power. Those who'd committed their lives to revolution went their separate ways after the fall of the Eastern bloc. I'd believed documentaries could change the world, but now I had my own family and faced mundane temptations.[26]

The first-person narrative voice lends tranquility to the topic, which has been hijacked by the ideological war and used in flammable accusations between the two Koreas. The confessional calmness contrasts with loud visual images in black and white, flashback scenes of this moment, featuring anticommunist slogans along the country roads, such as "Down with Communism" and "Report the Spies to the Police." Captured by a shaking camera situated in a moving car, these incendiary images are purposely incongruent with the tranquil narrative voice: public media in both Koreas have been dealing with this politically charged topic of the ideological war in a denunciatory tone, but *Repatriation* gives the deepest personal inflection to the historical events that have been buried in state rhetoric for most of the division. In a state where the price individual citizens had to pay for speaking their personal thoughts was often life itself, who could be a better example to showcase the failure of the confrontational system of division than North Korean political prisoners? And what could a documentary like this achieve, if not suggest an alternative to a political system that debilitates humanity itself?

What particularly stands out in the narrative strategy is the director's subtle effort to disintegrate the legacies of the Cold War, such as the binary nation-state system or personal contradictions of straddling the revolutionary and the mundane: the historical and the personal are pitted against each other in a matter of seconds, bringing the macro-level history close to everyday experience. What remains in the end is a unique epistemology that the historical can only be known by the emotionally experienced. What comes across in the process is the humility of the director, who brings viewers immediately into the intimate world of his confession. The calm and soothing voice of the director-cum-narrator presents a sharp contrast to the previous example of the North Korean documentary film, where the haughty voice of an anonymous female narrator tells an emotional tale of Lim's border crossing.[27]

But even at the cost of accepting these reductive binaries of North and South, state documentary and independent documentary styles, *Repatriation* alerts us to more subtle strategies of reimagining citizenship through intimate emotional accounts that are equally dependent on kinship rhetoric, as we have seen in *Praise to Lim Su-kyung*. Not to be accusatory of its potentially manipulative power, but to recognize the unique ability of a first-person narrative in a documentary film, I pay special attention to the director's fluid movement back and forth between history's front stage (the official history of both Koreas) and backstage (how individuals' lives altered in the course of inter-Korean confrontations during the Cold War). *Repatriation* is a story of how division of the state cannot break the kin relation, and how the power of emotional citizenship creates an alternative space for revisiting an often-suppressed chapter in Korean history by weaving the grassroots perspective into the record. Confessional in tone, it is a story unafraid of sharing intimate feelings—fear, sympathy, sorrow, and the shame of living through the division, which segregated the people of North and South not only from their respective states but also from one another.

SPIES OR GRANDPAS?

"They were pure and innocent, and I was drawn to them," confesses the filmmaker, Kim, when introducing his subjects early in the film. Kim calls one of his central subjects "Grandpa Jo," a familial term that builds emotional intimacy with a subject whom the South Korean society has perceived as perilous for the past six decades.[28] The director himself is keenly aware of the paradoxical intimacy and fear that his film subjects inspire. "Twelve years of encounters with spies" is the tongue-in-cheek subtitle he placed on the film's website to accentuate the ironic juxtaposition of conflicting feelings, inviting visitors to further consider why this oxymoronic interface exerts power in the minds of the South Korean audience.

"Spies" is a word loaded with ominous implications for the South Korean people. During the height of the Cold War era, spies from North Korea were the most threatening border crossers imagined by the South Korean popular media. To prove this point, the director shows actual footage of South Korean newsreels featuring the arrested North Korean spies, not to reinforce the deep-rooted collective fear and hatred, but to encourage the viewers to unlearn the Cold War mindset that the South Korean government has so forcibly instilled. Kim reveals how these newsreels used a special lighting tech-

nique to make the captured spies look more threatening. This technique was also frequently deployed in the popular South Korean TV drama series *Investigation Team 113*, which aired in the country from 1973 to 1983 and had a formative influence on how South Koreans perceive people in the North—as threatening, destructive, and untrustworthy.

There actually were spies who crossed the border surreptitiously and carried out their dangerous missions in the South; all the interview subjects featured in *Repatriation* were indeed sent as information collectors and propagandists to South Korea by the North Korean state in the early 1960s. South Korea sent similar "missionaries" to the North. According to the film, the number of undocumented spies from both sides adds up to more than 7,000, but both Korean states officially refute their very existence. Often denied by both regimes, a forgotten chapter of Cold War history, these spies are the ultimate test cases of how individuals in extreme situations constitute their own definition of citizenship that is rooted in their personal emotions rather than the regulatory norms of state ideology. Kim Seokhyeong, for instance, was a "spy" sent by North Korea to convert South Korean intellectuals. After three decades of decimating torture and confinement, he still holds the unbroken conviction of his initial faith. For the most part, in the film, Kim appears as an unusually articulate individual whose eloquence easily wins over his listeners. But the film manages to capture a faltering moment as he reveals his intimate thoughts to other long-term prisoners, exposing a conflicted notion of citizenship torn between the bureaucratic and the personal.

> I served thirty years in prison. From the time I came out . . . from that very moment [pause] My feelings . . . and I am sure that all of you comrades feel the same. . . . When I left the prison, I was prepared to start life anew, but . . . I am sure you all agree: I do not want to be a citizen of Seoul. And I can't be one either. Still, it's impossible to live without a resident registration.

The usually composed Kim breaks down in tears, interrupting a sentence. Emotion, not reason, takes over in this footage, exposing Kim's conflicted thoughts stemming from a discord between the emotional and the bureaucratic vectors of citizenship. While acknowledging the necessity to comply with the administrative requirements for residing in Seoul, Kim confesses that he has no feelings of belonging—a more crucial part of genuine citizenship from an individual's perspective. Still unquestionably loyal to North Korea, Kim ultimately shows the failure of the South Korean state, whose punitive system

could not accomplish its goal despite having tried every possible method to convert him for the past thirty years.

For such long-term prisoners who remarkably managed to adhere to their faith, the pressure intensified after the Joint Declaration of 1972.[29] South Korea wanted to prove the superiority of its regime and launched a "conversion team" in charge of making the political prisoners denounce North Korea. At the end of 1972 there were around 500 political prisoners. After the conversion team did its work, around 350 conformed. It was a seldom-documented ideological war carried out within the confines of the prison walls, hidden from public view, and it involved a wide range of physical and psychological torture. In a solemn interlude, which serves as an extension of the dedication shown at the beginning of the film, the documentary in complete silence projects the names of the 19 long-term prisoners who died during the conversion project and an additional 117 names of those who perished in prison due to illness in the aftermath of torture.

After a sobering tribute to their uncanny endurance, the narrator asks, "What is it that these long-term prisoners wanted to shield despite the terror-inspiring cruelty? Where lies the source of their strength?" The director invites the viewers to join him in his quest for answers to these questions by shifting the central focus of the film from ideological contestations of the Cold War to the sobering nature of human resilience. In doing so, he lets the subjects speak for themselves rather than dictating answers to the viewers, in clear contrast to the didactic North Korean documentary film *Praise to Lim Su-kyung.*

An interview with Seo Junsik, a torture victim who was arrested for allegedly spying for North Korea while studying in Japan, reveals an insight into how and why human beings made of soft flesh and frail bones can endure so much pain and terror: "Human beings survive extreme situations not by the force of reason, but by the teeth-grinding spirit of resistance." Another long-term prisoner becomes equally defiant in his answer: "People who believe that violence can change people's ideology are utterly inferior beings. I could not simply submit to such inferior beings." The brutality of the state power during the conversion project had an unintended effect on the victims, whose focus of resistance became the defense of their humanity itself.

Having let the interviewees speak for themselves, the narrator provides his conclusion: "It's not about the ideological struggle, not about nationalism or socialism. Ideology is only a part of human reason, and reason is only one aspect of what makes up complex human existence. The torturers violated the human dignity of the prisoners, who had no choice but to resist, just so that they could affirm their sensibility as human beings." This perhaps is the most

valuable insight the documentary provides in confirming the predestined failure of state violence, which can potentially transform any ordinary human being into an extraordinary subject of history. As the narrator confirms, "These are not special people. They simply adhered to ideals they passionately believed in, as young people typically do. But if one has enough integrity to guard one's belief throughout life, then that makes the person extraordinary."

While tracing these prisoners' triumphant defense of their personal convictions and human dignity in the face of terror, the documentary also features a shadier part of this historical tragedy: those who gave in to the terrors of the state. It does so not to portray them as failures but to further confirm the impossibility of forcing individuals to conform through state violence. Unlike the firmly determined prisoners who fought the excruciating torture designed to make them denounce their political conviction, Kim Yongsik gave in to the pain of waterboarding. Converted in 1972 and released from prison in 1988, meek-looking Kim, at first glance, appears nothing like a victim of horrendous torture. The narrator confesses that he has not seen a kinder face in his life. Anyone who looks at him will think that human beings are good in nature. Kim, with his typical humor and innocent cadence, complains: "I only have two wishes. For all the mothers in the world, if you are going to give birth to sons, only give birth to those who are as kind as [Florence] Nightingale. If not, then don't. Second, for all the shoemakers in the world, please make the toe area soft, so when you are kicked around, they won't cause so much pain." As he talks about shoes, he lifts his pants and shows deep, permanent scars: "I am a son of a peasant and I have no learning. I only have one pride, and that is to stand by what I believe to be right. I served twenty-six years in prison, and my belief was the only thing I had left to guard. But torture broke that sacred thing for me. Conformity by torture—is that real conversion? It is stultifying." The failure of state violence is accentuated even more when it is denounced by the individuals whom the state believes to have conformed. Like Kim in this interview, the victims of violence might have submitted to force temporarily, but their rejection of state-imposed conversion most conspicuously discloses the shaky ground of authority that cannot sustain itself without terror.

The physical effects of state violence are marked on the film subjects, who present their bodies as a literal battleground between individual conviction and state authority. The scars and stitches on the long-term prisoners violate primarily their corporeal integrity, but more foundationally, their human dignity itself. These literal and metaphoric traces of state transgression now become powerful evidence of the faltering moral ground of the state in the face of determined individuals who persistently challenge the aberrant institutional

powers. "Body remains a powerful spatialized representation of citizenship,"[30] and the long-term prisoners' scars become optimal evidence of individual triumph over forceful state authority when the film captures how some of them eventually return to North Korea.

As a thaw in the inter-Korean relationship took place at the beginning of Kim Dae-jung's presidency in 1998, the campaign to send back unconverted North Korean political prisoners on humanitarian principles gained momentum. The catalyst of the movement came in June 2000, when the leaders of North and South, Kim Jong-il and Kim Dae-jung, held the first summit meeting in Pyongyang. The final agreement to allow these long-term prisoners' return was made by the South Korean government soon after the meeting, and it was decided that any willing unconverted prisoners would be returned to North Korea in August 2000. As the final moments in South Korea approach for Grandpa Jo, he decides to visit the shores of Ulsan, the first South Korean place he set foot on when he arrived from the North in the early 1960s. He was soon captured, during which process he lost a comrade. Now that Jo was returning to North Korea, he wished to bid his fallen friend farewell while he could. "How wonderful would it be to return home with you," Grandpa Jo says, staring at the hillside where he first landed and shedding tears over the imaginary remains of his fallen friend. In tearful silence, he touches the ground and takes a bit of soil in a small plastic bag to bring home to the North. In this symbolic gesture to bring the deceased along on the journey, the living and the dead will unite in crossing the border that they wished to pass ever since leaving their beloved hometown in the North.

Leaving One Home, Arriving at Another

As the date for the border crossing approached, tension also rose between the soon-to-be-returnees and right-wing South Korean civic groups, which staged vociferous protests that South Korean prisoners of war detained in North Korea should also be returned to their families. The documentary neither filters any of these messy encounters nor romanticizes the overwhelming sensation the political prisoners must have felt on the eve of return. Instead, the film becomes a quiet observer of this moment, charged with all sorts of emotions: returnees' overwhelming anticipation of returning home, the fury of conservative South Korean activists who still call them red "spies," and the director's mixed feelings of sadness and happiness. In place of dramatizing the situation

through a didactic gaze, the director lets the tense emotion leading up to repatriation breathe and speak for itself.

From the start, the long-term prisoners' journey back home is a miniature war. As the returnees converge in lodgings near the border that will be the starting point of their border crossing, chaotic drama erupts. Before letting them board the bus headed to the DMZ, the South Korean government sends out security forces to screen their baggage, which is met with furious opposition. In a final act of staging their defiance against the South Korean state that held them prisoner for multiple decades, the returnees stage a protest against a thorough inspection of their luggage by walking out. With this one last blow, they emotionally disengage from the South Korean state they are to leave behind.

This altercation is not the only noise that makes up the cacophony of this emotionally charged moment. More chaotic are the various responses staged by the South Korean people themselves. Once the fight over the luggage inspection is over, the South Korean state succumbing to the returnees' protest, the prisoners board the bus to the DMZ area, but soon discover that part of the road is blocked by many right-wing organizations, including the families of abductees by the North Korean state. The film captures the collision between those who came out to protest their return and those who wish to bid farewell to the returnees. One furious anticommunist protester wails: "What about South Korean war prisoners? How come these red commies get to go home and the South Korean war prisoners are not sent home?" "Comrades, farewell, farewell comrades." "Aren't these dirty commies? Stop those dirty commies!!!" As a fight erupts between the two groups and police hoping to make the road clear so that the returnees can continue their journey, the camera captures a structure that displays the sign "Gate to Unification." This shot ironically overlaps with the chaotic protests that are becoming less and less intelligible. The film soon turns silent and eventually fades out on the bleak image of a monument dedicated to unification, refusing to comment on the eruptive conflict of the moment. As the scene fades, the buses that carry the returnees disappear from sight. The camera cannot cross the DMZ with them, and therefore cannot capture the most dramatic moment of their journey. Unlike the border crossing in *Praise to Lim Su-kyung*, which was dubbed a self-sacrificing act for Korean reunification by North Korea and broadcast to many around the world, all that is left in *Repatriation* is the anticlimactic absence of the most anticipated moment, which the unconverted prisoners dreamed of for decades.

Largely left for the viewers to imagine, the long-term prisoners' crossing of the DMZ makes the world's most heavily guarded border porous, and evokes the notion of flexible citizenship that transcends the overpowering divide between South and North Koreans. Although the camera cannot capture the entirety of the returnees' crossing, it suggests that so much more than their luggage crossed the border too. Just as their bodies carry indelible markers of their violation by the South Korean state, their hearts also carry undeniable ties to the South Korean people. Despite capturing some South Koreans' furious protest against repatriation, the film manages to show a convincing separation between the state and the people in articulating how emotional citizenship is based on the bonds among people that form outside of the state apparatus.

Indeed, the film exposes not only the South Korean state force's failure but also the North Korean state's manipulative stance toward the returnees. The narrator, in a typically calm and nonaccusatory voice, states that the returnees were being used as a propaganda tool by the North Korean regime. In reconstructing their lives in the aftermath of repatriation, the film shows footage from a North Korean documentary featuring how they were given a hero's welcome on the squares and streets of Pyongyang as they were carried on a moving platform bearing the slogan: "Glory to the unconverted long-term prisoners!" *Repatriation* quotes footage from the North Korean documentary featuring the prisoners walking toward the overwhelming image of the sun while an overtly dramatic female voice dubs them "eternal fighters of the General, the sons of the Sun!" The tone is basically no different from the one in *Praise to Lim Su-kyung*, which is diametrically opposed to the tranquil narrative tone of *Repatriation*. The documentary film as state apparatus, the director of *Repatriation* seems to argue, is not suited to capture the introspective complexity of human existence that transcends ideology.

In the face of the overwhelming ideological machinery of the state, *Repatriation* manages to illustrate the stunning reversal of the returnees' body politics in North Korea. The film shows a North Korean photo album entitled *We Were Seated on Golden Cushions*, featuring pictures of the returnees surrounded by their North Korean families in a comfortable home environment—a typical propaganda publication produced by the state. One picture from this book captures Grandpa Jo surrounded by his loving family. Other pictures show how seven of the returnees married young North Korean women soon after they returned. The background story of how they met and started families is not revealed by the North Korean documentary, but given that the marriages

took place so soon after the prisoners' return to the North, one can speculate that the meetings would have been arranged by the North Korean state. Regardless, these images of the returnees feature the restoration of their patriarchal authority, which has been severely violated by the South Korean state. As heads of their families and as newlywed husbands, their bodies are deployed to signify the moral superiority of the North Korean state, which rewards its most loyal subjects. The director of *Repatriation* reveals through this footage the equal degree to which individual bodies are disciplined by the two Korean states to their own advantage. In either forced torture for the sake of gaining loyalty or carefully orchestrated representation of domestic happiness for the sake of rewarding loyalty, the physical body becomes the focal ground for constituting citizenship demarcated by the state.

Repatriation fends off the equally conniving influences of both Korean states by resorting to the sense of belonging spontaneously created among people. Juxtaposing the states' official representations of the returnees with the director's sincere longing for those he can no longer talk to or interact with, the film once again underlines the forces of emotion that transcend the geographic and ideological divide. In August 2001, precisely one year after the returnees departed for North Korea, the director gets an opportunity to hear the latest news of them through a friend who is allowed to travel to Pyongyang.

The traveler reports back, noting once again the significance of the basic human impulse over all other competing forces: "Of course, speaking of material circumstances, they are better off in North Korea. But more fundamentally, what makes them genuinely happy is that they have finally returned to their hometown and to their family. To return to a place where one belongs— isn't that the universal foundation of human happiness?" This traveler was able to capture a short interview with Grandpa Jo, who stared directly into the camera in a message to be sent back to the director: "To me, Kim Donghun is like a son. I really miss him." The face of a defiant, unconverted political prisoner, as Jo is known in both South and North Korea, in this moment, becomes nothing more than a face of a family member who has now traveled beyond one of the world's most heavily guarded borders. It is highly unlikely that the two shall meet again in their lifetime.

The familial ties that create human-to-human contact defy the contested visions of the two Korean states. Whether the returnees are political heroes or just stubborn nonconverts matters no more than whether they are South Koreans turned North Korean or North Koreans who simply returned from the

enemy state after a long break. What did these long-term prisoners cross, after all, in September 2000, when they traversed the DMZ amid political protest and chaos? They were unable to declare forced loyalty to the South Korean state; were they able to deny a sense of belonging to a community of ordinary South Koreans they lived with for nearly ten years upon their release from prison?

Grandpa Jo's reciprocal acknowledgment of an imagined kinship with the South Korean film director advances the emotional bonding that transcends any forceful ideological stipulations of citizenship. The narrator responds with an equally intimate statement: "Grandpa Jo's comments made me feel ashamed, because I did not do much for him. This very feeling of shame became the motivation for finishing this documentary. I really miss him." The film closes on this directorial remark of humility, leaving much room for viewers to ponder the boundaries of human kinship. Recognizing each other as members of a kinship created among people who locate themselves outside the nation-state system is the primary force that validates emotion in understanding the foundation of citizenship.

STILL CROSSING

Perhaps the most vociferous advocate of the shift from a state-centric discourse on citizenship to an experienced, embodied, emotive one is political science scholar George Marcus. In *Sentimental Citizen,* he challenges the long-standing "presumption of a detrimental relationship between emotion and politics"[31] and argues for rediscovering the foundational role emotion plays in the formation of political subjectivity:

> People are able to be rational because they are emotional; emotions enable rationality. Our emotional faculties work more in harmony with our capacity to be rational than in antagonism to it. Rationality is not an autonomous faculty of the mind, independent of emotion. . . . The practice of citizenship must acknowledge the role emotion plays in the development of rationality; if emotionality enables rationality, then the effort to exclude passion will also undermine our capacity to reason.[32]

Marcus's advocacy for the power of the emotional in forging citizenship resonates with the growing tendency to reconsider a public sphere that is imbued

with emotive, sensory, and intimate forces, best illustrated in *Repatriation*. The film also illustrates well what Lauren Berlant terms "intimate public spheres,"[33] which refers to "an affective space, a space of attachment and identification that is not saturated merely by ideological or cognitive content but is also an important sustainer of people's desires for reciprocity with the world."[34] To be intimate in public, for Berlant, is equivalent to being emotional in public media such as *Repatriation*; for the North Korean prisoners in this film, to share a personally embodied knowledge about their historical moment is to create an "affective space" out of the geographically charted border of the DMZ, the symbol of an ongoing Cold War marred by barbed wire and machine guns.

This chapter suggested an alternative way to look at the DMZ as an intimate public sphere, to counter the conventional view of the border area as the quintessential frontier saturated with the embittered legacies of the Cold War. While there are still obvious hostilities staged along the DMZ, as seen in the protests of anticommunist groups in South Korea and the South Korean police arrest of Lim Su-kyung, equally present are indelible feelings of longing for the people on the other side. As Paik notes, "the division system is an artificial system which needs to be overcome, finds a dramatic illustration in the highly militarized state of the so-called Demilitarized Zone."[35] The tranquil silence of nature breathing may be the only thing heard in the DMZ today, but there are countless citizens, both dead and living, who would eagerly follow their hearts and cross that forbidden line. Once again, a sobering moment in the film: on a gloomy day, the unconverted political prisoners are gathered at the funeral of a fellow prisoner who died in South Korea before permission to return to the North was granted. In an emotional farewell to one who fell too soon to join their long-overdue journey back home, the remaining prisoners wish the deceased to cross the line even in the netherworld:

> Comrade.
> This land is corrupt.
> It is our fatherland,
> but this society has corrupted it.
> We've said many times
> that it's not fit for people to live in.
> Yes, corrupt it is.
> But your body is buried here,
> and it is still our ancestral land.
> It is our homeland.

Comrade!

Your body is buried here, but if there is a soul
—I don't know if there is a soul or not—but if there is a soul,
I know yours is free now to soar up into the sky,
fly free to the North and rest there. . . .

4

BORDERS ON DISPLAY
Museum Exhibitions

A DECADE-LONG THAW FROM 1998 TO 2008 WAS A VERY SPECIAL period of deviation from an otherwise unremitting history of animosity between the two Koreas. A decade was surely enough time to have unsettled the seldom-questioned place that the division system holds in the minds of the people, but it was not long enough to transform the reality of ongoing inter-Korean contestations in any fundamental way. It seems as if ten years of the Sunshine Policy were nothing but a fleeting dream, especially in light of recent shifts in the political leadership of both Koreas, with Lee Myung-bak and Park Geun-hye assuming the presidency in 2009 and 2013 respectively and the expedited power transfer from Kim Jong-il to his son Kim Jong-un in 2011. The Lee administration took a hard-line policy toward the North, while the newly emerging, yet utterly underexperienced North Korean leader Kim Jong-un needed to assert a steely political profile in the world through a set of hostile military attacks on the South and nuclear tests.[1] As a result, inter-Korean politics reverted to pre-1998 conditions, with freshly renewed distrust toward one another.

The North Korean nuclear crisis, which consumed the first decade of the new millennium,[2] had done much damage to the restoration of the inter-Korean relationship, and multiple levels of civilian cooperation and exchange that commenced during the Sunshine Policy came to a halt in the new Cold

War era. Although undeniably complicit in reviving the Cold War, the North Korean state deplored in a state newspaper editorial that "the lessons learned from the past ten years [1998–2008], marked by the joys and hopes of reunion as well as the frustration and anger of fallout, remind us that adhering to the principles of the 6.15 Joint Communique is the only path to reunification. When we deviate from them, we drift away from this goal, only to face misfortune and disaster."[3]

The souring relationship reached its nadir in 2010 after a North Korean torpedo sank a South Korean warship in March, and the North Korean army attacked the South's Yeonpyeong Island in November. These events provoked both fury and anxiety in the South: despite a long history tension since the cease-fire in 1953, the two attacks were extraordinary in nature and scale. The sinking of the ship was North Korea's first strike on a South Korean military facility and personnel, while the attack on Yeonpyeong Island was its first on South Korean territory. North Korea immediately blamed the South, defending their military action as inevitable self-defense in light of military aggression launched by the South Korean and American joint military forces.[4] The state media also criticized the South Korean military for displaying and airing anti-North Korean slogans for psychological warfare in the DMZ area in the wake of these events.[5] In response to North Korea's daring moves, South Korean President Lee, in his radio address to the nation on December 27, 2010, stated that "if we fear war, we can never stop war from taking place . . . we came to realize that only a strong response [to North Korea's provocations] can deter war and defend peace."[6] The second Korean War seemed imminent, but the military engagement ended with South Korea's counterattack on North Korean missile facilities and the ensuing calumny from both sides.

Under these circumstances, each state's vision of the "other" Korea was pronounced through much more visceral propaganda; state museums became prime examples of newly solidified visions of the Cold War in the twenty-first century. Impressions of war have a way of surviving the moment of their creation, often inspiring new images and triggering new "memories" for those who were not even part of the original event. The scars of trauma can be more like phantoms than actualities, lingering in the minds of those who never even experienced the trauma directly. Memorials and museums are major architects that alternately erect or erase landmarks of the past, often inviting visitors to subscribe to a particular version of history that is not always aligned with earlier narratives and histories.

Using the 2010 DMZ Special Exhibition at the Korean War Memorial in Seoul and the absence of representation of the Korean border in the Victori-

ous Fatherland Liberation War Museum in Pyongyang as case studies, this chapter examines both Korean states' theatrical staging of discursive memories of the Korean War in a museum space, especially in regard to the DMZ and the impossibility of crossing it in the reignited Cold War in the twenty-first century. The dramatic nature of the exhibitions at both venues will become clear below, but my central questions concern the curatorial designs. I am especially interested in the ways spectators are conditioned, both ideologically and kinesthetically, to recall the DMZ crossing experience that few of them experienced firsthand: this process can be quite similar to how spectators watching a theatrical performance are sometimes invited to join the events taking place on stage. What does it mean for state museums to stage vicarious crossing experiences for their visitors? What happens when the exhibition's mise-en-scène controls spectators' experiences of Korean history—namely, the partition of Korea and subsequent creation of the DMZ—so completely that it potentially alters their perceptions of the historic past and hopes for the future? More broadly, I ask how the performative embodiment of memory about the border and border crossers, often aided by new technologies of seeing, might serve as a powerful agent of each Korean state, forging an uncompromising vision of citizenship for museum visitors, whose emotional affiliation with objects on display creates an empathic viewing experience.

KINESTHETIC EMPATHY AND THE
TECHNOLOGY OF SEEING

Using the language of theater, performance, and dramaturgy to characterize the DMZ and DMZ crossers in a museum space is not simply metaphorical; many Korean artists have grappled with the DMZ, creating a multitude of performances that deploy site-specific strategies in order to fashion simulacra of that forbidden space. Several have designed and produced multimedia performances and art installations just outside the southern border of the DMZ. Examples include DMZ 2000, a multimedia performance project featuring Nam June Paik's video installation[7] and Ping Chong's performance piece *Bojagi*, as well as numerous art exhibitions, poetry recitals, and Korean and Western music performances. All of these were staged and performed between December 31, 1999 and January 1, 2000, with the intention of celebrating the new millennium, commemorating the tragedies of war, and welcoming a propitious future. The modifier "DMZ" proclaimed the event's site-specificity, although Imjingak—an observatory pavilion on the South's

side of the DMZ—and its surrounding area served as the actual site of the performances. DMZ 2000's organizers and artists nonetheless laid claims to the zone in order to compensate for the impossibility of being physically inside this no man's land.

Although geographically close to the border, DMZ 2000 lacked the aura of an actual site that witnessed authentic acts of war. The artists therefore sought other means of achieving this. The self-proclaimed site-specific performances invited spectators to engage with them both kinesthetically and sensually, causing strategically situated experiential moments to generate empathic resonance between performer and spectator, thus allowing the latter to viscerally feel the trauma of war.

Such well-intentioned efforts, however, cannot fully succeed, because, as Peggy Phelan points out, interpreting trauma through writing can dilute the raw pain experienced by the human body.[8] Performing or exhibiting war traumas in public spaces can be considered analogous to Phelan's writing process, since the physical pain experienced through participating directly in war cannot be fully replicated by any embodied mimetic performance, no matter how artistically or theatrically rendered and convincing it appears to be. Elaine Scarry suggests why this is so: "Whatever pain achieves, it achieves in part through its unsharability, and it ensures this unsharability through its resistance to language."[9] Pain, or the visceral response evoked by kinesthetic experience, cannot be shared in the fullest sense via representation.

In order to compensate for the impossibility of experiencing the "real" trauma of the DMZ, many artists of the postwar generation endeavor to engage spectators kinesthetically and affectively by means of empathic "seeing." Most Koreans encounter the DMZ not as an actual physical space, but through mediated images: photographs, plays, films, and exhibitions. Such secondhand ways of seeing the DMZ might at first seem counterintuitive, because how, after all, can images create kinesthetic empathy? Can a mediated gaze potentially generate empathy if the artist strategically authenticates her/his representation as a real experience by expanding the spectators' gaze to embrace a highly kinesthetic sensation of physically interacting with spaces seen in photos, films, and videos? If seeing can be blended symbiotically with feeling via simulated contact between the spectator's physical body and the visual representations of the DMZ, then could the unsharable nature of historic pain potentially become sharable?

Museums and memorials are, after all, places to view artifacts that mark major historical thresholds. The spectacle of war—especially the visually rich twentieth-century wars—is ideal for museum display. The resilient relation-

ship between violence and vision is forged not on chance, but on a calculated marriage between physical sensation and ideology. Paul Virilio reminds us that "for men at war, the function of the weapon is the function of the eye,"[10] while Rey Chow argues that "preparations for war [are] increasingly indistinguishable from preparations for making a film."[11] Both point to the fact that the technology of seeing is central to modern warfare—in other words, the position from which we see determines our ideological differences and allegiances. The DMZ—a spatial vestige of war—is particularly well suited to the yoked technologies of displaying and seeing in a museum setting. These technologies shape the paradox, where the visitor's passive experience of viewing eventually turns into an ideological act of seeing and feeling the pain of the Korean War from a particular political stance—a process often arranged by the curatorial strategies of exhibition organizers in an attempt to create a sense of emotional citizenry among spectators.

DMZ Special Exhibition in the Korean War Memorial, Seoul[12]

Palpable tension between the paradoxical nature of the real DMZ and its mediated representation constitutes the theatrical core of "Inside the DMZ: An Exhibition Commemorating the Sixtieth Anniversary of the Korean War." The exhibition, which ran from May 4 to November 30, 2010, at the War Memorial of Korea located in the center of Seoul, had many organizers, sponsors, and co-sponsors, including the South Korean Ministry of Defense; the right-wing newspaper *Chosun Daily*; the Military Science Research Center; high-tech Korean enterprises like Hyundai Rotem, Doosan, and M Plus; and multinationals such as Canon and Hewlett-Packard.

I visited the exhibition on July 27, 2010, which, coincidentally, marked the day in 1953 when North and South Korea signed an armistice. Exactly fifty-seven years after the cease-fire, when such a display might have seemed an ossified memory piece, this commemorative exhibit was quite timely. After all, in 2010, tensions between the two Koreas had flared up again, culminating in North Korea's military attack on a South Korean warship and civilian quarters, making a new war seem imminent. In the wake of these incidents, "Inside the DMZ" assumed new meaning: it seemed to suggest that viewing events from the past war and taking a position on them might evoke a prophetic vision of a second war. Museums—and even more so, memorials—are spaces in which to organize and posthumously commemorate relics of the

past, but this exhibition played the more unusual role of forecasting the un-
known by presenting a historiographic dramatic narrative in which the two
Koreas adopted contrary roles. In this scenario, the failed North assumed dual
paradoxical roles: as an eschatologically doomed land that can only be saved
by the South's humanitarianism, *and* as a strategic target that must be de-
stroyed by the South's advanced military technology. Sacrificing ideological
nuance and utopian images of peaceful coexistence to a more bellicose vision
of the future, the exhibition's dramatic narrative not only reflected the war-
plagued past but also anticipated the North's future absorption by the South.
The organizers theatricalized these ideologically charged images in installa-
tions designed to embody South Korea's role as a liberator and the North's as
an oppressor and prison warden. As they proceeded through the exhibit, spec-
tators experienced both the kinesthetic pleasure of national pride and the
kinesthetic pain of confinement and persecution. The installations depicted a
classic battle between good and evil, where the triumph of good was the pre-
dictable denouement. In this sense, the exhibition's dramatic narrative resem-
bled the homiletic anticommunist plays produced in postwar South Korea,
such as Yu Chi-jin's *I Will Become a Human Being* and *Thus Flows the Han
River*.[13]

The exhibition's apparent purpose was not to stage an objective history of
the Korean War, but to explore and manage its memory; the installations not
only theatricalized histories and memories of the war but also presented hy-
pothetical war scenarios. Therefore the exhibition endeavored to accomplish
two missions—persuading South Koreans to acknowledge the North's culpa-
bility and conditioning them to behave as citizens of the superior nation, the
righteous unifiers of the two Koreas. Nonetheless, the kind of future envisioned
and presented by the organizers is troubling, not only because of its obvious
Cold War–style ideological bias, which predicts inevitable conflict, but also
because of the museum's fragility as a rehearsal space designed to bring visi-
tors into ideological alignment with the exhibition's prophetic vision.

Paradoxically, anticipatory mimetic rehearsal of an unknown future is not
entirely indefensible. Based on the two conceptual points of the known pres-
ent and the unknown future, such rehearsals simulate a cohesive continuum
between now and then by means of repetitive authentication of the unknown.
When presented in museums and memorials, the process of authenticating
the unknown gains stronger momentum, because the organizers of such spaces
allegedly value historical accuracy and sober objectivity. Consequently, visi-
tors are less skeptical about what they see than they are of other sorts of exhi-
bitions in public spaces. The innate historicity peculiar to museums and

memorials, compounded by the authenticating strategies of equating seeing to believing and experiencing to foreseeing, buttressed the exhibition's dramatic narrative.

Spectators journeyed through four carefully fabricated "zones," each of which carried a title: the first was "The Korean War," the second "Miracle Over the Han River," the third "North Korea Today," and the fourth—a special photo exhibition interspersed with three-dimensional video screens— "Inside the DMZ." The mise-en-scène of each zone had an inherent temporal logic: visitors experienced the flow of exhibition space as a chronological mapping of the history of the two Koreas since the division, beginning with memories of the war, then moving on to their present state, and ending with a futuristic vision of the DMZ. More importantly, the exhibition's flow reveals how technologies of seeing reconstruct memory, thereby changing the way history as an event is expressed, embodied, and experienced. The temporal flow from past to present synchronized with a seemingly deliberate visual evolution, from faded black-and-white photos to interactive three-dimensional cartography of the DMZ. These temporal and visual transitions were consistent with the organizers' apparent intention to represent Korea's history as a crucial leap from conflict to peace. Behind this patina of pacifism, however, was a rather disingenuous parading of what James Der Derian calls the "Military-Industrial Media Entertainment Network" (MIME-NET), whereby war no longer takes place on tangible ground, sea, and air, but is rather a collage of images fabricated by media technology, the entertainment industry, and the idea of play-based training rehearsals.[14]

ENTER THE WAR, ENTER THE MEMORY

Like the prelude to an epic war drama, the first sector of zone 1 was expository, depicting the geopolitical tensions that arose after World War II and helped to ignite the Korean conflict. Pictorial illustrations, mostly archival black-and-white photos that reinforced the historical authority of the events on display, helped spectators to follow this rather complex network of political calculations and military alliances. The photos not only anchored the exhibition's historical gravitas but also functioned as "a technology of memory"[15] that produced a deceptively objective version of the historical past. Although spectators are often unaware of curatorial interventions in an ostensibly objective pictorial exhibition, their experience of and response to historically authoritative photographs in the live space of a museum or memorial are necessarily

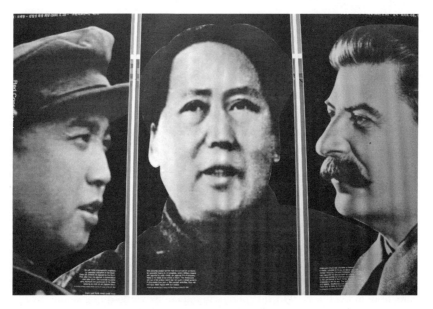

FIGURE 4.1 Large black-and white photos of Kim Il-sung, Mao Zedong, and Joseph Stalin overwhelm visitors in the special exhibition. Photo: Suk-Young Kim

filtered through the individual sensibilities of the curators and exhibit organizers, who shape and alter representations of the past and rehearsals of the future. The photos in zone 1 required visitors to physically look up—an uncomfortable posture that affected their experience of the past, making it an uncomfortable, somatic ache. Whether or not this was deliberate, targeting the sensory system in this manner triggered a kinesthetic response to the photos on display: the physically awkward posture of gazing up may have affected people psychologically, causing them to experience a historical past in which Korea lacked the necessary strength to sustain its autonomy and freedom.

Grotesquely enlarged images of Stalin, Mao, and Kim Il-sung printed on massive scrolls overwhelmed spectators as they passed through zone 1 (fig. 4.1). The huge display panels towered over them, forcing them to gaze upward at this axis of evil—a triumvirate of warlords responsible for both the Korean War and the division of the nation.[16] Their images of unbridled power and ambition were located high above eye level, making their domineering presence impossible to avoid. Printed text explaining the cooperative relationship among the three was at eye level, but the visual representation of the masterminds behind the Korean conflict overwhelmed the more easily accessed textual narrative.

The conspicuous disproportion between pictorial and verbal modes of sig-
nification accentuated the critical role of the visual in representing the vio-
lence of war. In zone 1, which focused exclusively on the Korean War, an
enormous photograph from 1947 depicting a Korean family trying to cross the
38th parallel hung from the ceiling (fig. 4.2). It captured the moment when a
U.S. soldier on the south side of the border stopped them; in the photo, sig-
nage in both English and Russian—"U.S. Zone South Korea"; "Russkii Zon,
Sever Korei" (Russian zone, North Korea)—separated the soldier and the fam-
ily. The majority of local Koreans, including this family, must surely have
been unfamiliar with these signs written in the languages of the occupying
forces, and yet the photo captured the irony of the situation: foreign forces
that arbitrarily created a barrier between sectors of a formerly unified nation,
exercising their respective jurisdiction over each side and regulating the
movements and lives of Korean citizens. This strange image of a foreign sol-
dier towering over a native family, whose members' faces manifested their
long and difficult journey in search of a better life, symptomatically presented
the predicament of a subjugated people unable to defend (or cross) their own
border. The predicament of Koreans attempting to negotiate the partition

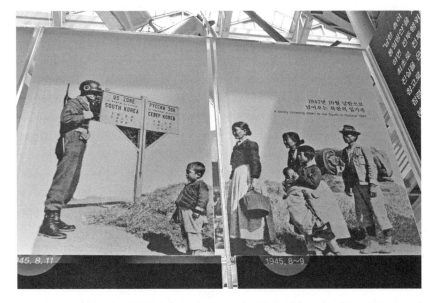

FIGURE 4.2 A special exhibition shows how two occupying forces—the United States and
the Soviet Union—controlled the Korean people's mobility from 1945 to 1950. Photo: Suk-
Young Kim

further complicated the cartography of paradox, where conflicting desires and forces haunt the border itself.

An installation depicting the outbreak of war (the North Korean army crossing the 38th parallel on June 25, 1950) ended the physical discomfort of having to gaze upward at the images hanging in zone 1. For most South Koreans, this "sneak attack" on June 25 signaled the outbreak of war. Like an interlude inserted into a cohesive performance piece, this installation used life-size figures of soldiers and a crude re-creation of a Soviet tank used by the North to embody the crucial moment of crossing the parallel. Why did this kind of installation represent one of the most important moments of border-crossing in the history of the war? Why instead did not the curators offer visitors historical footage of the actual event? Was no camera available to record the border crossing—the sneak attack—that provoked the war, or are there other plausible scenarios? Did the North Koreans want to erase any evidence that they had initiated the war and therefore intentionally fail to document the event? This absence of documentary evidence of the North's June 25 invasion was troubling, but the curators presented other film footage of the war, played at regular intervals in a continuous loop on a video screen behind the tank installation.[17]

The absence of images documenting the initial border crossing not only was curious but also raised an intriguing question about the potency of visual representation: Can images alone trigger memories of the violence done to the people of Korea by the war? Twentieth-century wars have, after all, been captured, memorialized, and perpetually regenerated through iconic images that both document the particular moment in history and produce ongoing debates and narratives. Using the U.S. bombings of Hiroshima and Nagasaki as her examples, Chow argues for the power of visual representation in commemorating war events, claiming that our understanding of World War II is inevitably related to the dropping of the atomic bomb in Hiroshima and Nagasaki, pictorialized in the now familiar image of the mushroom cloud, with effects of radiation and devastation of human life on a scale never imaginable. Alternatively, we can also say that our knowledge about what happened to Hiroshima and Nagasaki is inseparable from the image of the mushroom cloud. As knowledge, "Hiroshima" and "Nagasaki" come to us inevitably as representation and, specifically, as a picture. Moreover, it is not a picture in the older sense of a mimetic replication of reality; rather it has become in itself a sign of terror, a kind of gigantic demonstration with us, as spectators, as the potential target.[18]

The missing image of the moment of North Korea's crossing the 38th parallel, if it existed in the form of a documentary photograph, would surely have become the iconic emblem of the Korean War. But the absence of such visual

documentation allowed the exhibit's curators to embody what would other-
wise have been a two-dimensional photo in a fictional three-dimensional ani-
mated installation depicting a full-size tank and wax figures of North Korean
soldiers stepping over the parallel and knocking over the marker that divided
South from North. The lack of archival evidence should have compromised
the historicity of the event, especially in a museum space where the accurate
representation of past events is a condition of its existence. In this case, how-
ever, the installation, photos of other border crossings, and images of the
figures who created the border allowed the curators to circumvent that lack.
Removed from the time and space of the original crossing, the installation
used a site-specific strategy to authenticate itself: it asserted that the imagina-
tive re-creation of a missing historical image would not disturb the museum's
authority to claim that seeing and believing are one. These surrogate images
did not recall, but instead created from scratch an emblematic image of the
war in order to lay semiotic claim to the Korean border area—a space that no
nation-state can now claim.

Ecliptic Visions from the South's Side of the DMZ

The various displays of war trauma in zone 1 required one mode of viewing;
glittering spotlights hanging from the ceiling not only helped spectators make
the transition to zone 2 but also imposed a new mode of viewing. These spot-
lights seemed to say, "The dark past is over and a glorious vision of prosperity
awaits you!" in zone 2, "Miracle Over the Han River." Overused to the point
of jaded cliché, this phrase has become a metaphor for postwar South Korea's
rapid economic growth, often pointing to the proud citizenship that South
Koreans have come to enjoy. A large color photograph depicted a panoramic,
nocturnal cityscape of Seoul—now a prosperous urban center oblivious to its
traumas of war. The glittering spotlights hanging from the ceiling brilliantly
accentuated the image. A 1988 Olympic slogan, "From Seoul to the World,
and from the World to Seoul," graced the upper-right corner of the photo,
bolstering the idea of the South Korean capital city as an international center
of trade, culture, and industry. A matching four-panel display titled "Dynamic
Korea," complete with statistical charts confirming the South's status as an
economic powerhouse, paralleled the prosperous cityscape: from annual ex-
port figures to investment in the space industry, the display radiated national
pride and encouraged spectators to identify with its celebratory rhetoric.

Zone 2 was a triumphal procession, marked by displays of advanced military technologies. An array of authentic weaponry proudly adorned the central space: a utility helicopter, K-11 automatic rifles, a T-50 advanced trainer (a type of aircraft used by the South Korean Army), vertical launchers, and a guided-missile combat system. It is tempting to speculate that the organizers and curators intended this display to boost the self-congratulatory narcissism of South Korean citizens, who were thus invited to view the country's military strength as the core of national virtue.

In point of fact, the high-tech aircraft and missile technology was installed in such a way as to invite viewers' interaction. When I visited, many children were sitting happily in the helicopter's pilot seats or playing with the numerous guided-missile consoles at hand; interacting with authentic military technologies as if they were video war games turned these weapons of mass destruction into sleek playthings. It is important to remember that military service is compulsory for Korean males; if the stakes involved at the museum were low, they will be much higher, of course, when these schoolchildren graduate to the "real thing." At the same time, this installation projected South Korean citizenship as male-centered, giving a sense of empowerment to only those who become the predominant members of the South Korean army.

In this context, games played at the museum might usefully be understood as male citizens' "tech rehearsals" for an impending skirmish, or even role-play in a full-blown dramaturgy of war. The placement of these war machines in the museum space, however, diminished the spectator's experience of vicariously "participating" in a belligerent action, and the display's considerable entertainment value further tempered its effect. Indeed, familiarity with virtual war games may have desensitized some users to the human tragedy of the Korean War—the subject at the core of zone 1. Paradoxically, the second zone seems to have been designed to expunge the lesson of the first: that the desire for absolute power never justifies savage aggression.

The first zone vilified Kim Il-sung, Stalin, and Mao as the perpetrators of aggressive acts against innocent citizens of South Korea. Visitors did not interact with or climb upon the installation, but instead viewed it from a distance; thus its representations of violence might be described as historical and didactic. Zone 2 staged violence quite differently; South Koreans were not the victims but the perpetrators. Anyone—both children and adults—who operated or played with the war machinery was positioned as a potential aggressor in a scenario of armed conflict. This element of play, however, masked not only their collective identity as perpetrators of aggression but also the imaginary consequences of their violent actions. This is similar to Diana Taylor's definition of

"percepticide," with one crucial difference: percepticide presumes that spectators intentionally overlook state violence because of the fear of persecution,[19] but the exhibit's curators appeared to have preemptively prevented spectators in zone 2 from considering the consequences of their (imaginary) violent acts, so therefore they never attained the awareness necessary for percepticide. If zone 1 generated physical pain through empathic kinesthesia, zone 2 seemed to short-circuit the sensory system, preventing spectators from responding viscerally and empathetically to the violence of full-scale warfare.

From a somatic perspective, then, visitors experienced zones 1 and 2 quite differently: the first required them to feel the pain of Korea's tragic war history, while the second encouraged them to play the psychologically liberating role of aggressor. The transition in the mode of representing violence, from black-and-white photos to full-color integrative technology, is also important. As Virilio points out: "even when weapons are not employed, they are active elements of ideological conquest."[20] Certainly, museums are not actual battlefields and military weapons and technologies staged in this zone were not deployed in an actual combat situation, but the weapons on display nonetheless initiated an ideological battle wherein the military superiority of South Korea boosted the national pride of visitors. "Museums," according to Steven Dubin, "have always featured displays of power,"[21] but rather than representing the futility of war, the South Korean installation paraded glitzy military equipment, thereby transforming it into desirable symbols of power. Advanced military technology in the guise of an interactive, virtual war game concealed the real victims of war. Perhaps unintentionally, zone 2 echoed Walter Benjamin's assertion that "any future war will also be a slave revolt of technology."[22]

Eschatological Visions for the North's Side of the DMZ

In stark contrast to zone 2, which traded on symbols of national superiority while offering spectators the vicarious pleasure of playing as war heroes in rehearsal for a yet-to-be-performed combat scenario, the third zone ushered spectators back to the somber realities of contemporary Korea. Here the focus shifted, however, to the upper half of the Korean Peninsula. Titled "North Korea Today," zone 3, the dark shadow of the previous zone, featured the North just as South Koreans imagine it: a wasteland littered with political prisoners and starving vagrants, all living in terror of Kim Jong-Il's mercurial dictatorship

(fig. 4.3). All-too-obvious icons of North Korea's many sins marked the entrance to this "station." Heart-rending photographs of malnourished, almost skeletal children; maps of the North's notorious gulags; and a caricature of the "mad leader" greeted visitors as they stepped across the threshold into this living hell. The dazzling brilliance of zone 2 yielded to the dimly lit interior of zone 3, where predominantly black panels evoked a prison space that stood metonymically for North Korea itself. Like the action in a medieval morality play, the progress from zone 2 to zone 3 reminded visitors that they have before them a moral choice: either good (capitalist democracy) or evil (socialist totalitarianism). The Korean everyman must choose. If Catholic dogma drove the characters, actions, and ideologies of the morality play, the rigid legacy of Cold War ideology shaped the dramatic narratives of zones 2 and 3.

As they proceeded through the exhibition, spectators encountered video screens showing footage (apparently shot by a secret camera) of a public execution. No voiceover accompanied the event, which, in the space of the museum, occurred in dead silence. Prison-camp survivors were also mute: their written testimonies appeared upon the dark walls, but none was given visual or embodied form. Like the chiaroscuro lighting marking the passage between the two zones, the absence of visual–verbal coordinates in zone 3 was striking and distinguished it from the previous zone, which indulged spectators in a pleasurable fantasy of a prosperous postwar nation in full-color, interactive multimedia format. Their encounter with zone 2 was simultaneously visual, verbal, and experiential.

Imperfect modes of representation truncated and thereby compromised the integrity and intensity of spectators' sensory encounters with North Korea. A reconstruction of a tiny cell in a political prison, designed for torture by claustrophobia, constituted the sole installation in zone 3. Built according to the specifications of a former inmate who experienced punishment by solitary confinement, the installation welcomed visitors into the cell: "Please feel free to experience it for yourself," the sign read. This invited South Korean visitors to assume the role of political prisoner—a radical departure from the last zone, where visitors played not victims but victimizers. The dramaturgical logic of the exhibition would have had them believe that the only experiential possibility of "being North Korean" is confinement, entirely eliding other possibilities of being a North Korean subject.

Encountering North Korean oppression through a brief, albeit embodied experience inside a prison cell must surely have created empathy for the abject subjects of North Korea, who, in the absence of South Korean intervention, continue to suffer horribly. Whether intentionally or not, the curators

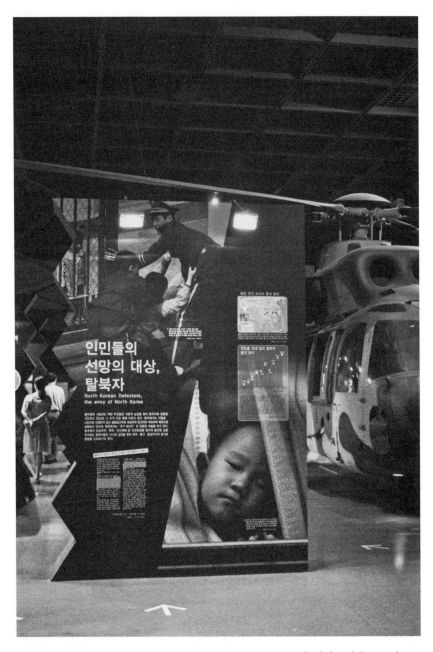

FIGURE 4.3 A stark contrast marks the North Korean zone on the left and the South Korean zone on the right. If the former is characterized by the predicaments of refugees who are eager to escape the draconian regime, the latter is characterized by military strength that will ultimately save North Korea. In this picture, the South Korean military machine on the right seems literally to invade the North Korean zone. Photo: Suk-Young Kim

created in zone 3 an eschatological site, whose mode of visual supplication is so ubiquitous in South Korea that it has become clichéd.[23] South Korea's relentless demands for regime change in the North inspired this genre of visual narrative. Such public displays of mourning for the suffering citizens of North Korea also reveal the triumph of the neoliberal viewpoint: that free market–based democracy—the only viable form of government for Korea—must replace totalitarian socialism. From the South's perspective, North Korea cannot be a redoubtable opponent, only a thuggish and weakling neighbor; in South Korea's scenario, the nation is morally obligated first to conquer and then to rehabilitate the North. To visit the exhibit's zone 3 was to return to the gloomy, war-ravaged past of zone 1, the historiography encouraging spectators to locate the sinister parallels between zones 1 and 3. The exhibit forcefully conveyed that South Koreans should never be tempted to return to the traumatic past—a past that still haunts their unfortunate North Korean kin.

The contrapuntal logic of contrasting the two Koreas so starkly is clear when one considers the arrangement of the zones, which comprised a display of South Korean war machinery evoking pride in visitors, positioned between installations of devastation both past and present. Spectators successively passing through the zones surely concluded that, in the event of another war between the two, the South's superior military would obliterate North Korea. The effect of this visually exaggerated contrast was to reassure viewers of South Korea's ascendancy. The curatorial approach to staging future conflicts was, of course, more nuanced, relying upon the principle of accumulation to point first to the South's strength and then to the North's vulnerabilities. As at a morality play, spectators at the exhibit could easily distinguish good from bad and victor from loser. The gloom of zone 3 ended in a corridor with walls covered by mirrors. Laser projections of life in the DMZ were presented on the corridor's screenlike walkway. The projections changed rapidly, from barbed wire, to soldiers patrolling through deep snow, to a North Korean soldier perched in a watchtower, to images of wildlife in their DMZ habitat. As spectators passed through, they faced themselves, fractured into many pieces by the mirrored walls, while they stepped on and over the constantly morphing laser images of the DMZ (fig. 4.4).

The corridor helped visitors to segue smoothly from the accusatory tone of zone 3 to the gentler one of the DMZ. Its schizophrenic panoply of faces and objects reflected the identity crisis of contemporary Koreans living in diametrically opposed regimes. South Korean visitors passing through this corridor, where the motley assortment of objects, nature, and people that define the DMZ today saturated one's field of vision, might have experienced,

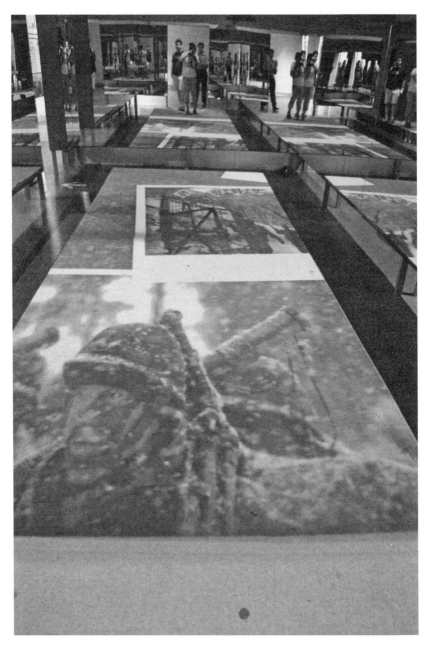

FIGURE 4.4 The corridor marks the symbolic entrance to the DMZ in the special exhibition.
Photo: Suk-Young Kim

physically, the abstract notion of division itself. This surprisingly frank representation of the DMZ as a place of disorder and uncertainty seemed to refute the binary logic of the Cold War era that so dominated the exhibit's other zones.

While passing through this corridor of mirrors, spectators were forced to face the messy realities of Korea's division. The fragmentation of oneself because of the mirrors and the hallucinatory laser projections was viscerally kinesthetic. Here, technologies of seeing defied logical narrative development, and the result was chaos, devoid of cohesive vision. In this context, perhaps hallucination and reality were not so far apart: the reality of the division of Korea is, after all, chaotic and illogical. Or perhaps reality was parading as hallucination in order to ease the pain of gazing directly at the lingering realities of an unfinished war.

Inside the DMZ, or the Future of No Man's Land

A new environment awaited spectators when they emerged from their surrealistic experience in the corridor. Compared to zone 3, the airy ambience of this contemporary gallery space felt like a pristine nature preserve. Indeed, zone 4 was a welcome relief from the other zones. White walls displayed a series of photographs featuring the paradoxical coexistence of man-made conflict and an environment of natural wildlife completely indifferent to the surrounding human world of absurdity and violence. A photo collage of South Korean soldiers performing mandatory military service in the DMZ was imbued with an idyllic sense of playtime in paradise. The reality represented in these photos was quite contrary to the actual hazards faced by soldiers in the DMZ, who occasionally set off land mines left behind from the war or, in extreme cases, exchange gunfire with North Korean soldiers. The photo exhibition conveyed a sense of the DMZ as frozen in time, a place where nature turns a blind eye to the tragedies manufactured by humans. As spectators moved through the previous zones, time seemed to flow forward with them, but in zone 4 time seemed to have stopped; they could see and experience the existing state of affairs in the DMZ, where it is as if the forces of history have paused or even stopped altogether.

Unfortunately, another encounter with new technology (devices intended to help visitors imagine Korea's geopolitical future) intruded on zone 4's serenity. Such a conclusion was, however, inevitable, because the experiential technologies that made the zone a habitable space also connected it to the other zones. Cyber-technology and virtual reality altered spectators' perceptions of space and transformed the DMZ museum display into a tangible and

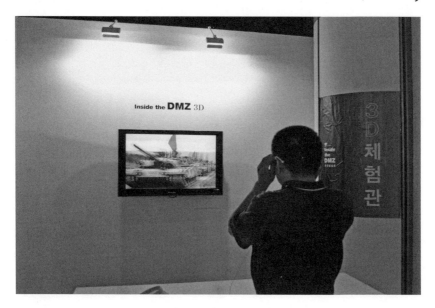

FIGURE 4.5 A museum visitor watches North Korean tanks approaching the DMZ on a 3D screen. Photo: Suk-Young Kim

inhabitable space. The exhibition's sponsors—high-tech, multinational companies like Canon and Hewlett-Packard—made these perception-altering technologies available to the curators. These new means of seeing allowed spectators to experience the DMZ as if they were actually in it: they could take pictures of themselves with the wildlife—images of animals were presented in a DMZ that was mapped virtually on a flat screen—or watch as North Korean tanks, red flags waving from the turrets, approached (fig. 4.5).

Visitors could play with interactive three-dimensional screens that seemed to physically transport them to the joint security area's watchtower or to the United Nations' DMZ camp—both off-limits to civilians; they could activate a screen captioned "DMZ 360 Degree Panorama," choose a specific location, and explore it as if gazing through a telescope. The caption on another screen, which featured a map of the DMZ, instructed users to "Click on the red button and you will be able to view the sights on the map" (fig. 4.6).

These new technologies diminished the distancing effect of mediated representation, allowing visitors to have a simultaneously vicarious, visceral, and highly subjective experience of the DMZ. Ironically, this personal experience derived not from being in the actual space but from a technologically enhanced simulation. This once unapproachable, forbidden land, this reminder

FIGURE 4.6 DMZ 360-degree panorama in the special exhibition. Photo: Suk-Young Kim.

of an ongoing war where civilians are generally prohibited transforms into a personal space, allowing spectators to place themselves into the grander scheme of national history. Like the interactive operating of war machines in zone 2, the touch-screen interaction and photo editing here simulated the site-specific experience of actually being in the DMZ—or more precisely, created a sense of ownership of this contested strip of land that belongs to neither South nor North.

Shadows of the past that still haunt the DMZ—dead soldiers, civilian casualties, and families torn apart—recede as new generations of Koreans process the war vicariously through such restorative technologies. For older generations, who personally experienced the war, remembrance arises from the mnemonic recalling of lost spaces and people—forsaken hometowns or family members left behind. But for those who have encountered the war primarily in books, experiencing it through technologies like those presented in the exhibition becomes a highly controlled process whereby computer programs dictate the war's legacies.

Literary scholar David McCann reminds us that "rhetoric about war and remembering the dead in war demand a recording of emotions and a sequence of ceremonial events that are not natural."[24] The exhibition's reshuffling of historical events, which is central to the process of fabricating absent memory,

relied for its effect on an array of technologies—not just South Korea's war machinery, presented to demonstrate the South's military superiority, but also technologies of everyday life, such as the 3D displays and interactive touch-screens that created an experiential simulacrum of actually being there. These technologies, which manipulate ways of seeing, altered spectators' perception and experience of the war and its aftermath. Although no one can predict the DMZ's future, South Korean visitors to the exhibition could play the role of legitimate occupier by virtually placing themselves in it. The distance between zone 1's black-and-white photographs and zone 4's virtual technology was very great indeed: in this context, technological advancement became one way to document the development of Korean history since 1945; spectators' vatic passage through the zones simulated the chronological disposition of time.

Can we claim, however, that we were/are really there? Will advances in virtual technology ever fully compensate for absences in real or historical time and space? Calling forth a specific location on the touch-screen map of the DMZ places the spectator virtually in the site, but what if simulations of the future are based on a map that is always already a simulation of a transitional phase designed to avoid transnational conflict? The DMZ was, after all, created to halt the war temporarily, but currently it functions as a buffer zone to conceal an ongoing war. Whatever the DMZ was or is, it will not become an enduring landscape of the future; hence its role as a signifier of paradox. As Jean Baudrillard commented:

Today, abstraction is no longer that of the map, the double, the mirror, or the concept. Simulation is no longer that of a territory, a referential being, or a substance. It is the generation by models of a real without origin or reality: a hyperreal. The territory no longer precedes the map, nor does it survive it. It is nevertheless the map that precedes the territory—precision of simulacra—that engenders the territory.[25]

Used as a generative model to configure the contentious territory of the DMZ, the virtual map had yet another layer of the hyperreal: the land itself cannot, after all, be mapped coherently. When mapped at all, it must be mapped ideologically, a process that produces multiple conflicting maps, like the projected DMZ images in the corridor between zones 3 and 4, which alternated between military stalemate and the enduring forces of nature. If museums are indeed suitable places for rehearsing the future (as suggested in this exhibition by the juxtaposition of a strong South and corrupt North), what then did zone 4 foreshadow? What effect did it have on spectators? The

exhibition's dramatic narrative denied North Korea's vision of the future as represented in the zone. South Koreans constituted the majority of visitors, and they emerged from the exhibition as the rightful owners of that contested space, the sanctioned citizen-inhabitants who, if necessary, were well prepared to fight a new war that would transform a simulated future into reality.

For Michel de Certeau, one of the crucial grounds for any historiographical project is the concept of place, which introduces the environment upon which the project is built.[26] Indeed, history cannot be situated outside the space and place, whether it be a tangible geographic location or a virtually imagined ideological landscape. In its present form, haunted by both past and future, the DMZ is simultaneously real and imagined. Still contemplating its bifurcation, I walked out of the museum plaza and onto a four-lane street, only to find myself face to face with the towering fence of the guarded headquarters of the South Korean joint chiefs of staff. Soldiers toting machine guns stood at the ready, their grave and rigid bearing signifying the importance not only of this place but also of military affairs in general in a divided nation still fighting an ongoing war. The U.S. military base, which functions as the headquarters of a U.S. Army that never left Korea after the cease-fire, lies next to the War Memorial. High, forbidding concrete walls and barbed wire surround the base, while a large sign marks it as the U.S. government's sovereign property (fig. 4.7).

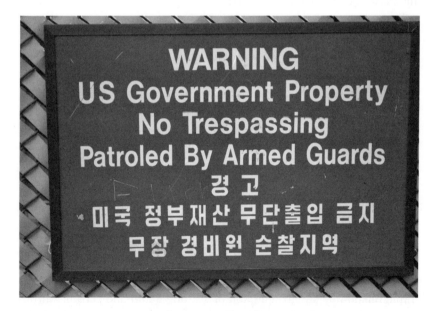

FIGURE 4.7 A warning sign outside the U.S. military base in Seoul. Photo: Suk-Young Kim

For local Koreans living in an allegedly postcolonial state (that still relies on foreign forces for protection), no reminder of the war could be more conspicuously ironic than this military base. Locals must surely wonder what really has changed since 1947, when a U.S. border guard prevented a family from crossing the 38th parallel—depicted in the black-and-white photograph in zone 1 of the exhibition. The soldier controlled this—and, by implication, any—family's mobility and destiny; he decided whether they could cross to U.S.-occupied South Korea or would be forced to return home to North Korea. Paradoxically, South Korean citizens still allow foreign troops to make many of their military decisions.

Taking a long view of Korean history (from 1945 onward), as well as a much closer view of the particular circumstances of 2010, the exhibition theatricalized many of the symptomatic antagonisms between North and South that bedevil their troubled relationship. It also explored ways of seeing (without even contemplating the futility of war), as if faithfully reflecting on Benjamin's thesis that "all efforts to aestheticize politics culminate in one point. That one point is war."[27] The exhibition argued that as long as the memorialization of war focuses on the glorification of South Korea's advancement over the North, any public display of war can be morally substantiated. But if state politics alone define war, its "museumification" cannot be substantiated at the grassroots level as a discursively embodied experience, and the restitution of the war's memory will be done by private citizens, whose various versions of it will constitute a polyphonic dissonance where affective power infuses life into past traumas and hypothetical futures.

If this exhibition failed, it was in missing the opportunity to create an emotional citizenship that might transcend the jaded rhetorical binaries of North and South, confinement and freedom, totalitarian and neoliberal. The exhibition could not mask the everlasting absurdity of the partition, which becomes mundane after repeated stagings in various settings and media. Finally, even the most advanced, expertly executed technology kept spectators from seeing the human side of the Korean division.

The Absent Border and Implicit Crossers in the Victorious Fatherland Liberation War Museum, Pyongyang

Pyongyang, Pyongyang, I very much wished to visit you. Not only to quench my curiosity about the uncharted land in my personal journey but also to

write about the Victorious Fatherland Liberation War Museum (Joguk haebang jeonjaeng seungni ginyeomgwan) in a way that corresponds well to the preceding account of the South Korean War Memorial. But the simple fact that I, a South Korean citizen, cannot go there of my own volition already tells a story about crossing the DMZ, one quite pertinent to the main topic of this book. I could not follow the audacious path Lim Su-kyung took just for the sake of visiting the museum. Hence, even before I attempted to move to the North side of the border, my journey turned into a hypothesis, a series of "what ifs." Although I am not allowed to enter North Korea, my imagination crossed the border. I rely on this "vicarious crossing" for the time being to probe into prohibited places.

In the tour guidebook published by the North Korean National Tourism Administration, the Victorious Fatherland Liberation War Museum takes significant space in the chapter dedicated to Pyongyang tourist attractions, with a list of elaborate details to impress potential visitors:

> The museum exhibits the historical materials covering from the period of the anti-Japanese revolutionary struggle to that of victory in the Fatherland Liberation War. It has total eighty exhibition rooms in thirty halls. It covers an area of 18,000 square metres and has a total floor space of 52,000 square metres. It consists of a three-story main building, a grand cyclorama hall of the operation for liberation of Taejon with a floor space of 3,000 square metres and several auxiliary buildings. Data and materials on display attest to the factor of victory and source of strength of the KPA and the Korean people who defeated the world's would-be strongest US imperialists and brought about the beginning of their decline. Lectures of war veterans and heroes and heroines of the Republic are very vivid and interesting. The museum was opened in August Juche 42 (1953) and the present building was rebuilt in April Juche 63 (1974).[28]

The museum is presented to readers/would-be visitors via an elaborate list of data, recounted in a triumphant tone well suited to a place dedicated to commemorating national victory. So proud were North Koreans of this place that in 1973, the government produced a stamp celebrating the impending opening of the expanded version of the museum. But these secondary reading sources and anecdotes cannot substitute for an actual visit. Unlike the South Korean War Memorial, where I could observe and measure every part of the exhibition in person, this museum existed for me in two-dimensional pictures in a guidebook that left abstract impressions. I could only search online to scruti-

nize the photos and video footage taken by other tourists, or read the impressions written by those who were able to visit the museum.[29] Hence, I fully acknowledge that I cannot present a full-fledged comparison to the analysis of the War Memorial in Seoul, only its pale counterpart.

Nonetheless, there is much to be gained by looking at the North's and South's visions of the DMZ and its crossers in tandem. The well-known differences in the two Koreas' interpretation of the war history—who started it and who emerged victorious in the end—in museum exhibitions are eclipsed by strong similarities in the two states' strategies, which rely on the emotive experience of border crossing to validate the state authority. The comparison will also elucidate how both state museums do not differentiate among various articulations of citizenship by the state and by individual dissenters. For the most part, each functions as the agent of the state and thereby subsumes all unofficial perspectives on citizenship, quite different from the double border crossings in the previous chapter, in which the state's and individuals' articulations of citizenship collided in a most visceral way.

By all accounts, the Victorious Fatherland Liberation War Museum is an impressive space designed to inspire solemnity and awe in the minds of visitors. Erected to memorialize the North Korean victory over Americans during the Korean War, perhaps only naturally, it features nothing of the creation of the DMZ, one of the most prominent legacies of the conflict and a perpetual reminder of unfinished warfare. Instead, the museum is full of spoils of war that the authorities proudly display as conclusive evidence of North Korea's military and moral superiority over its enemies. The conspicuous absence of representations of the border before and after the war invites visitors to question: How was it possible for the North Korean army to prevail over the enemy without crossing the 38th parallel to the other side? Why are significant moments—the initial border crossing on June 25, 1950, which started the war, and the creation of the DMZ on July 27, 1953, which brought a temporary cease-fire—completely missing from this commemorative space solely dedicated to the war?

The absence of discussion of the DMZ is quite common in the North Korean state rhetoric, which indicates that the DMZ in the minds of North Koreans is a source of shame, a symbol of an unfinished war that contradicts the state's claims of victory. It is a place of temporary transition into the future, which will see its elimination.[30] So one could argue that it is futile to ask why the DMZ is not represented in this prominent national space. Rather than fixating on the absence of this most visible war legacy, I focus on a relevant and seemingly more imperative question: How is the absence of the DMZ in

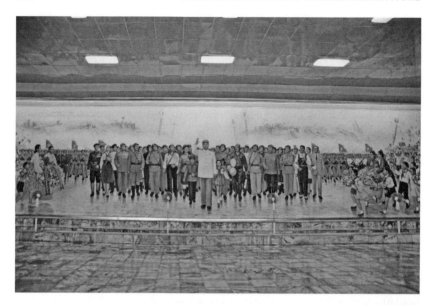

FIGURE 4.8 A gigantic painting featuring Kim Il-sung surrounded by North Korean people adorns the entrance of the Victorious Fatherland Liberation War Museum. Photo courtesy of an anonymous traveler to North Korea

this museum redressed by looming representations of alternative war experiences, which speaks volumes about the North Korean state's policing of war memories? And how does that process carve out an ideal body of citizens? My central questions concern the curatorial design, an eclectic juxtaposition of various objects and media—archival photos, oil paintings, and three-dimensional installations—meant to condition spectators, both ideologically and kinesthetically, to recall events in history that few experienced firsthand. Although an explicit representation of the border is missing, I argue that at the center of the museum is an implicit staging of heroic border crossing—which can potentially unveil how the technology of seeing revises the way visitors project the historical past and visions for the future.

Victorious Citizens, Invincible Father

The first object visitors encounter upon entering the museum is a mural of breathtaking scale (fig. 4.8). In the austere entrance hall with gray marble walls and gleaming floor hangs a colorful illustration of people greeting Kim Il-sung, who stands out in a white uniform. He towers over the crowd, who

look up to him in awe and admiration; his right hand is raised to greet both those who cheer him in the painting and the actual visitors to the museum. He occupies the focal point of not only the painting but also the museum itself, metonymically claiming the centripetal power he exercises in North Korea. There is nothing new about Kim Il-sung's centrality given the orthodoxy of North Korean visual arts: he commands full attention from museum visitors while already receiving it from the crowd in the painting, hence creating a continuum between the people inside and outside the art.

This kind of theatrical blending of real space and pictorial illusion extends to the composition of the entire painting: the human figures are framed by the gray background, which makes them chromatically blend in with the gray architectural materials of the museum hallway. Instead of a vivid landscape or cityscape, the painting features gray sky as a background, and the ground on which the human figures stand closely resembles the gray marble tiles of the museum floor. Such a seamless continuum of illusion and reality is the backbone of North Korean arts as much as Kim Il-sung's centrality is its guiding spirit.

What is truly noteworthy about this painting, however, is its representation of the people admiring their leader. Featured in the mural are people from various walks of life—soldiers, workers, laboring intellectuals, peasants, virtuous wives and mothers in modified traditional Korean dresses—who make up an ideal body of citizens in the eyes of the North Korean state. Closely flanking Kim Il-sung are a boy in a military uniform and a girl in a modified traditional dress. Each wears a red scarf around their neck, and they join Kim Il-sung in welcoming the visitors by directly gazing at them. In fact, these two happy children are the only figures in the painting who do not look toward the Great Leader. All others, both children and adults, male and female, turn their eyes to Kim Il-sung, who does not return their gaze. The exceptional perspectives of these children deserve particular attention. What can be gleaned from their vision, parallel to that of the sacrosanct leader himself?

I suggest that the artists made a distinct choice when they made these children's gaze mirror that of their father, Kim Il-sung. On one level, this could be seen as a reflection of how the North Korean state emphasizes children as the future pillars of the country; more profoundly, it is a way to create a continuum of life in which the state leader merges with and reappears as the future citizens of North Korea. By intermingling Kim Il-sung's perspective with those of the children, he becomes reincarnated as the future generations. Implied here is a visual logic that the leader shows the children what they should see, and the children will continue the leader's vision into the future. A cyclical notion of time emerges, transcending the temporal limits of one person's lifespan.

Behind the triumvirate of "straight gazers" appears a row of various professionals, featuring marines, pilots, and military forces at the center and workers, peasants, and intellectuals at both ends. This central marching party, in turn, is flanked by cheering citizens of all professions, while in the foreground are women and children dedicating copious flower baskets and bouquets to the glory of the state father. This panoramic portrayal of North Korean constituents reflects a wide range of ages, genders, and professions. What kind of citizenship does this mural intend to capture? Are these people simply a faithful reflection of the North Korean model citizenry? Could they include non-North Koreans, as the museum is open to foreign tourists?

All the eyes of the painted figures are focused on the Great Leader alone, directing the viewers' gaze to follow theirs toward the sacred central icon of this gargantuan visual composition. By doing so, they invite museum visitors to join their worship of Kim Il-sung regardless of their citizenship. The painted North Korean citizens form a semicircle around the leader, which the museum visitors can close and complete. This painting as the first object on display frames the ideological experience of visiting the museum: those who enter will be Kim Il-sung's children, perpetually positioned to look up to him for guidance. At the same time, merging his prominent figure with children makes him one of us, the people who cannot exist without his eternal presence. In stark contrast to the South Korean War Memorial's clear division between starving North Koreans and triumphantly militaristic South Koreans, the Victorious Fatherland Liberation War Museum positions all visitors to join the seamless body of ideal North Korean citizenship.

This inclusive opening statement also sets a clear tone for how history will be displayed in this space of commemoration: the most sacred vision of North Korean history will be presented through the medium of oil painting instead of photos and videos. There is no doubt that photographs and video footage reflect the perspectives of those who take them, but oil paintings add another dimension of intervention, as the artist must come up with a complete rendition of the subject matter. Although Kim Il-sung's face in this painting bears a close resemblance to the actual face of the leader, his overpowering position among the people is invented by his placement at center stage, towering over his admirers. Although museums are intended to be the repository of the accurate historical past, here in the Victorious Fatherland Liberation War Museum, oil paintings are as legitimate as documentary photos. To be precise, the pictorial illusion even supersedes actual photos. After all, does it really matter for the North Korean state what media are used, as long as the ideological core of past memories is carefully reproduced and guarded? This visionary

painting does not capture only the past. As seen in the curious linkage between Kim Il-sung and the children, it connects the past to the future and the future with the sacred origins, creating a cyclical notion of oneness among its citizens. Just like its South Korean counterpart, the North Korean state museum is invested in claiming the future as much as the past.

Violent Crossings

In the room introducing the historical background of the Korean War, displays of black-and-white photos capture the volatile moments leading to the eruption of the conflict. Just like the South Korean War Memorial, the Victorious Fatherland Liberation War Museum creates an impression of documentary accuracy in arguing for a certain historiographic interpretation. There are displays of South Korean newspaper articles juxtaposed with photos and charts, all testifying to the American military involvement in training the South Korean army for war. According to a data chart on display, the number of South Korean soldiers rose from 5,000 to 150,000 as a result.

In the same vein, another photo displaying bilingual signage—first in English, then in Korean—installed by the Americans reads: "This is a military training area. Farmers are warned not to use for cultivation. Damaged crops will not be compensated." The denunciatory tone of this display is ubiquitous, underlining the imperial attitude of the Americans acting as a sovereign power in South Korea, creating a striking parallel to the South Korean exhibition of a photo of a family stopped by an American soldier guarding the 38th parallel. Both images are about displaying the imperial power's control over local civilians' daily life, especially their restricted mobility in their own land: the photo in the South Korean exhibition explicitly captures the American control over the border between North and South, and the photo in the North Korean exhibition hints at the border created between Koreans and the illegitimate occupiers of Korean territory. The North Korean photo intends to create emotional ties between the actual museum spectators, most of whom are North Koreans, and the imagined South Korean civilians, who were subject to American regulations at the time the photo was taken. Indeed, it is an affective reminder that South Koreans are still living under the imperial yoke. Here the North Korean state is playing to feelings of indignation, rallying Koreans on both sides and thereby bringing together the imagined South Korean civilians and actual North Korean museumgoers into one body of citizenry. The notion of the border plays a crucial role in this process: by projecting

Americans as the key culprit in creating borders in Korean territory—between North and South, or between the Korean civilian areas and the U.S. military base, as shown in the photo—the exhibition makes clear that the origins of partition hark back to the unjustifiable aggression of the American military empire.

In the same section, there is a striking photo of the 38th parallel, perhaps the only explicit image of the inter-Korean border in the entire museum. In a panel display is a close-up shot of a bilingual sign—first in Korean and then in English—marking the border before the outbreak of the war. "Here is 38th Parallel, Let's Dash North!" Obviously, the photo was taken from the south side, implying that if it were meant to present an actual image of the 38th parallel, it would have been taken after the outbreak of the war by the North Koreans who crossed to the other side. Or it might have been captured from the American or South Korean army after the war began.

Whether this photo is a credible indication of actual history or not, its main purpose in the museum is to accentuate the military ambitions of the American–South Korean coalition. Meant to ignite an incendiary response from viewers, the belligerent slogan in the photo turns into irrefutable evidence by sheer force of emotion. Dangerous border crossing, as foreshadowed here, is

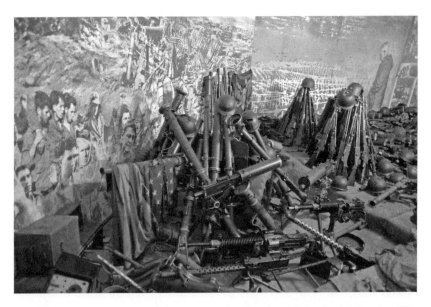

FIGURE 4.9 Displays of American defeat in the Victorious Fatherland Liberation War Museum. Photo courtesy of an anonymous traveler to North Korea

imbued with emotional implications, which encourages actual and potential visitors to resist foreign forces and expel them from the homeland.

Rather than resorting to the conventional system of division, which emphasizes the differences between North and South, this section of the museum invites visitors to look at Koreans as one body of people who have been violated by foreign powers. Unlike at the South Korean War Memorial, where the differences between South and North Koreans are marked on all levels, the true border, according to this museum, lies not between two parts of Korea but between the evil American imperial force and the unified Korean citizenry.

EXHIBITION ROOM 79, OR HOW THE WAR ENDED VICTORIOUSLY

Perhaps the most peculiar and complex of all the exhibition halls, at least to non-North Korean visitors, in respect to the emotions provoked, is Exhibition Room 79, where war spoils collected from the defeated Americans are proudly displayed (fig. 4.9). Actual rifles and missile launchers are stacked to form tiki huts in a space protected from visitors by a transparent glass panel. A tattered American flag is placed next to the piles of confiscated arms and weapons, its capture the ultimate disgrace that befell the enemy camp. Behind the installation of confiscated weapons is a large-scale black-and-white photo of a cemetery, where countless white crosses mark the graves of American war casualties. In the foreground stands an American soldier with his head lowered and eyes closed in mourning for fallen compatriots. This photograph would have invited a solemn response if it were displayed in an American museum commemorating Korean War veterans. However, it stands for an utterly different idea in the Victorious Fatherland Liberation War Museum: here is a grim image of Americans paying the price for partitioning a foreign land, dividing local civilians, and violating the border they created to serve their own military ambition. The photo's primary display value lies in accentuating the well-deserved tragedy brought to the belligerent aggressors.

In the adjoining display space are even more disturbing black-and-white photos of American prisoners of the Korean War. There is a close-up of an American soldier whose face is bleeding from a wound. This image of anguished human suffering would have surely evoked sympathy in the minds of viewers and denounced the cruelty of warfare in any other context; but in the North Korean museum, it becomes prime evidence asserting North Korea's victory over its enemies. One nation's tragedy becomes another nation's

justice and pride in this installation, showcasing how one and the same image can produce remarkably different effects depending on the emotional borders of the exhibition.

Deploying multidimensional media in this section—two-dimensional black-and-white photos of war casualties intermingled with three-dimensional installations of actual weapons—is another way of advancing the technologies of seeing as means to increase the historical veracity of objects on display. Yet the exhibits render negative images of the war enemy, as opposed to paintings, such as the one in the museum entrance, used to capture the visions of the North Korean past and future as eternally linked to its Great Leader. The contrasting media for representing the historic past—photos and oil paintings—raise questions about whether there is an inherent hierarchy among them. Is artistic intervention reserved for re-creating sacred figures and memories, while photos serve as better visual evidence capturing past atrocities?

Though I would like to speculate that this is indeed the case, the juxtaposition of different media in representing the war experience primarily seems to reveal the curators' vision of arranging history not as it happened, but as it should "feel." Whether two-dimensional photos or three-dimensional installations, these objects collaborate to inspire viewers' imagination, heavily steeped in emotive response. Rather than making visitors review the past through reason, the Victorious Fatherland Liberation War Museum instead invites them to relive the past through emotion.

As in the South Korean War Memorial, there is a conspicuous lack of representations of human border crossers during the war. Visitors' affective experience in the museum becomes central in the absence of the factual past, since the copious emotional responses intended by the dramaturgy of exhibition—ranging from anger, indignation, and frustration to thrills of liberation by the Great Leader—precisely fill that gap. This is why the museum exhibits inanimate items that crossed the border as if they were human agents capable of feeling the emotional magnitude of history as it unfolded. In the basement of the museum is a large collection of war machines, such as tanks used by the North Korean army and enemy tanks that were captured. According to Chris Springer, author of a tour book about Pyongyang, the first tank to enter Seoul is proudly displayed with all the splendor of a victorious war hero.[31] If indeed this is the first tank that crossed to the south side, as North Koreans claim, it is the object that the South Korean War Memorial lacked for re-creating the scene of the outbreak of the war and therefore had to present in a crude installation form. The tank as the first border crosser evokes a sense of justice in keeping with the museum's consistent dramaturgy of war that justifies the

North Korean army's crossing to the south side of the 38th parallel as an act of self-defense and the liberation of subjugated kinsmen. But the heroic authority of this tank can only derive from the Great Leader. The inanimate border crosser acquires a human dimension only when it is commanded by Kim Il-sung himself, whose vision, as in the mural at the museum entrance, transcends the chronological development of time and the linear movement of border crossing. Nowhere in the museum is this idea better realized than in the cyclorama, where the time and space of Korean history revolve around the sacred center of Kim Il-sung.

Revolving Stage, Revolving Memories

At the heart of the museum, in a special rotunda building adjacent to the main compound, is a cyclorama depicting the Battle of Daejeon. According to the museum guide, the battle marked the first victory of the North Korean army over the American imperialists. Spectators are invited to take a seat on a slowly revolving platform, which allows them a 360-degree panoramic view of momentous scenes: North Korean soldiers press enemies on the south side of the 38th parallel, crushing the helpless South Korean and American army while South Korean civilians welcome North Korean soldiers with open arms. Such a spectacular range of action is presented through a combination of three-dimensional objects and installations against a realistic backdrop, an oil painting featuring the ruined cityscape and burning fields and mountains of the Daejeon area. Heavy smoke rises into the sky from ruins of the buildings and fields, which become indistinguishable from the battle action taking place in the foreground with three-dimensional figurines, life-size tanks, and missile launchers. To add to the realistic effect, the cyclorama becomes animated at intervals with special lighting and sound effects (fig. 4.10).

According to various accounts, the cyclorama is the highlight of a visit to this museum. Most visitors note the breathtaking lifelikeness of this re-created battle scene and most video footage does not fail to capture this installation. According to Spain-based tour company KTG DPRK Tours and Information's website:

> The most impressive part comes at the end where you will be taken to a revolving room and what is thought to be the biggest 360 panorama in the world. The background of the room is painted with battle scenes (according to the guides it took over forty people more than one year to

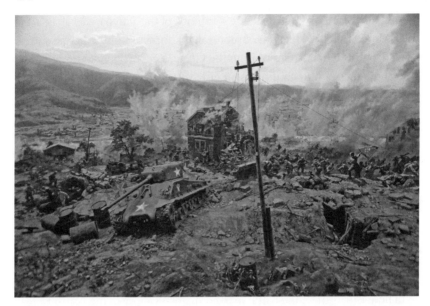

FIGURE 4.10 The installation features a seamless blending of a life-size tank with an oil painting backdrop depicting the heroic battle of the North Korean army in Daejeon. Photo courtesy of an anonymous traveler to North Korea

paint). Between the spectator and the wall there is a 13.5 metre distance three-dimensional setting. There are original war elements such as weapons, military vehicles combined with huts, soil, etc. The whole thing is so realistic that it is hard to be able to differentiate the painted background from the three-dimensional scenes. It then all starts revolving around the spectators.[32]

True to this description, the installation seamlessly blends the two-dimensional background with three-dimensional figures while stationary images meet the revolving perspective of the spectators. This raises questions about how the technology of seeing might alter the perceptions of museumgoers about this particular event in history.

The blending of two dimensions with three dimensions might not appear as complex as the virtual technology featured in the South Korean War Memorial, but it nevertheless extends the logic of its southern counterpart. Both museums try to use as many kinds of media as possible in an attempt to capture a living experience of war, the original image of which cannot be re-created. Just like the missing moment of border crossing was substituted by an

installation of North Korean tanks violating the border in the South Korean War Memorial, nonexistent archival footage of the Battle of Daejoen is replaced by this multidimensional reconstruction.

Whether this re-creation of the original event is veritable or not, it is nevertheless crucial for understanding the historic assumptions of the organizers. Although the moment of the North Korean soldiers' border crossing is missing, the cyclorama features them on the south side of the 38th parallel, staging them as "implicit" border crossers. By all indications, their crossing in this installation is nothing short of heroic, as they bravely march southward, crushing the frontlines of American and South Korean soldiers. A battalion of North Korean soldiers carries the North Korean flag and presses onto the enemies crushed on the ground, where a tattered American flag marks the defeat of the evil imperialists. The North Korean soldiers' bodies form a fluid movement that signals their march forward, bearing iconic resemblance to the statues of heroic citizens in North Korea that adorn the museum grounds.

There is another crucial reason these implicit border crossers become heroes. Amid the great destruction and chaos of the battleground, there is a remarkably tranquil section in the panorama where time seems to stand still. Amid lush farmland surrounded by mountains is a humble peasant's shack. In the courtyard are gathered a few South Korean villagers circling a portrait of Kim Il-sung, obviously overwhelmed with emotion, awestruck in the presence of the sacred leader. A tall officer in North Korean uniform proudly joins them in worship. The South and North Koreans seamlessly mingle and surround the image of Kim Il-sung, who is literally at the center of the circle uniting their bodies into one citizenry. Just like the painting in the museum entrance hall, this detail in the cyclorama seems to envision the seamless blending of South and North Koreans as fellow citizens who should be liberated and merged by this leader.

The image of a circle is a seminal concept, ideologically stating that this unison came about because of Kim Il-sung and his army's crossing the border. Border crossing for them is not a linear downward move from North to South, but an act of joining what has been divided into one entity, allowing the encirclement of North and South into one people. Perhaps the intention of installing a revolving stage to present the victory over the Americans is not only to mesmerize visitors with its spectacular scale and detailed artistry but also to instill the idea of the reconciliation of one citizenry through the spatial and ideological loop.

Reading the significance of the circle—pictorially depicted North and South Koreans circling the portrait of Kim Il-sung and the rotating stage—becomes

more pertinent when we consider that at the center of the ceiling overhead is a bright red star. In contrast to the revolving stage, it remains perpetually still, providing a center of gravity. Unlike the museum visitors, who can only see part of the battle scene at any given moment, the star provides a perfect vantage point from which all details can be seen at once. This all-seeing red star is the genuine focus of the installation, eternal in its position from whichever angle the visitors look up to it.

Needless to say, the red star in the cyclorama, with its semiotic centrality in North Korea, stands for Kim Il-sung. The same visual logic is found in the gargantuan painting near the entrance to the museum: Kim Il-sung is surrounded by people not only inside the painting but also outside of it, and together they close the circle around him. Likewise, the red star on the ceiling is literally surrounded by the museum visitors, who move in circles as the stage revolves; at the same time, it is also surrounded by the painted figures in the background of the cyclorama. Kim's presence stands as a centripetal focus as well as a centrifugal force to direct people around him, who shall all unite as one body under his tutelage. The North Korean army's border crossing to the south side might be simply implicit in this installation, but its heroic nature is explicit: it is a necessary prerequisite to attaining the ultimate unity among the unjustifiably divided people.

The envisioned citizenship here transcends the divide between North and South, foreign and domestic, as the circle is meant to embrace and be embraced by all. Although I cannot personally visit this museum to claim this experience, my "vicarious crossing" allows me to imagine: What would it feel like to sit on the revolving stage and be mesmerized by the spectacular visions of victory while an eternally shining red star sees it all from the empyrean? Would I feel embraced by the eternal presence of the Great Leader, or would the critical distance between what I feel and what I am supposed to feel alert me to resist the manipulative indoctrination by the state? The museum tour ends on a high note, with transhistoric eternity as embodied by the red star, but it also forecloses multiple ways of seeing various border crossers and the possibilities of contemplating complex emotions regarding the North Korean presence in the South and the American involvement in the Korean War. Alternative ways of seeing outside the focal center marked by the red star are only to be imagined and speculated about in this museum, which counterintuitively invites potential visitors to feel what is not being displayed on stage.

5

NATION AND NATURE BEYOND
THE BORDERLAND

THE NEWLY ENFORCED COLD WAR IN THE NEW MILLENNIUM HAD many detrimental effects on relations in the Korean Peninsula,[1] but the most noticeable change was the suspension of the Geumgang Mountain tourism project. Since its launch in 1998, the project had brought nearly two million South Korean tourists to the North Korean mountains on the east coast—a mass crossing of the DMZ by civilians, of an unprecedented scale in the history of the Korean division.

This operation came to a halt in July 2008, when a North Korean guard shot and killed a South Korean female tourist when she walked out of the designated tourist area. The South Korean government immediately stopped sending tourists to the North side of the DMZ on the ground that it was no longer safe for its citizens. In response, the North Korean authorities called the South Korean government's decision an opportunistic move to stifle North Korea into isolation. As the state newspaper editorial declared: "The conservative thugs [the Lee Myung-bak administration in South Korea] took the opportunity and blamed us for intentionally 'killing an innocent tourist,' halting the Geumgang tourism operation as a part of their master plan to oppose the Republic [North Korea]. This is nothing but their cunning strategy to disperse negative attention paid to their government."[2] Even four years later, *Rodong Sinmun* featured a vitriolic editorial on November 26, 2012, stating that

the Lee administration had been persecuting those who strove for the success of the Geumgang Mountain tourism project, which was "not just about sightseeing, but a crucial step toward facilitating reconciliation between both Koreas through exchange."[3] As this incident indicates, the two Koreas' stance cannot be more different, which only points to the tantamount challenges of reaching a rapport that would allow for a free flow of people across the DMZ.

Despite or because of the ongoing contestation, the DMZ area continues to be a unique destination for tourists who cannot cross the line. Both governments capitalize on this duality. On every anniversary imaginable—of the outbreak of the Korean War or the signing of the armistice agreement that created the DMZ—the area is a prime destination for tourists of various backgrounds. For instance, the provinces adjacent to the DMZ, such as South Korean Gyeonggi and Gangwon provinces, constantly emphasize their geopolitical significance as tourist capitals. In preparation for the sixtieth anniversary of the signing of the armistice and the creation of the DMZ in 2013, the Gyeonggi Province Assembly decided to increase the budget for the anniversary events to 10.8 billion won. They suggested "holding a marathon between Imjingak and Gaeseong and revamping the area surrounding the Bridge of Freedom in Imjingak Peace Park."[4] Likewise, Gangwon Province actively devised and promoted tourism packages. As a South Korean newspaper reported, one travel agency specializing in DMZ tours worked with the city of Sokcho and the prefecture of Goseong "to prepare a package that will appeal to mature consumers. They plan to sell pilot packages starting in December 2012 and further refine the details of the package for sales in 2013."[5]

What propels the popularity of the DMZ area as a tourist destination is the fact that the zone itself cannot be accessed for mass tourism. Its vicinity has turned into a site-specific destination to approximate the impossible locale that lies beyond reach. In lieu of actual crossing, which has been rare and difficult throughout the past sixty years of division, South Koreans have had to settle for an alternative experience of getting as close as possible to the border area, where the Civilian Control Line (CCL) is located.[6]

Approaching the far northern end of the South Korean CCL may be a means of imaginary travel to the North—a vicarious crossing that allows for an imagined reunion with North Korean kin. But it also provides visitors an opportunity to mourn the division as a fact, forcing them to face the impossibility of reaching beyond the border; it is a checkpoint where the realities of segregation, rather than any chances of reconciliation, play out in the most visceral way.

It is far more difficult to learn how North Korean civilians are able to approach the Northern part of the DMZ, which is necessary to engage with the touristic mapping of the other half of the buffer zone. However, several well-documented projects cater to foreign (used to mean "non-Korean" in this chapter) visitors who have access to Panmunjeom, located at the southernmost end of the North Korean DMZ. From there, tourists are able to visit the actual Military Demarcation Line (MDL) and physically approximate the symbolic weight of this historic place. But since this tour package was not available to me as a South Korean citizen, I will instead emphasize the tourist experience in which I was personally able to participate: visiting Imjingak on the South side of the DMZ and participating in the Geumgang tour project. The latter enabled millions of South Korean citizens to cross the border back and forth to North Korea—a pale alternative to the experience of being on the North side of the DMZ. Including an account of a North Korean citizen who visited the DMZ vicinity as a tourist would provide the ideal balance to my personal visit to Imjingak. However, I was unable to secure such a story. Additionally, as this chapter focuses on the autoethnographic approach to the questions of DMZ crossing as an act of emotional citizenship, I incorporate the projects to which I personally had access. To this end, Geumgang Mountain tourism is the best substitute.

In both cases, the dualistic concepts of crossing are staged in a most dramatic mode: building on utter contradictions, they merge wishful thoughts for the fluid reunification of two Koreas with the sobering reminder that they cannot be realized. This ambivalence is vital to the forces that make the DMZ and its vicinity an idiosyncratic tourist space, as it invites visitors to participate in an intense emotional experience rather than being detached bystanders of ongoing history.

VISITING IMJINGAK IN 2009

One of the most prominent sites at the northernmost end that South Korean civilians can access is Imjingak Pyeonghwanuri (Imjin Pavilion Peace Park), an expansive park area that hosts a series of monuments commemorating the Korean War and the painful legacies of division. Located just south of the DMZ, adjacent to the CCL, Imjingak is a spatial embodiment of the unfinished business of the Korean War. Before the war, the inter-Korean railway connecting Seoul and the North Korean city of Sinuiju (Gyeongui-seon) used to run through where the park stands now, with a stop located inside the current park itself. During the Korean War, the city of Paju, which is a host town to

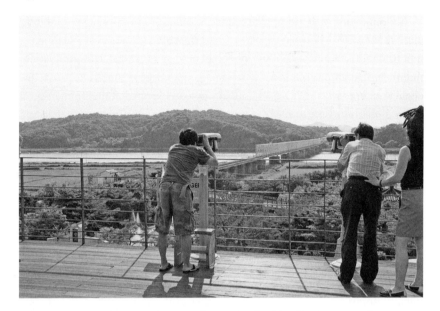

FIGURE 5.1 Visitors to Imjingak gaze at the North side of the DMZ. Photo: Suk-Young Kim

Imjingak, provided an active passage for civilian war refugees migrating from North to South. The park opened in 1972 as a three-story building with an observation deck from where visitors could look beyond the DMZ area on a clear day (fig. 5.1). It has become a perennial destination for separated families living in South Korea, who see the place as the closest approximation to their lost hometown in the North.

In recent years, the area has developed into a sprawling multifunctional park, with Imjingak at its center. The park embraces an outdoor exhibition area, cafes, restaurants, and bike trails—providing respite for visitors, especially those from the Seoul metropolitan area, where such a lush and open environment is hard to find. The educational facilities are used primarily for elementary school students, with special programs designed to help them experience "life, history, and peace,"[7] such as bike tours, observation of nature, and arts and crafts classes with themes centering around DMZ history. Imjingak Pyeonghwanuri is also a staple site in the itinerary of foreign visitors, who seem primarily attracted to its significance as the last bitter outpost of the Cold War era. If one nation's trauma is the main force attracting local and global visitors, can we call this mobilization "tourism"? How is the element of historical trauma related to the conventional notion of mass tourism as a way to encourage pleasure and leisure through consumption?

Although Imjingak is not located inside the DMZ proper, it is the closest place that civilians are able to access. From there, visitors peep into a telescope in a futile effort to glimpse traces of authentic North Korean life, only to find themselves gazing at the verdant landscape. Dean MacCannell significantly noted that "the act of sightseeing is itself organized around a kernel of resistance to the limitations of the tourist gaze."[8] Indeed, the experience of visiting the Imjingak area as a tourist is built on the sense of limitation, the realization that tourists cannot cross the border. At the same time, in a bizarre juxtaposition, some elements in Imjingak evoke the desire for recreational pleasure, the same way that the DMZ itself conjures up ambivalent feelings of national trauma and natural aura. Although the recreational elements are subdued here, like in amusement parks, they display values of pleasure typically reserved for tourist consumption, such as amusement rides and stars' handprints, which have nothing to do with the history of the Korean War and division. Although small in scale, these elements call into question whether the Imjingak area is undergoing a paradigm change as a tourist destination, shifting from the commemoration of the violent past to the celebration of the peaceful, leisure-filled present and future. As one South Korean visitor expressed on a blog: "With time flowing, it breaks my heart to think that the tragedy of division can only be accessed through a tourist experience, but it is also meaningful, for the sake of future generations, to preserve these historic sites and let them see for themselves."[9] As this visitor noted, Imjingak tourism appears to be predicated on paradoxical juxtapositions of painful history and touristic activity. It simultaneously imbricates the hopeful visions of crossing the DMZ in the future and the frustrating impossibility of doing so in the present.

Such a mélange of potential tourist experiences calls for revision of the modernist definition of "tourist." "An exponent of leisure and mobility,"[10] the tourist, according to Maxine Feifer, is an entity produced by the accumulation of material wealth and free time from capitalist excess. The tourist visiting the DMZ area is predominantly positioned to feel uncomfortable in the face of national trauma and will be compelled to deny the conventional tourist entitlement to leisure and mobility. People who visit are not there to openly enjoy themselves, hence denying the principle of leisure; nor do they expect to cross the line, hence denying the principle of mobility. Rather, they are primarily invited to join the suffering of those who mourn the loss of their families on the other side and share a sense of hope for reconciliation, no matter how futile that may be in actuality.

Given this situation, what attracts visitors to Imjingak might be seen through the concept of "trauma tourism," a term coined by arts scholar Laurie Beth

Clark. In grappling with the puzzling coexistence of conventional tourist activities with the memorialization of tragic past events, as at sites such as Holocaust memorials and the "killing fields" in Cambodia, Clark points to what makes trauma and tourism rife with tension:

> I began using the term "trauma tourism" in 2002 because I thought it captured the contradictions inherent in the practices of visiting memory sites. I find the oxymoronic quality of the term to be most accurate about the ambivalences I have observed. While I first thought the internal tension of the term was between the association of tourism with pleasure and trauma with pain, I now feel more convinced that the tension is that trauma is held to be sacred while tourism is considered profane.[11]

Rather than pitting "pleasure" and "pain" against each other, Clark sees "sacred" and "profane" as the true divide that characterizes the tension between trauma and tourism. While Clark's refreshing claim deserves serious consideration for the analysis of Imjingak tourism, it does not sufficiently consider the role consumerist transactions play in linking the "pleasure" aspect of tourism with the "profane" nature of tourist activities. Nor does the term sufficiently address the tenuous engagement between the "pleasure" and the "sacred" aspects of tourism: as evidenced in the case of Paju (the host city of Imjingak) municipal government's developmental projects, there seems to be no perceivable conflict between the pursuit of leisure through recreation and shopping and the heartbreaking mourning of national division. The truly bizarre part of seeing the amusement rides and celebrities' handprints in Imjingak park is that they link the sites of national trauma more directly to the conventional tourist sites where consumption—whether labeled pleasurable or profane—is not only encouraged but also a foundational goal. If consumptive desire should be silenced in the DMZ tourist discourse in the solemn commemoration of war tragedies, then can the conspicuous consumerist element be seen as the developers' ironic gesture, admitting the limitations of the DMZ area as a memorial to past tragedies? How do elements of leisure and trauma coexist in this already heavily contested space?

As anthropologist Robert Oppenheim points out, consumption is a key activity for travelers and is not necessarily tied to material transactions, such as buying souvenirs or admission tickets. More profoundly, it is part of the tourists' interaction with the space in which they find themselves:

What is perhaps most unusual about travel as a consumptive activity is the way that it irreducibly blends the two. It is not simply a scene where objects are transacted; transactions with the world are themselves the ultimate "objects" consumed in traveling. This makes travel a limit case for consumption studies, but such cases can at times reveal otherwise unseen dynamics.[12]

Consumptive desire in Imjingak does not just reference monetary transactions, but broadly incorporates the emotion that arises from travelers' interaction with the space, whether it be dominant sentiments of trauma and mourning or unexpected elements of pleasure from leisure activities. Imjingak tourism is indeed interesting because it shifts the focus of tourist consumption from tangible commodities to a much more illusive transaction of emotions—from nostalgia and grief to recreational pleasure.

In this chapter I explore these contradictory emotive impulses that make the Korean DMZ an extraordinary tourist destination, teasing out the ways global and local tourist projects claim this unique geopolitical biosphere by taking a closer look at much-contested perspectives championing the ecological value of the DMZ and the local anxiety to remedy national trauma through its eventual abolition. In the process, I speculate upon the DMZ's future as either an open passage for free crossing or an environmentally protected sanctuary. Both possible scenarios bear significant implications for citizenship, based on ethnocentric nationalism or global environmentalism.

TRAILS OF NATIONAL TRAUMA

My visit to Imjingak on June 25, 2009, was a solemn experience, coinciding with the anniversary of the outbreak of the Korean War, known as the 6.25 War in South Korea. I arrived in the late afternoon, when various events commemorating the war were about to conclude. Fresh flowers dedicated to the monuments for war veterans and separated family members evidenced the special role this place plays for people coming to terms with memories of the past and assuaging the anxiety of the unresolved conflict. Many elderly visitors were silently looking to the northern horizon in search of any familiar traces from the past. The observation deck was filled with visitors whose nostalgic gaze gained deeper shades as the summer dusk illuminated their deep wrinkles.

Quite akin to religious pilgrimage, visiting Imjingak primarily valorizes the experience of suffering, emotional purging, and hopes for future reconciliation in the Korean Peninsula. The religion of these pilgrims is the unquestioned belief that Korea should someday be one entity—a recurrent attempt to restore the original state, much like the sequence of religious events throughout the year that mark both the progression of time and its cyclical repetition. Spiritual authority in the case of DMZ tourism stems from the sacrifice of war casualties and the ongoing suffering endured by war survivors, who, like religious martyrs, invoke a shared sense of visceral pain in posterity. When the separated families visit this place, glancing in the direction of their lost hometown, they simulate the experience of pilgrims who aspire to miraculously recover and share in the original suffering endured by religious figures. This mnemonic and restorative power of Imjingak is quite similar to that of the museum spaces discussed in the previous chapter, organizing the visitor's kinesthetic sense to process history as experienced personally though their body. Perhaps the most representative element reflecting such dual sensations—of being physically trapped on one side of the border while attempting to cross the limitations of time and space—is the Altar for Remembering Lost Homelands (*mangbaedan*) dedicated to the lost hometowns in the North. Erected in 1985 to provide a ceremonial space for those who want a vicarious experience of visiting their hometown during major Korean seasonal rituals, such as the Harvest Moon festival and the day of ancestral rites, it has become the focal point to channel feelings of loss and mourning. An austere stone monument next to the metal fence of the Civilian Control Line, it silently overlooks the Imjin River and the bridge to the northern bank that only a limited number of authorized personnel can cross. Dedicated to those who desire to move beyond the barbedwire lines, it nevertheless marks the point where they should stop marching northward and come to terms with their sadness here and now. Unlike the spontaneous flow of the river and the free-forming clouds that cross the border, the monument remains still, not able to join the flow of nature. As if in compensation, behind the altar stand seven stone tablets, each with carved images of historic sites and landscapes of various provinces in North Korea. These images, palely captured on the surface of grey stone, are symbolic incarnations of the separated family members' desire to set foot on the North side. At the same time, these sites in North Korea, albeit only images, have crossed the border to be presented to the people who claim them as their own.

In a similar vein, a monument dedicated to the "Song Yearning for the Hometown" (*manghyangga*) presents strong emotions of separated family mem-

bers who seek temporary relief from their perpetual grief. On the monument are inscribed these lyrics, under the title "Thirty Years That Had Been Lost":

> Whether rainy, snowy, windy,
> for thirty years I longed for you.
> I cried for long, lamenting my lonely fate.
> We, the brothers and sisters,
> were at least able to have a belated reunion.
> But where are you, Mother and Father?
> I cry out for you, only to hear silence.
>
> Will I be able see you tomorrow, or the day after tomorrow?
> Every day I have been waiting in tears for the past thirty years.
> I cried for long, lamenting the loss of my hometown.
> We, the brothers and sisters,
> were at least able to have a belated reunion.
> But where are you, Mother and Father?
> I cry out for you, only to hear silence.

Reminding us of the story of the Jeong family reunion, introduced at the beginning of this book, the song is a plea to the heart, to the emotional resonance family ties can evoke in visitors. Imjingak does not lack these kinds of emotional narratives. A small stone monument called the Torch of Reunification, erected on December 30, 1979, bears a dedication composed by the poet Yi Eunseong: "Here rise the flames of the Torch of Reunification—it is the wish that flares up in every Korean's heart." On the surface of the monument is a carving of a family, father, mother, and son, embracing in a tight circle. Although staged without any reference to specific people, the generic rendering of this family unit potentially resonates with particularities of each separated family's history. The monument is an invitation to sympathize with the suffering of others by drawing upon universal aspects of human existence, a sublimation of individual differences into a relatable icon called family.

While these monuments attest to unresolved emotional angst through their inscriptions, the Bridge of Freedom has become a landmark in the history of division, simultaneously marking the potential for crossing and the impossibility of doing so. The bridge was built in haste in 1953, after the cease-fire, when 12,773 prisoners of war were to return from North to South. Having served as

a passage to those willing to cross the border, at present the bridge betrays its name by restricting mobility. Bridges are built to connect two separate points in space, but the Bridge of Freedom stands as a reminder of the absolute impossibility of connection: its northern end is barred by a metal fence, beyond which lies the area civilians cannot access. The fence has become an emotional frontier for visitors to post their hearts and minds: Korean flags, national flowers, and schoolchildren's pleas to make reunification become reality as well as their drawings sent to their "friends" in the North are interspersed with open letters sent to lost family in the North, to be neither read nor returned.

Amid the countless heart-piercing stories and images posted, my eyes rest on a collage of two photos. Without any words of explanation, the photos, neatly positioned on a single paper and carefully wrapped in transparent plastic, tell a story that cannot be adequately captured by words. At the top is an old black-and-white photo of a young man holding two little boys, who are sitting on his lap. The young man is in white traditional Korean clothing and looks directly into the camera. Judging from the clothing, the photo was taken generations ago, most likely before or during the war. The serious expression on this man's face is typical of a photographed male subject of the war generation and contrasts with the innocently smiling faces of the two boys, who do not look older than age three. At the bottom is another photo, a montage made of a close-up portrait of a grown-up man inserted in the frame of a flower blossom (fig. 5.2).

Who is the man in the old photo? Is he the father of two little boys on his lap? Is he the person in the second photo, or has one of the little boys grown up to be that man? There is no way of knowing. But these strange faces tell a familiar story, silently but deeply probing into the onlookers' imagination. Intuition tells me that the three people in the first photo are family members who now must endure forced separation, some in the South, some in the North, who can no longer share the intimacy that used to characterize their family life. Perhaps one of the little boys, who is now a man living in the South, posted the photos in his silent longing for the lost father and brother. The bodily warmth of a father holding his two little boys closely on his lap is a reminder of the sensation of being embraced by a parent, and the joy of embracing a child. Now with only a wishful hope that may not be realized in this lifetime, the one who posted this collage sends a nostalgic heart beyond the wall. He might not be able to cross the line himself, but his longing transcends it.

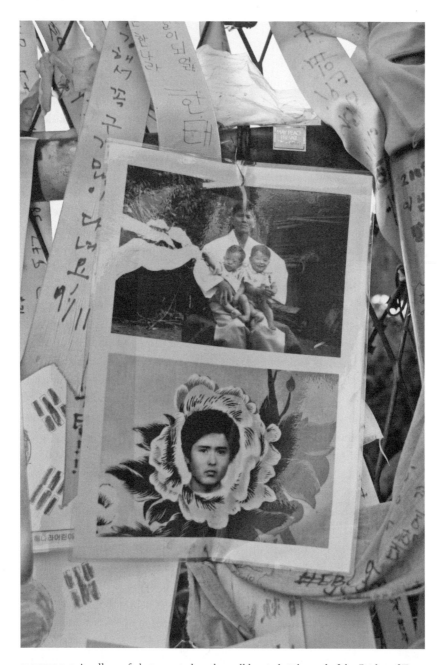

FIGURE 5.2 A collage of photos posted on the wall located at the end of the Bridge of Freedom. Photo: Suk-Young Kim

FROM TRAUMA TO RECREATION?

As the Bridge of Freedom illustrates, DMZ tourism, with its quintessential concepts captured in iconic images of barbed-wire walls and nature, is about celebrating mobility as much as mourning immobility. Imjingak provides an occasion for visitors to experience potential mobility between North and South and its lack—often contradictory, but also inseparable from each other. The result is an ambivalent emotional experience predicated on the hopeful "vicarious crossing" and the frustrating impossibility of actual crossing. Visitors are constantly reminded of both possibilities at once, which invites them to engage in an internal conflict between or reconciliation of the two.

The train is another paradoxical metaphor built on the traumatic memory of separation and hopes for connection. Here the duality is accentuated even more, as the Imjingak park provides a memory of fluid mobility between the two Koreas and the lack of such a connection in the present. The railway system connecting Seoul in South Korea and Sinuiju in North Korea opened in 1906. Before the war, the railroad used to run through Imjingang Station, located in the present Imjingak park. This train brought passengers back and forth from Pyongyang, which was the next stop on the Seoul–Sinuiju line prior to the train's halt during the Korean War. Just like the bridge, trains on display in Imjingak implicate the dual forces of mobility and stagnation. However, the emblem of the train acquires deeper complexity, as there are many types of trains in the park area.

First, there is a monument standing where the Seoul–Sinuiju line train stopped at the end of the war in 1951. Then, there is an exhibition of an actual train from the war period, which had been heavily bombarded and then discarded in the DMZ area. After fifty years of abandonment, it was restored and placed on display in Imjingak in 2009. Finally, there is a miniature train for visitors to ride along tracks set up in a limited section of the park. How do these various kinds of trains—the first two obvious symbols of the tragic war legacy and the last a vehicle of entertainment—collaborate in representing narratives about war and division? How do these icons of mobility and stagnation coexist in this contested tourist space?

The monument dedicated to the inter-Korean train's cessation on June 12, 1951, stands next to a small steam engine coated in shiny new black paint. There is no clear indication whether this was the actual train operated during the war; according to the official homepage of the municipal government of Paju, the host city of the Imjingak Peace Park, this train was restored to resemble actual

trains that operated in the 1930s, during the colonial era. Despite its dubious origin, the monument standing next to it is inscribed and associated with one of the most well-known slogans in South Korea: "Let the iron horse run again." This slogan metaphorically animates the train as a living being, a horse, while it metonymically represents the collective desire of Koreans to cross the border freely, the way they used to during the war. The train becomes an animate border crosser onto whom the visitors' desire is transferred.

The imposition of human perspective onto the inanimate object makes the interaction between the visitors and the train significant; but more crucially, it accentuates the paradoxical coexistence of the impetus to move (represented by the train) and the lack of ability to move (represented by the space where the train halted). Directions to various cities in the North and South are indicated on the monument itself: to Busan, 497 km; to Mokpo, 490 km; to Sinuiju, 444 km, to Pyongyang, 208 km; to Hamheung 394 km; to Najin, 996 km—all in the service of the desire to cross the border, as if it did not exist. While the destinations in North Korea invite tourists to imagine traveling to those cities, the stationary monument train, perpetually immobile in order to mark a particular point in history, forecloses the possibility of crossing.

These antithetical forces find a similar resonance in the second display: a reconstructed train that was bombarded on December 31, 1950, and had been discarded in the DMZ for fifty years. During that time, this "ghost train" became another powerful symbol of the divided country. When in 2004 the South Korean Cultural Heritage Administration designated it as national treasure number 78, the train was transformed from an accidentally abandoned article in history to an intentionally displayed object in commemoration of the national past. The train was restored over two years with support from the South Korean steel mill giant POSCO, and in its clear surface more than 1,000 bullet holes are to be found—all testifying to the violence that went on during the war. The restored train is shown in a prominent place in Imjingak next to the memorial dedicated to the lost hometown (fig. 5.3).

The day of my visit to Imjingak coincided with the opening of this train. Careful visual documentation accompanied the new exhibition, providing a close-up look at the meticulous restoration process. Amid a series of photos capturing this transformation, emphasis was placed on one featuring a tree growing out of the train's rusty remains. This tree, like the train, was transplanted to the new exhibition grounds, next to the restored train that used to house it. Like monuments, trees root themselves deeply in the ground; they are not meant to be moved around. Trains, on the other hand, are destined to

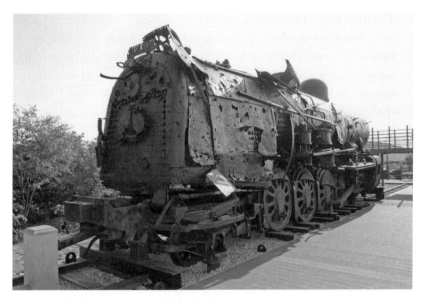

FIGURE 5.3 The train heavily bombarded during the war has been restored and put on display at Imjingak. Photo: Suk-Young Kim

be on tracks, constantly moving in all directions and crossing bridges and regions, enabling people's mobility along the line. The juxtaposition of these two incongruent objects is symptomatic of what Imjingak signifies in the broader landscape of war legacies. As the site of a former train station that connected passengers to the next stop in North Korea, it stands today as the barricade blocking South Koreans from going farther north.

Unlike the aforementioned two trains, which embody the conflicting forces of war and truce, mobility and stagnation, the last train is a rideable miniature railway. Named "Peace Train" in an obvious wish for the future in Korea, it imposes a bizarre image of an amusement park in a space where the overriding emotional forces are predicated on tragedy. Festively adorned with bright light bulbs and colorful decorations befitting Disneyland, the train betrays the solemn semiotics of this place. In addition to the Peace Train, there are also staple elements of a fairground, such as a colorful merry-go-round and a pirate ship named *Super Viking*. Their presence feels blasphemous, like heartfelt laughter at a heart-wrenching funeral. My observations were reflected by one of the visitors who posted on the official website on Paju municipal government a mild protest, pointing to how random elements of entertainment disturb this quintessential site of mourning:

The Altar for Remembering Lost Homelands and the song dedicated to lost hometowns are essential parts of visiting Imjingak, providing the visitors with so much heart-wrenching experience. This is a place where separated family members and people with memories of Korean War experience visceral pain stemming from lingering division. . . . But this space of mourning and sadness had to be invaded by the noise of popular songs and amusement rides coming from nearby Peace Land inside Imjingak. I believe it is a big mistake to create an amusement park area in a place filled with painful memories.[13]

As this visitor complains, the postmodern collage of incongruent elements in this memorial space challenges anyone who wishes to come up with a cohesive reading of the park.

Although Imjingak nowadays attracts many young visitors who would normally enjoy such amusement rides, the Peace Train nonetheless gives curious shades of meaning to other train-related monuments. Once again, the apposition of various kinds of trains raises a question: how do elements of leisure and trauma go hand in hand, especially in the anthropomorphic representation of trains as actual and potential border crossers? It is difficult to simplify this as concerning only generational and experiential differences among visitors—to say that the older generation of Koreans with war experience or those who have ties to North Korea are drawn by nostalgic forces of the train monuments, whereas the younger generation, especially children, are attracted by the amusement rides—because there are plenty of devices to establish emotional affiliation between the generation that lived through the war and those who did not. Rather, I want to entertain the idea that a knowing distinction is made between the solemn commemoration and leisurely fun in visitors' emotional transaction with the space. They are juxtaposed as different, but not mutually exclusive elements in the park.

I would like to present a hypothesis that the designers of Imjingak Peace Park were aware of its double significance as a site to commemorate the unfortunate past and also a space to have a pleasant time in the present. This arguably stems from emotional fatigue caused by the incessant mourning of division as a national tragedy. The way the Korean War is remembered in South Korea has been monopolized by the state rhetoric of mourning during most of the division. Although the experiences of war left indelible scars for Koreans on both sides, it could take more than a tragic narrative to overcome the trauma. Locked up in the prison house of suffering and mourning for too long, South Korean society is more than ready to deviate from the oversaturated war-related reflections, not

only by indulging in historic amnesia and mind-numbing consumerism but also by openly facing war legacies with humor and pleasure. In Stephen Epstein's illuminating thesis on South Korean pop culture's humorous rendition of North Koreans since the Sunshine Policy,[14] we learn that laughter and entertainment can speak more poignantly about the national hopes for reconciliation than conventional narratives describing North Korea, which range from tragic to hostile. While analyzing the significance of dismantling the Cold War rhetoric on the border region in South Korean popular imagination, Epstein advances the idea that the DMZ area is a site replete with potential for subversive comedy:

> The two sides stare each other down, present within the same space across a clear dividing line. After years of commentators pointing to the oxymoronic name "demilitarized zone," to the extent that noting the incongruity had become a cliché, we are witnessing a genuine demilitarization of the zone in South Korean pop culture, such that it forms a setting for humorous play.[15]

The tension that used to define the border area can be stultifying, ready to be shattered by liberating humor. As Henri Bergson would observe, "rigidity is comic and laughter is its corrective."[16]

The emotional forces these three types of trains invoke in visitors rest not only on tragedy but also on nostalgic fun. Steam trains, as signs of modernity and speed in the nineteenth and early twentieth centuries, are historic relics now—the age of bullet trains. They represent a particular sentiment of a bygone era, detached from the contemporary routine that defines everyday life. As artifacts of time, these trains, even without the war narratives that accompany their display, are poised to invite tourists' gaze. John Urry notes:

> What makes a particular tourist gaze depends upon what it is contrasted with; what the forms of non-tourist experience happen to be. The gaze therefore presupposes a system of social activities and signs which locate the particular tourist practices, not in terms of some intrinsic characteristics, but through the contrasts implied with non-tourist social practices, particularly those based within the home and paid work.[17]

Framed and affirmed by the tourist gaze that draws a distinction between contemporary mundaneness and past historicity, the trains are museumified, posing as tourist objects to be gazed and photographed, clearly distinguished from functional vehicles of today. By this measure, they unite in simulating

the real crossing between North and South, each asserting a different degree of staged authenticity. The playfulness of the implied movement in these trains, which all aim at future reconciliation, combines to dispel the conventional tragic narrative spilling into the present. Need there be an authoritative distinction between the authentic train and the amusement park train in this playfully performative world? In the postmodern collage of various time phases that accumulate to produce the emotional experience of crossing to the North, does it really matter whether a distinction is made between the historically authentic and the merely invented?

This rather uncanny merging of playfulness and actual trauma finds variations in many other elements in the park. The Bridge of Freedom, which so painfully embodied people's longing for the other side, also offers a version of light entertainment. By the entrance stands a photographer/tour guide/storyteller, Jeong Seongchun, who busily greets the visitors about to witness the emotional frontier of division (fig. 5.4).

He stands in front of a small booth peppered with large and small flags of the United Nations and South Korea. Next to it are self-promoting panel displays of various newspaper articles about his photographic projects capturing separated families. Wearing a fashionable cap and dark, sporty sunglasses,

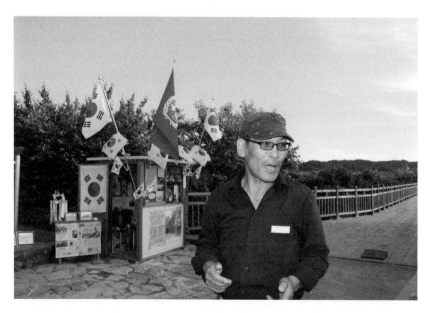

FIGURE 5.4 Amusing tour guide Jeong Seongchun tells the story of his escape from North Korea to tourists by the entrance to the Bridge of Freedom. Photo: Suk-Young Kim

Jeong is a busy man, buzzing around by the entrance to the bridge and volunteering to tell about his own family barely escaping deadly bombardment in North Korea. "When the war broke out, we used to live right there on the other side," he says, pointing to the northern edge of the Imjin River. "When the air raid started pouring in like heavy rain, our family waited till darkness and crossed the river on a small boat, all narrowly escaping death, to this side of the river." As he recounts this, his gestures become animated, the storyteller obviously enjoying his own performance. As he flutters his arms to describe the unbelievable scale of air bombing of his hometown, veins on his neck bulge out and his voice reaches a dramatic note in emulating the sound of the explosion. People gather around this seasoned storyteller who knows how to please a crowd with his entertaining manners and dramatic tales.

Whether Jeong is telling an authentic story based on a reliable memory or not is beside the main point, which is that this man, who once upon a time allegedly crossed the border himself, is repeatedly reenacting the moment of crossing that befits this particular locale, a tourist attraction that invokes nostalgia. Joseph Roach has noted that "kinesthetic nostalgia . . . in which movements and gestures descend like heirlooms through theatrical families"[1] is crucial for the fabrication of true memories. Able to draw on a very personal story built on the archetypical war narrative to which many Korean listeners can nostalgically relate, Jeong stages a highly effective performance by linking the particular with the universal through kinesthetic affinities between the imagined and the real. But by virtue of repetition in an exaggerated manner, his reenactments of crossing gain a tragicomic dimension.

What makes his performance stand out on the tourist trail littered with traumatic memory is his obvious pleasure in exhibiting himself. Like a costumed jester in an amusement park, he adds to the entertainment value of this allegedly tragic space. What the tourists see is perhaps the result of years of accumulated experience dealing with the types of visitors who are drawn to this place, but also welcome alternative narratives not shaped by the predominant tragedy. His performance, therefore, is likely to be a carefully constructed repertoire with a particular audience in mind. According to tourism scholar Philip Crang, this type of rehearsed gesture is common to human actors who work at tourist destinations:

> The dramaturgical performative metaphors used to represent much tourism-related employment, where workers are said to take on roles, workplaces become stages, managers become directors, and so on. I suggest that this turn to the performative geographies of display, and their

role in constituting the character of jobs, opens up a conceptual agenda
still underexplored in the sociology of work more generally.[19]

The comical effect from Jeong's enjoyment of his role is indeed a part of the
"performative geographies" displayed, quite befitting this site that is becom-
ing increasingly resilient in accommodating both tears and laughter. In the
mellifluous stream of stories after stories, it is not only tears and laughter that
blend but also history and story, performed authenticity and shared memory.

Perhaps this collapse of joyful play and tragic history is why visiting Imjin-
gak is a different tourist experience from visiting Panmunjeom—an iconic
building located on the Military Demarcation Line in the DMZ where gov-
ernment-level inter-Korean talks and negotiations take place.[20] Panmunjeom
is located in an active border area where the armed forces of North and South
Korea face each other. This supposedly neutral land shows the highest mili-
tary tensions among all contentious borders and is not open to Korean civil-
ians. Imjingak Peace Park, on the other hand, is a simulation of such an active
border, but with only relics from the past to display. Its present is defined by
nostalgia (Altar for Remembering Lost Homelands) or hope for the future
(Peace Train). The void of the present moment creates a vacuum in historical
continuity, allowing playful elements to join the commemoration of the past
and the prediction of the future.

The liminality of this space is even more accentuated within a broader
geocultural context, in which another bizarre force, commercialism, creeps
in to complicate the future of the DMZ vicinity. Imjingak's host city, Paju,
launched a developmental project to attract a large number of visitors to the
area with an expansive outdoor shopping mall, which, together with the park,
is meant to form a tourism belt in the region. Located within 20 miles of
Imjingak, Paju Premium Outlet opened its doors to the public on March 18,
2011, the second outdoor shopping mall of its kind in Korea but the first in scale,
with nearly 200 stores offering products by globally recognizable brand names.
Such an expansive outdoor space can only exist at some distance from Seoul,
a megacity oversaturated with dense population and traffic. The construction
of this mall was a joint venture between Shinsegae Corporation, which owns
a high-end department store and is a branch of the South Korean conglomer-
ate Samsung, and the city of Paju, which hopes to emerge as a new kind of
tourist attraction offering shoppers access to global brands of the twenty-first
century. According to the CEO of the outlet, Choe Wuyeol, the goal is to attract
3.5 million visitors every year. He means international visitors, as the outlet
will have multilingual staff members who can guide Chinese-, Japanese-, and

English-speaking tourists. "We will strengthen ties with other tourist re-sources in the city of Paju, such as Imjingak, Heyri Arts Village, Gyeonggi English Village, to create a belt for shopping and tourist activities in northern Gyeonggi Province."[21] This new network of tourist attractions reinforces a strange paradigm of cohabitation that goes beyond the tension between play and trauma: shopping with gazing into what might be North Korea, arts appreciation with English training in an immersive environment. The odd mingling may or may not be sustained—only time can tell—but the city's rec-ognition of Imjingak as a tourist attraction in relation to other commercial enterprises is telling. A strong claim is made that any efforts to make Imjingak attractive—whether commercial or pleasure driven—will be fueled by the municipal engineering forces that also intend to revamp the place as part of the tourist area that subscribes to the conventional notions of leisure and mo-bility. "Past trauma is not enough anymore," the latest municipal tourist proj-ect seems to claim, and they found the mightiest partners in the capital-heavy corporations to lift the image of Paju from the tear-ridden trauma trails to a jolly recreational destination.

NATION AND NATURE ON THE BORDERLAND

In the spatial configuration of the surrounding region, another prominent fac-tor joins the forces of commercialism and entertainment to drive the future projection of the DMZ. With its expansive grounds and lush environment, the Imjingak area has been molded into the icon of pacifism and environmen-talism. These two aspects are indeed attractive to refresh the jaded image of this place, so long associated with trauma and tragedy. As if capturing this shift-ing paradigm for what makes Imjingak a tourist attraction, I found a small sou-venir called "bird egg chocolate" for sale when I visited a light-filled wooden pavilion that hosts an outdoor café by the creek in the middle of a bucolic park setting (fig. 5.5). This area is clearly separated from the main monuments and displays that revolve around the past, such as wartime trains, the observa-tion deck, and the monument to the lost hometown.

Windy Hills, an expansive, hilly space covered with green grass and deco-rated with large outdoor sculptures and thousands of pinwheels, was added in the 2000s to reshape the image of Imjingak as a place not only to mourn but also to relax. In line with the tranquil mood shaped by this section of the park, the souvenir box of chocolates features a white dove—a quintessential symbol of peace—and a brief history of the DMZ in a paragraph, as if capturing the

FIGURE 5.5 Wooden pavilion by Windy Hills in Imjingak Peace Park. This latest addition to the park accentuates the peaceful recreation Imjingak has to offer. Photo: Suk-Young Kim

concurrent forces of national history and universal environmental values. Given that the DMZ area is known as a bird sanctuary, the dove adds the tenet of environmental protection to pacifism.

Although it is easy to assume that the environmental discourse emerged only recently with the dismantling of Cold War politics in the Imjingak area, intriguingly, even during the height of the Cold War in the 1970s, ecological protectionism was publicly displayed in the park. On October 5, 1978, four years before the 1982 United Nations Charter for Nature was declared, a monument was dedicated to nature protection, displaying an inscription of a Charter for Nature Preservation. "Mankind is born from nature, lives in nature, and returns to nature. All creatures in the sky, earth, and sea become the foundation of our lives," reads the plaque on the monument, which further displays concrete resolutions[22] to protect the environment as a civic duty. The seventh resolution, "every citizen should maintain a clean environment around them and strive to cultivate lush and beautiful land," calls for a certain kind of environmental citizenship.

The resolutions are simple rhetorical devices rather than actual policy to be implemented, yet it is significant that such a commitment to environmental protection stands side by side with overpowering memory devices such as

the observation deck and other monuments invoking national trauma. The monument, by virtue of its location, expresses its concerns about what is to be done with the DMZ area and anticipates the rigorous debate about the future of this space at the crossroads of two equally compelling forces, ethnocentric nationalism and global environmentalism.

Since the late 1990s, growing international concerns about the environment have become major issues in the DMZ area. The U.S.-based DMZ Forum, launched in 1997, has been a key player in generating awareness about the DMZ's unique environmental value in international circles. According to its website, the forum is "an international Non-Government Organization, working with other international and national environmental and peace-seeking NGOs."[23] Initiated by Ke Chung Kim, a Korean American entomologist at Penn State University, the movement acknowledges the importance of preserving biodiversity in the DMZ for the sake of protecting endangered species. There is no doubt that the area is a unique environment for diverse species, as Don Oberdorfer notes:

> Ornithologists have recorded 150 species of cranes, including white-napped cranes and endangered red-crowned Manchurian cranes, buntings, shrikes, swans, geese, kittiwakes, goosanders, eagles, and other birds passing through or living in the verdant strip each year. There are also other species that make the DMZ their home, such as pheasant, wild pigs, black bears, and small Korean deer.[24]

With so many species to protect and the forces of environmental protection growing around the globe, the DMZ preservation project gained momentum in 2005 when it received a blessing from a patron emeritus of the Peace Parks Foundation, Nelson Mandela. Moreover, the founder of CNN, Ted Turner, joined the DMZ Preservation Project as a front man, attracting the attention of politicians, diplomats, and media alike. After visiting the DMZ in 2005, Turner urged that it be declared a World Heritage Site, which would ensure that dozens of species unique to the area are guaranteed their current haven.

Casting a sideways glance at other contentious borders around the globe can shed some light on the current activism and aspirations for the future of the Korean DMZ. A parallel case in point: on December 23, 2009, German radio station SWR2 aired a remarkable story of a group of young environmentalists who successfully transformed a portion of the Berlin Wall—formerly known as a "death strip"—into a unique ecological sanctuary.[25] Through grass-

roots activism, these activists created an environmentally protected zone, or "green band (*gruns band*)" as it has come to be known, along the former inter-German border between southern Thuringia and Bavaria. According to this report, Kai Frobel was a fourteen-year-old boy in the mid-1970s when he started to take note of rare bird species along the border. He frequently rode a bicycle to the border to watch birds with binoculars, under the watchful eyes of border guards who returned his gaze with their own binoculars. He eventually started to notice people and villages across the border and became acquainted with an East German boy of the same age, Gunter Berwig, who shared Frobel's interest in bird watching. The two formed an environmental group consisting of five members aged fourteen to seventeen years old, and together they monitored and collected information about rare bird species. Many were located inside the so-called "death strip," or the border itself, where civilian access was forbidden. Frobel went on to study geoecology and continued research on flora and fauna along the inner German border. Just before the wall fell, he approached the federal government to work for environmental protection and nature conservation. A month after the wall fell, over 400 conservationists assembled under the group's initiative to discuss the future of the border region habitat. The name "green band," designating the area along the former border stretching 100 to 300 meters wide and 1,400 kilometers long, was chosen during the inaugural meeting.

Although this movement was enthusiastically supported nationwide and by the unified German government, it also met challenges, as some 2,000 acres were taken by the farmers in the area. Intensive protection measures keep 85 percent of the original habitat area intact. Frobel continues as the project manager for the "Green Band," working assiduously to protect some 600 endangered species out of 6,000 listed species. For him, this represents not only the environmental protectionist spirit but also "the importance for remembering," as the green band is essentially "a memorial against forgetting what has played out for people across the border."

Taking inspiration from successful cases like this, environmental organizations like the DMZ Forum have started lobbying both Korean governments. As part of the mission, Turner even crossed the zone to meet the North Korean leadership and discuss this plan. As environmental activists see it, the DMZ features pristine ecology untouched by rapid industrialization since the time of Dwight Eisenhower. Who can argue against such efforts to preserve the environment? As Melissa Etheridge, the theme song writer for the documentary film *An Inconvenient Truth*, said at the Academy Awards ceremony in 2007, caring about the Earth is "not red or blue, it's all green." I asked Ke Chung Kim if he

had encountered any opposition to his movement, to which he answered, "The North Korean government's initial reluctance was the only minor opposition thus far."

But the local perspective tells a different story: those South Koreans who have settled along the south side of the DMZ for generations since the armistice claim that the projection of the DMZ as an ecological sanctuary is certainly wrapped in the environmental romanticism of city dwellers and global activists. They claim that the DMZ, instead of being an ideal sanctuary for wildlife, is desperately in need of restoration:

> The environment of the DMZ is devastated due to heavy concentration of military forces, establishment of military facilities, and routes to distribute military supplies. Military from both sides routinely set fire in the DMZ to prevent sudden attacks from the enemy, so there is no room for humans to breathe, not to mention wild animals. For the North Korean military to supply its own food, the Northern side of the DMZ has been turned into farmland. Sooner or later, it will be impossible to reverse the course of destruction if we do not intervene now to restore the damaged landscape of the DMZ.[26]

More crucially, to Koreans of both sides, the DMZ might simply signify a passage to a final destination, the end of a journey in search of a lost home. As if reflecting such a sentiment, the two Korean governments collaborated on what Koreans call the "Unification Train Project," which reconnected South and North by reconstructing a railway between the two capitals. The actual train operation was short-lived, commencing on December 11, 2007, and halting on November 28, 2008, due to the vicissitudes of the faltering inter-Korean relationship. But the collaborative effort to reconnect the two Koreas through the DMZ illustrates fascinating potential scenarios for the future, the realistic possibility of using the zone as a passage for free crossing—and hence suggests a future for the DMZ different from that of environmentalists.

The debate about reconnecting the two Koreas by train has always existed in popular sentiment, as seen in the displays of halted war trains in Imjingak. But actual possibilities started to emerge with the dismantling of Cold War politics in the late 1980s. During his speech at the 1998 Northeast Asia Economic Meeting held in Nigata, Japan, Professor Kim Suyong of Kim Il-sung University noted that the project carried unprecedented significance when he commented on it as a dying wish of the deceased North Korean leader Kim Il-sung: "Linking railroads means unification. The issue of connecting rail-

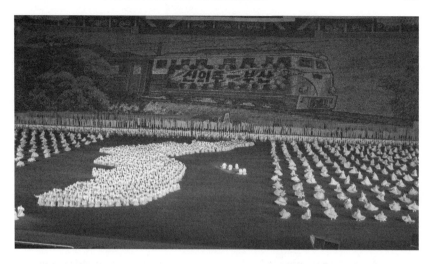

FIGURE 5.6 The North Korean card section shows an inter-Korean train operating in uni-fied Korea. The letters on the train read "Sinuiju-Busan," the two final destinations in North and South Korea. Photo courtesy of Billie Lee

roads between the two Koreas is a matter whose basic accord was discussed by leader Kim Il-Sung up until one day before his death. Therefore, its implemen-tation was one of the last instructions from leader Kim."[27] With such a mighty political endorsement, the reunification train appeared in the popular cultural sphere, with the most famous example being the card section in the Arirang Performance—a mass spectacle that relied on some 100,000 participants to ac-curately portray a moving train connecting North and South (fig. 5.6).[28]

In South Korea, the project gained tremendous momentum after the sum-mit meeting of the two Korean leaders in June 2000. On July 31, 2000, it was decided during a ministerial meeting between the two Koreas that the inter-Korean railway would be reconnected. In 2003 Seoul and Pyongyang agreed to hold a symbolic ceremony in the DMZ to mark the relinking of the railway. They planned to place two 82-foot rail tracks to link the Seoul–Sinuiju rail-way in the western sector and the Donghae line in the eastern sector of the 2.5-mile-wide DMZ. Work to remove land mines in the zone, survey the land, and construct transportation corridors for the rail lines and parallel roads was completed soon after.

The unification train made its maiden voyage across the DMZ on May 17, 2007, a symbol of the united Korea of the future. Before boarding, then Unifi-cation Minister Lee Jae-joung said at a ceremony at Munsan Station, 7 miles south of the DMZ: "It is not simply a test run. It means reconnecting the

severed bloodline of our people. It means that the heart of the Korean Penin-
sula is beating again."[29] However, the operation came to a halt in November
2008 due to problems in the inter-Korean relationship. Although the train
traveled only 222 times across the DMZ, it ingrained in the minds of Koreans
the notion of the zone as a threshold, a temporarily marked space meant to be
fully integrated into a united Korea. For some, it is not an autonomous space
but a site epitomizing the unwanted moment of division in Korean history in
spatial terms. A South Korean official working for the Ministry of Unification
mentioned during an interview, "The most fulfilling experience I have ever
had was to see the completion of the road linking two Koreas. When we first
started out the project some twenty years ago, the unpaved road was bumpy
and dusty. But now upon completion, you travel smoothly to North Korea in
your car and know that you live in Korea that is no longer divided."[30] Such a
sentiment resonates especially strongly for separated family members: the
DMZ is a place that hindered their return to their hometown after the end of
the Korean War, and thus it should be eliminated from their memory if Korea
becomes one nation again.

The DMZ preservation project, lofty as its ideals appear, may not necessar-
ily reflect the sentiments of many Korean people. In comparison, the Germans,
with the exception of the aforementioned green band, demolished the Berlin
Wall with cathartic pleasure instead of building a memorial and thereby per-
petuating its presence. At the same time, Turner's environmentalist approach
to the DMZ brings global perspectives and organizations such as UNESCO
into play, as the preservation project is lobbying UNESCO to endorse the zone
as a World Heritage Site. The future of the DMZ seems freed from the maca-
bre burden of history, and thereby one of the quintessential locales represent-
ing the ongoing story of Korean division may be denationalized. But could
such globally minded environmental movements be also driven by commer-
cial forces? It is difficult to argue against protecting the environment, but
what if the ecological sanctuary were to serve as a site of global tourism, at-
tracting bird watchers and scenic tourists alike? Status as a World Heritage
Site could be used to keep destructive developmental projects away, but it
could also be an effective marketing tool to lure tourists. If the DMZ were to
be kept as a nature sanctuary at the expense of foreclosing any transportation
projects to link North and South, would it stay free from all other develop-
ment, such as commercial projects potentially engineered by one of the
world's best known businessmen? Suspended between nature and nation,
speculations for the future and stagnant present reality, the DMZ area contin-
ues to invite heated debates and eclectic visitors alike.

JUST TOURISM?

By no means does DMZ tourism, which closely courts the idea of crossing, provide a unilateral experience. Just the fact that visiting Panmunjeom is reserved for non-Korean tourists, whereas areas such as Imjingak are open to Koreans, illustrates the disparity and paradox embedded in the question of who owns the history of division. While visiting the Panmunjeom area centers on the narratives of conflict, visiting other DMZ areas, such as Imjingak, balances trauma with serene and peaceful visions for the future.

Tourism is inherently a voyeuristic activity. It is about peeping into others' lives as well as into one's own life as if it were a foreign experience. "The whole object of travel is not to set foot on foreign land; it is at last to set foot on one's own country as a foreign land," English writer G. K. Chesterton shrewdly observed. Imjingak tourism seems to serve both ends for Koreans—to set foot on the forcibly alienated forbidden land beyond the border and to set foot on their own country as a strange land that paradoxically espouses both Cold War rhetoric and the desire to escape it, the status quo and the momentum for change, and finally, the desire to prevent border crossing and the equally strong desire to accomplish it.

But most of all, the enormous and still underarticulated forces that draw visitors to Imjingak reinforce the tenacious grip of this place on the past, present, and future. Imjingak has its roots in historic events as a site-specific memorial, invoking deeply traumatic memories of damaged ethnocentric unity. But unlike other tourist destinations in the DMZ area, such as Panmunjeom and underground tunnels allegedly dug by North Koreans for a surprise attack on South Korea, Imjingak tourism, for the most part, does not project North Korea as the dangerous enemy for visitors;[31] rather, the experience of visiting the park guides tourists to imagine North Korea as their lost hometown and North Koreans as separated family members.[32]

However, unlike Normandy or Auschwitz, Imjingak adheres to a past that is not in the pluperfect but in past continuous tense: the Cold War is not a chapter in history that concluded in Korea, but still an inherent part of everyday reality. The Imjingak area is for South Korean civilians the closest thing to the actual border, which could remain in its current form or potentially disappear. In this respect, unlike the Berlin Wall, it is not a relic but an active border that effectively divides the country. Also, unlike the U.S.–Mexico and Israel–Palestine borders, there is hardly any movement between the two sides. Conflict is ongoing in the DMZ area, but its long-sustained stability makes the zone a

unique borderland, where an ongoing past, stagnant present, and uncertain future come into contact. Suspended in this temporal arc, it espouses ecological purity, leisure, and recreation, all fueled by the ever-growing forces of global environmentalism, while still very much mourning the vivid traumas from the past and seeking to fulfill consumerist desires of the present.

Along these contradictory lines between what has been and what could be, a wide range of emotional forces is shared by an equally wide range of visitors. Not only grief but also the purging of unfulfilled longing through comforting, comedy, and pleasure make the Imjingak area an attractive place to visit. It is like the department store of emotions: one can get everything, from genuine sorrow to vicarious sorrow, by gazing at other mourners, and if that does not work, there are amusement rides and shopping malls to save the day. As diverse as these emotional forces are, they create a sense of community through almost kitschlike, universalizing sentiments. "Kitsch engagements with trauma,"[33] as Clark terms it, bind shoppers and leisurely visitors together as trauma and nostalgia bind separated family members, while environmentalism brings activists together beyond nationality. Each emotion creates its own citizenship, and tourism makes that process most viscerally performed.

Crossing the No Man's Land

An impressionistic collage of light blue and green rapidly passes by on the other side of a large window marked with greasy fingerprints and layers of dust. The air-conditioned bus is filled with South Korean tourists eager with anticipation, quietly observing everything that evolves in front of their eyes. Occasional chatter erupts among fellow travelers, soon to dissolve in the queasy smell of gasoline while the gentle shake of the tour bus diffuses the seamless merging of the blue sky with the azure ocean. The spectrum of blue shades now and then is filtered through the verdant row of newly planted trees, behind which stand miles of metal fences topped with barbed wire. As if protecting the tranquil horizon from the unruly human world, the fences dispel the illusions of idyllic utopia. Nature is so apathetic while people strenuously look for clues left by the gory battles that swept back and forth across this place over half a century ago. Nature is mute, but people want it to tell a story, a story often denied to them, about the time when there was no border, about the wartime when frightened civilians crossed the area desperately clinging to any chances of survival and the successful crossers were left to wonder about their families who were not able to come with them. Indeed, many who are

traveling with me on the bus have connections to North Korea, some with family members still living there and others with ancestral burial grounds on the North side to which they have not been able to return since the end of the Korean War. Of all ages and social backgrounds, most tourists seem to share one aspiration during this trip—to get closer to the heart of visceral trauma from the war and separation, whether it be personally experienced or abstractly imagined. But the dazzling sun in the summer afternoon seems to turn its face away with boredom, jaded by the sameness of the scenery that has remained still for the past sixty years.

August 2005, from no man's land.

I cross the DMZ as one of the South Korean tourists along the east coast highway. We are on our way to visit the North Korean Geumgang Mountain—a precipitous beauty well known for its exceptional scenery. But scenic nature is not the only focus of tourism, which capitalizes on this unusual experience of visiting the forbidden land. I personally had no particular urge to see the North Korean scenic sites—I would much rather see urban areas with real city residents—but I signed up for this tour since it is the only way for South Korean citizens to experience crossing the DMZ. I was more curious about crossing the zone, which so much of the South Korean national imagination has labeled an impossible act, than about setting foot on North Korean soil per se.

Although I have shared a detailed account of this trip elsewhere,[34] I have yet to share the apathetic and somewhat disappointing impressions I felt while crossing from South to North, and then from North to South. Nor have I written about the fact that Geumgang Mountain tourism is essentially border tourism, or more precisely speaking, a "cross-border tourism"[35] that takes movement across the border as the highlight of the experience. But quite contrary to what I had imagined, I personally did not feel the overwhelming emotion of shock and awe—the mode of border crossing represented in the DMZ Special Exhibition at the South Korean War Memorial. The crossing was too short and progressed too uneventfully, in an air-conditioned bus running smoothly on a newly paved road past pleasing scenery. Have I really crossed the forbidden line—that vivid scar marking countless personal and national tragedies? Where is the tremendous emotional response, which should have been only natural for this embodied journey of trespassing on the most persistent symbol of division?

By sharing my not-so-gallant experience of crossing, I wish to deepen the already ambiguous signification of the DMZ. The feeling of detachment I

experienced stems not so much from post-tourist irony[36] but from the remarkable tranquility that has characterized the DMZ for the past sixty years. It seems as if nothing happened and nothing will happen in this remarkably green zone. Other than the metal fence with barbed wire, this tourist crossing experience did not point to any traces of the Cold War in the DMZ. Had we crossed near the Panmunjeom area, where the presence of military conflict is more prominently displayed, with border guards from both sides intensely gazing at each other, then perhaps my impression would have been different. But this crossing alerted me to the multiple faces the DMZ possesses, marked not only by military strife but also by serene landscape devoid of immediate human presence.

The tranquility of the DMZ also speaks volumes about the foundational principles of tourism, to do away with real-life labor and conflict and see a beautified version of life that is not to be found in mundane scenery and activity. While the peaceful route of crossing is carefully chosen to avoid the quotidian (in this case, the realities of tense division), the tourist gaze seeks the authentic experience of the DMZ, as a spatial embodiment of ongoing conflict and violence. The dissonance between tourists' expectations of seeing a real slice of history and the tour company's cleansing of that troubled history echoes again in the fissures between the DMZ as an open passage for tourists and the DMZ as a forbidden land in the national imagination of both Koreas.

In addition to the contentious dichotomy straddling national tragedy and ecological purity, another factor comes into play: a sense of fatigue and an urge to move away from the multigenerational tensions constantly mangling the borderland. Even for a South Korean citizen like myself, contrary to my own high expectations, the DMZ can come across as a jaded embodiment of overworked tragedy, or a cliché that fails to strike an emotional chord. Seen through the windows of a tour bus, it can be many things simultaneously: a landscape of nostalgia for those who long to find a lost family connection, or a landscape of apathy for those, like myself, who find it lacking tangible trails of historic traumas. To add to these already discursive perceptions, while the bus is crossing the DMZ, the South Korean guide leading the group cautions tourists not to talk about any political issues, not to mention any strife between North and South when conversing with the North Korean employees who work in the Geumgang Mountain resort; instead, she urges us to look for similarities and connections as the bus emerges from the DMZ and enters North Korea. "Do not look for how backward North Korea is, but just think

about how life was thirty years ago in the South and you will find unmistakable links between the South and the North."[37]

Under such guidance emphasizing imagined emotional rapport, there is no room for an open debate to challenge the illusory unity between South and North. Any contentious statements about the reality of division and the differences between the two Koreas are marked invisible by the tourist operation. No matter what the genuine emotional state of the crossers might be, they are directed to accept forced intimacy and simulate the silence they observe in the DMZ.

Once the tourists are tamed into silent crossers, the tourist operation encourages them to play the role of a seasoned consumer. At the Geumgang Mountain resort in North Korea, visitors are herded to a pleasant shopping area where they are encouraged to purchase as many North Korean local products as possible. In lieu of meeting local people and getting a glimpse of their genuine lives, the South Korean tourists' interaction with North Korea is reduced to acquiring commodities made by invisible North Koreans. Many tourists who traveled with me expressed their desire to see the homeland before they die, but the only thing they could see was silent nature—a pale substitute for their hometown—and commercial enterprises developed by a South Korean conglomerate to look remarkably identical to generic shopping malls in South Korea. The only difference between South Korean malls and the shops in North Korea is that the latter heavily feature local North Korean products, such as food, spirits, arts, and crafts, as a reminder to the visitors that they are indeed in North Korea. Here their emotional affiliation is performed by their purchasing power, and live North Korean citizens are replaced by North Korean commodities—in a way similar to Imjingak tourism, where the absence of actual North Koreans was replaced by recreational pleasure, including shopping at a nearby outdoor mall.

This tour stands as proof that the DMZ is open to any South Korean citizen for crossing, in return for being mute and fulfilling an easy consumer's duty—signing up for the tour and paying the dues. As such, it depoliticizes the act of DMZ crossing. Before the beginning of the Geumgang tourist project in 1998, the opportunity to cross the DMZ was so scarce that the experiential rarity itself became foundational capital for imagined tourism. However, the consumerist approach to crossing the border turns that rare experience into a commodifiable transaction, enhancing the paradoxical profile of the DMZ—it is at once a wide-open passage for masses of tourists as well as one of the most contested borders in today's geopolitics. Trapped in these confusing

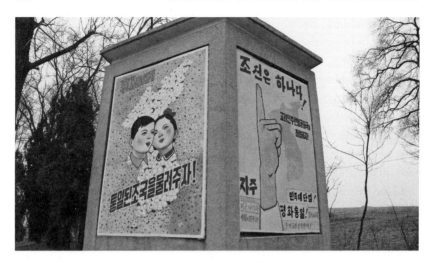

FIGURE 5.7 Photo of a North Korean monument on the way to the DMZ, taken by a foreign tourist. The mural featuring children displays the slogan "Let Us Pass Down a Unified Fatherland to the Future Generation!" On top of the adjacent panel with a map of Korea is the slogan "Korea Is One!" Photo courtesy of an anonymous traveler to North Korea

profiles, the only thing tourists can do is to remain silent without sharing their incredibly diverse emotional outlooks on the border.

CITIZENSHIP MATTERS

From the perspective of citizenship in the most primary sense (i.e., the nationality marked in one's passport), what makes the DMZ tourist projects truly paradoxical is their varying stances toward Koreans and foreign passport holders: citizens of both Koreas are strictly prohibited from accessing the confrontational zone in the DMZ—or in the case of South Korean citizens, are limited to zones that are cleansed apolitically, such as Imjingak and Geumgang Mountain. But non-Korean passport holders, mostly North Americans and Europeans, gain full access to the acutely confrontational sites along the MDL. Currently there are a handful of tourist agencies[38] providing foreigners with an opportunity to visit Panmunjeom from South Korea as well as from North Korea.

The highlight of this tour is going to the ultimate frontier, where the tense face-to-face standoff between the South Korean and the North Korean border guards can be seen. In this respect, the Panmunjeom tour is very different

from the Imjingak and Geumgang Mountain tours, which do not include a direct confrontation between North and South. From whichever side foreign tourists approach, they are bound to observe the perfect stillness of the border guards, whose blank faces strip them of any illusions of peaceful coexistence. Their faces devoid of emotion—a perfect emblem of the artificial nature of the division itself—constitute one of the main attractions for foreign visitors. Being outsiders to the long-lasting legacies of war trauma for the most part, these foreign tourists also add to the absurd spectacle of the tense confrontation: they are supposed to process the sixty-year history of countless separations and loss in a few hours at the most, while many local Koreans are entirely denied such close proximity to what was once their homeland.

The tourist trail leading to the heart of Korean division, albeit in an extremely truncated form, continues into the blue Military Armistice Commission (MAC) building, constructed over the MDL between North and South itself. Originally built by the U.S. military, it has served as a venue for over 1,000 talks between the two Koreas. Tourists entering this building are led by a United Nations Command Military officer under the protection of a South Korean guard, whereas tourists from the North side are guided by a North Korean military officer. Depending on which side tourists enter, they hear a radically different history of the Korean War. For instance, on the South Korean side of the building hangs an image of multinational flags representing countries that participated in the war, aiding South Korea under the direction of the UN. The UN tour guide will present these veteran countries in the spirit of brotherhood, which came to aid unjustly violated South Korea; on the contrary, the North Korean tour guide will claim that those countries demand their flags be removed from the MAC building, since they are ashamed of their assistance of South Korea during the Korean War. Such a phenomenon of seeing tourist sites from only one ideological angle has been termed "unilateral tourism," which "creates a vicious cycle of one-sided narratives, stereotypes."[39] This concept of tourist activities lacking multifaceted understanding of the site makes the MAC building a prime example of confrontational narratives of the past.

Despite embodying the persistent ideological standoffs that have marked the history of division, the MAC building is truly unique. Unlike the MDL outside—that long line of concrete slabs cutting across Panmunjeom, serving as the ultimate frontier that cannot be crossed—the MDL inside the structure can be crossed by foreign tourists. Visitors can walk around and transgress the otherwise forbidden line, marked by the speakers located on the conference table inside the building.

Crossing the MDL in the building is absurdly easy, which symptomatically reveals how division is a psychologically reiterated concept as much as an actual separation that cannot be overcome. Is the line not simply an abstraction of forced division, so formidably materialized over time through rituals of fear and intimidation that it reveals the comedy of rigidity when so easily transgressed by some random visitors? Compared to separated Korean families who have been longing to cross the line for their entire lives, these foreign visitors do not have the same stake in crossing, and the tourist framework diminishes the grave implications. Most tourists are bystanders of the historical burden local Koreans must bear, much the same way the South Korean tourists to Geumgang Mountain are completely detached from the realities of North Korea. In both cases, crossing the DMZ is simply a pale simulation or even a mockery of genuine emotional rapport, which is hardly attainable within the limitations of tourist mobility.

One particularly intriguing aspect of Panmunjeom tourism for foreigners can be found in the North Korean DMZ tour package, which includes a visit to the DMZ Peace Museum built on the specific site where the armistice agreement was signed on July 27, 1953. This structure is located on the north side of the MDL, within a short distance from the MAC building constructed on both Korean territories. According to the North Korean guide captured in video footage taken by foreign tourists who visited this museum, the current structure was originally built by North Koreans in just five days, in preparation for the signing of the armistice. Currently, the museum is a wide, empty space with just few relics from the historical event: the table on which the armistice was signed and the miniature North Korean flag on the table, carefully protected by a transparent display cube.

Listening to the North Korean guide in the video footage gives a good sense of how the North Korean state represents the history of the armistice agreement.[40] Speaking through a translator, the guide explains how the signing of the armistice was deeply shameful for the United States, as the first ever known defeat for the imperialists by the North Korean People's Army; for this reason, the Americans wanted to make it a secret event. So they asked the North Korean side to simply prepare a temporary canopy for the occasion, so that the site would not be permanently marked for future generations to see. But Kim Il-sung ordered that "the signing of an armistice, a tremendous victory for North Korean people, should take place in a significant place." The North Koreans heroically built the wooden structure just in five days, to the great disbelief of the Americans. The tour guide passionately interprets the outcome of the war—a temporary halt, in effect—as a victory to a group of tour-

ists who remain silent. As vacant as this museum is, the tour guide's trium-
phant rhetoric of the wartime feat resounds emptily, meeting with neither
approval nor disagreement from the foreigners. Those gathered around the
guide appear as docile as the South Koreans at Geumgang Mountain: they
are bystanders of history rather than its active shareholders.

Adjacent to this main exhibition is a modest wall display on Korean War
history and the postwar North Korean society. It features a black-and-white
photo of Kim Il-sung taken during the war and a calligraphic notice in red
letters stating that the place has been graced by Kim Jong-il's visit. Compared
to the Victorious Fatherland Liberation War Museum in Pyongyang, the
claims of victory in the Korean War are diminished, which raises questions
about what the DMZ signifies to North Korean authorities and how it miti-
gates the history of division in the eyes of foreign visitors. Does it not present a
contradiction to claim that the war ended victoriously at a site where an agree-
ment to temporarily stop fighting was signed? This paradox may as well be the
reason the DMZ museum is so subdued about its claims, compared to other
North Korean museums displaying the history of the Korean War. This also
resonates with my broader observations that the representation of the DMZ in
North Korean media is scant when compared to information about other rev-
olutionary sites such as Pyongyang and Baekdu Mountain in North Korean
history. This speaks volumes about how the DMZ comes across as an uncom-
fortable space in the memorialization of the past.[41] As the North Korean tour
guide somewhat melancholically says to foreign tourists seated around a con-
ference table across the MDL in the MAC building, "We are able to cross
back and forth only inside the building at present, but we will live to see the
day when everyone can cross freely back and forth everywhere. We will reach
unification by peaceful and independent methods. Come and visit again
then!" Could the same message be told to North Korean citizens, whose per-
ception of the war is nothing short of victorious glory for their side? As incom-
plete as the history of the war is, it cannot be given a finite memorial space in
the past absolute tense; nor can that history be shown to Korean citizens who
have their own memories as a starting point for determining anything about
the uncertain future of the two Koreas.

While numerous foreign tourists approach the MDL from both sides of the
DMZ and even cross the line continuously, there are still many Koreans,
who, even in death, cannot join the ever increasing group of DMZ crossers.
The devastating war left many soldiers missing in action, hailing from multi-
ple nations and caught on both sides of the border. Some of their remains

have been identified and brought back to their home, but even such a morbid and utterly belated homecoming seems limited to foreign citizens.

In April 2007, as part of ongoing efforts to relieve tensions between the United States and North Korea regarding the latter's nuclear development, then Governor of New Mexico Bill Richardson and Anthony Principi, then U.S. veterans' affairs secretary, traveled to North Korea and brought back the remains of six U.S. soldiers who went missing during the Korean War. The delegation crossed the MDL on foot through Panmunjeom, with the soldiers' remains following in separate black suitcases across the DMZ from North Korea to South Korea. Principi noted that retrieving the remains was one of the most emotional moments of his life. "To participate in such a noble mission to bring home the remains of men who 50 years ago were in harm's way, and now they're home, it was really quite moving."[42] According to this report, more than 33,000 U.S. troops died in the Korean War, which began in June 1950 when North Korea invaded South Korea. Some 8,100 U.S. servicemen still are listed as missing.

But missing in even larger numbers are South and North Korean soldiers, both living and dead. According to the testimony of South Korean POWs who have managed to escape North Korea and settled in South Korea, there are currently around 500 living POWs in North Korea still counting the days until the return home, hoping against hope.[43] Their crossing the DMZ is a mission that has a long way to go. The South Korean Ministry of National Defense estimates the number of its missing soldiers to be 130,000, with 30,000 to 40,000 remains most likely buried in either the DMZ or North Korea.[44] Where would they be now? Have their flesh and bone already dissolved into North Korean soil, seasons after seasons blossoming into nameless wildflowers on the field? Casting a glance at the other side of the DMZ shows an eerie parallel that sheds light on the fate of the fallen soldiers' remains. Just south of the DMZ, in the city of Paju, are hundreds of identical wooden poles marking the ground where enemies of the state—North Korean and PRC soldiers from the Korean War as well as North Korean spies killed during their missions in South Korea—rest in silence. Most poles are simply marked "nameless" (mumyeongin). Some poles bear the location where the body was found. These pale grave markers resemble wandering ghosts from the past, seldom visited and largely forgotten by posterity. According to a San Francisco Chronicle report, the South Korean state has gathered some 709 scattered remains of North Koreans and 255 Chinese and buried them here since 1996 on a humanitarian basis, in observation of the Geneva Convention. Currently the cemetery is being tended by a South Korean military caretaker, who ex-

plained to a journalist that "although it is the Korean custom to have tombs face south, we had the tombs face north so that the deceased can see their hometown."[45]

Although neither the PRC nor the North Korean government has shown interest in claiming the remains of their fallen soldiers,[46] recently there have been more and more visits to this place by Chinese tourists, who find it quite dejecting to see their countrymen lying in a shadowy corner of oblivion. Prompted by the increasing number of visits by Chinese, the South Korean government attempted to make improvements to the burial ground. But such efforts met with vitriolic opposition from South Korean war veterans. Won Bokgi, an eighty-three-year-old war veteran, vociferously protested: "How can we sympathize with the people who aimed their guns at us? I absolutely oppose such a move. . . . We should destroy such a place."[47] Embalmed in the silence of death for sixty years and counting, these fallen soldiers still ignite visceral emotion in many South Koreans. Whether the buried soldiers voluntarily participated in warfare or just were swept away by the irreversible tide of the global conflict, they all crossed the military front southward some six decades ago, not thinking that they would be buried in a strange land, never to return to their hometown. Even in death, crossing back to their families appears a distant dream, while their homes beyond the northern horizon fade away day after day, night after night.

EPILOGUE IN PAST CONTINUOUS

For a while I have been wondering how to bring this book to an end. Against my own wishes, the book turned out to be a motley compilation of both heartbreaking and hope-filled stories. How can I expect to come to a conclusion when the journey of writing has been punctuated by the unresolved past, unstable present, and unknowable future?

And yet I earnestly hope these stories I introduced have ingenuously spoken to the hearts and minds of those who have experienced neither forced separation from their families nor sudden partition of their homeland. I, for one, have only been a bystander of my homeland's own past and present, living my normal everyday life in convenient amnesia. Only in recent years have I felt the urge to be the inscriber of events I was only able to experience through accounts of other people's lives. The process of writing this book was marked by mixed feelings—the obvious discomfort of having to speak about others' suffering and a sense of removal from the situation of my homeland.

These feelings grew only deeper as I came to reside outside of Korea in adult-hood. Looking at both Koreas from a distance, I clearly see that the absurdity of the current state of division has become an accepted reality for too many whose lives are profoundly affected by it. Being a witness to others' pain is akin to sharing that pain, and the author and the readers cannot avoid taking part in this history still evolving in front of our eyes.

So perhaps it makes sense to conclude with a short story from my own fam-ily. Although nobody that I know of in the family crossed the 38th parallel during the Korean War or has kin in North Korea, I cannot be free from this unfinished history of division and war and the unconquerable desire to bridge the divide. As I was nearing the completion of this book, I received a phone call from my mother in Korea. Quite unlike her usually upbeat tone, her voice was heavy with grief—and the following conversation revealed the reason.

> I found your uncle's tomb the other day. It's been over sixty years since I saw him last. I embraced his tombstone and cried and cried. I cried my heart out for hours. He was so young when I saw him for the last time. All these years I have not been thinking about him, but when I saw him in his grave, I felt so guilty for having forgotten about him. He was there, lying calmly in the dark . . . always in his high school years and . . . whether I realize it or not . . . forever etched in the back of my mind.

As I listened to my mother in silence, from the distant corners of memory, something vaguely familiar started to lift its misty face. I suddenly remem-bered having heard about this uncle a long time ago. An elder brother of my mother, he was a high school student when the Korean War broke out. Like so many students of that time, he joined the South Korean army to defend his town from the North Korean invasion. My mother was only seven years old then and her memories of him remain vague, but she recalls how this kind brother embraced her with a smile before he left home. She also fondly re-members how he visited home once from the warfront and brought her a box of cookies—so much to her delight! Her memories of his hugs and smiles faded away, but she clearly remembers the box of cookies. After this visit, he died in a car accident on his way back to the front. Although he was not killed in action, he nonetheless perished while returning to military service, and his remains were buried in the Seoul National Cemetery on the south side of Seoul. Being a child who could scarcely comprehend the full meaning of loss, death, and war, my mother was left out of the family's grieving the untimely

death of her sibling, and her memories of him gradually faded. But by sheer chance, she was recently able to locate his grave site and to pay a visit. My uncle passed away in the early 1950s, and my mother's visit was in 2012. Over sixty years separated the siblings who are now reunited across the long distance that divides the living from the dead.

I remember visiting Seoul National Cemetery during elementary school excursions. South Korean children were frequently brought there for a field trip to invigorate their patriotic feelings and hatred of communist aggressors. Although our visits were astringently framed by the Cold War ideologies of fear and hatred, which often ignited my cynical responses, I recall how my heart was filled with genuine sorrow and solemnity when I saw the endless rows of white tombstones of those who fell on the battlefield, never to return to their homes and never to embrace their loved ones. I did not know that my uncle was buried there then, but the intimate proximity to the dead and the immense power of their silence spoke to me. It was a formidable experience to walk through so many who perished only to leave behind three characters of their names—and at times no names—on the pale façades of their tombstones. They were once among the living, and the living will someday inevitably join them. But they will never return to tell us what they saw and experienced. Such impossible tasks are left for the living, who will work through shattered remains, looking for the lost pieces of the past and telling incomplete stories of the fallen. No matter how futile their effort might be, the living will find strength for life while trying to reconnect with the forever lost. My uncle, who fell at age seventeen, will never come back to tell his stories of war, but having gone through the journey of writing this book, I feel that I might be able to glimpse what he saw during his very short life.

NOTES

Introduction:
Contesting the Border, Redefining Citizenship

1. *Yonhap News*, October 31, 2010, http://www.yonhapnews.co.kr/bulletin/2010/10/31/o
 200000000AKR20101031025900014.HTL?did=1179r (accessed January 11, 2011).

2. Both Korean governments clearly do not allow a free flow of people and informa-
 tion across the border. The South Korean government has a special National
 Security Law that criminalizes any unlicensed contacts with antigovernment or-
 ganizations, which have been, for the most part, identified with the North Korean
 state. Article 2, Sections 6 and 7 of the South Korean National Security Law define
 entering the territories of antigovernment organizations or praising them as crimi-
 nal acts.

 Established in 1948 as a way to arrest and persecute communist factions in
 South Korea, the law was amended twice, in 1963 and 1980. It has been controver-
 sial since its inception, often used as a tool to suppress any antistate movement,
 hence criticized by South Korean democracy supporters, the North Korean govern-
 ment, and international organizations, such as Amnesty International and the
 United Nations Human Rights Council. North Korea does not have a special law
 that could be seen as an equivalent to the South Korean National Security Law,
 but its Criminal Law clearly forbids unlicensed entry into enemy territory.

3. For a more detailed history of the joint tourism project, see Suk-Young Kim, *Illusive
 Utopia: Theater, Film, and Everyday Performance in North Korea* (Ann Arbor: Uni-
 versity of Michigan Press, 2010), 263–66.

4. Peter Andreas, *Border Games: Policing the U.S.–Mexico Divide* (Ithaca: Cornell University Press, 2009), xiv.

5. According to Don Oberdorfer, "it was reported that in 1945 Secretary of State Edward Stettinius Jr. asked a subordinate in a State Department meeting to please tell him where Korea was"; see Oberdorfer, *Two Koreas: A Contemporary History* (Indianapolis: Basic Books, 1997), 5.

6. Oberdorfer, *Two Koreas,* 6.

7. At the time of the country's division, there were some 1.2 million South Koreans with immediate family members north of the border. If the second and third generations are added, the total reaches nearly 7.7 million. According to Heo Jeonggu, who works for the Division of Inter-Korean Exchange Korean Red Cross: "Currently [as of August 12, 2011] 127,000 people [in South Korea] are registered with the Integrated Information System for Separated Families hoping to be reunited with their family members in the North. Excluding those who have died, the number of applicants still waiting to be reunited is at about 87,500." "Korea's Separated Families," *Arirang,* http://www.arirang.co.kr/News/News_View.asp?nseq=119180&code =Ne2&category=2 (accessed August 18, 2011).

8. Quoted in Oberdorfer, *Two Koreas,* 7.

9. Paik Nak-chung, "Korea and the United States: The Mutual Challenge," presentation at the symposium "America, Asia, and Asian Americans," The University of Chicago Center for East Asian Studies, November 18, 1991.

10. Paik Nak-chung, "The Idea of a Korean National Literature Then and Now," *positions: east asia cultures critique* 1, no. 3 (Winter 1993): 574.

11. See Joe Havely, "Korea's DMZ: Scariest Place on Earth," *International CNN.com,* http://edition.cnn.com/2003/WORLD/asiapcf/east/04/22/koreas.dmz/ (accessed March 25, 2010).

12. The representative of this environmentalist movement is the DMZ Preservation Project, led by U.S. scholars and activists. Initiated by Kim Ke Chung, a Korean American entomologist at Penn State, the movement acknowledges the importance of preserving biodiversity in the DMZ for the sake of protecting endangered species. The project gained momentum in 2005 when it received the endorsement of the patron emeritus of the Peace Parks Foundation, Nelson Mandela. Moreover, CNN founder Ted Turner joined the project, garnering the attention of politicians, diplomats, and the media alike. After visiting the DMZ in 2005, Turner urged that it should be declared a World Heritage Site, which would ensure that the dozens of species unique to the area would remain. As a part of his mission, Turner even crossed the border to meet with North Korean leaders and urge them to support his plan.

13. As though in response to such sentiments, the two Korean governments have been collaborating on what is called the "unification train project," which will reconnect North and South by reconstructing a railway between their respective capitals. Before the division of Korea, the railroad between Seoul and Sinuiju operated continually. But with war and the subsequent division of the country, the train became a tragic symbol of modern Korean history. In 2003, Seoul and Pyongyang agreed to hold a symbolic ceremony in the DMZ to mark the relinking of inter-Korean railways. The two countries planned to establish two 82-foot railways to

link the Seoul–Sinuiju railway in the western sector of the DMZ and the Dong-hae line in the eastern sector of the two-and-a-half-mile-wide DMZ. Work to remove existing land mines, survey the land, and construct transportation corridors for the railways and parallel roads was completed soon afterward. On May 17, 2007, the unification train made its maiden run across the DMZ, symbolizing the unified Korea of the future. Before boarding, the then South Korean unification minister, Lee Jae-joung, said at a ceremony at the station at Munsan, which is 7 miles south of the DMZ: "It is not simply a test run. It means reconnecting the severed bloodline of our people. It means that the heart of the Korean Peninsula is beating again." Associated Press, "Trains Make Historic Run Across Korean DMZ," *NBCNews.com*, http://www.msnbc.msn.com/id/18711246/ (accessed March 14, 2009). Unfortunately, operation of the train came to a halt in November 2008 due to deteriorating relations between the two countries. Although the train crossed the DMZ only 222 times, it established the notion of the DMZ as a threshold, a temporarily marked space meant to be fully integrated into a united Korea.

14. Many South Korean tourists who crossed the DMZ when Geumgang Mountain Tourism was run by the South Korean Hyundai-Asan Corporation from 1997 to 2008 were originally from North Korea. Although this tourism did not allow South Koreans to meet their family members in the North, it provided an opportunity for them to set foot again in the North and symbolically revisit their hometowns. For a more detailed account, see Kim, *Illusive Utopia*, 260–77.

15. D. Emily Hicks has noted that one who crosses the border is involved in "deterritorialization"—that is, moving away from his or her own soil—but at the same time is also involved in "'reterritorialization' to the extent that she or he clings to nostalgic images on the other side"; see Hicks, *Border Writing: The Multidimensional Text* (Minneapolis: University of Minnesota Press, 1991), xxxi. Consequently, the process of reterritorialization of the border crosser transforms the semiotics of the new soil to which she or he arrives; through the process of deterritorialization and reterritorialization, these border crossers mitigate and unify the extremely hostile, yet in many ways similar spheres of South and North.

16. Marvin Carlson, *The Haunted Stage: The Theatre as Memory Machine* (Ann Arbor: University of Michigan Press, 2003), 2.

17. Virginia Leary, "Citizenship. Human Rights, and Diversity," in *Citizenship, Diversity, and Pluralism: Canadian and Comparative Perspectives*, ed. Alan C. Cairns, John C. Courtney, Peter MacKinnon, Hans J. Michelmann, and David E. Smith (Toronto: McGill-Queen's Press, 2000), 247–64.

18. Seungsook Moon, *Militarized Modernity and Gendered Citizenship in South Korea* (Durham: Duke University Press, 2005), 175.

19. For a more detailed discussion of the relationship between the North Korean state and its citizens, see Kim, *Illusive Utopia*, 166–259.

20. Article 1, Section 7 of the North Korean Constitution, adopted on December 27, 1972.

21. Article 1, Section 4 of the North Korean Constitution.

22. Article 1, Section 1 of the South Korean Constitution, last amended on October 29, 1987.

23. For instance, *gungmin* was used broadly to describe the Korean people by the Japanese colonial regime, as in *gungmin hakgyo* (elementary school, literally translated as "people's school") or *gungmin chejo* (people's exercise). Recently, the South Korean government wanted to do away with the linguistic vestiges of colonial history and changed *gungmin hakgyo* into *chodeung hakgyo* (literally meaning "elementary school").

24. For a detailed account of how the term *minjok* came into use in the late nineteenth century, see Roy Richard Grinker, *Korea and Its Futures: Unification and the Unfinished War* (New York: St. Martin's Press, 1998), 21–22.

25. Among the prime examples attesting to this scholarly trend are Anne Anlin Cheng's *The Melancholy of Race: Psychoanalysis, Assimilation, and Hidden Grief* (Oxford: Oxford University Press, 2001) and George E. Marcus's *The Sentimental Citizen: Emotion in Democratic Politics* (University Park: Pennsylvania State University Press, 2002).

26. Peter Nyers, "Introduction: Why Citizenship Studies," *Citizenship Studies* 11, no. 1 (February 2007): 2.

27. Elaine Lynn-Ee Ho, "Constituting Citizenship Through the Emotions: Singaporean Transmigrants in London," *Annals of the Association of American Geographers* 99, no. 4 (2009): 789.

28. In regard to the nexus between personal emotions and broader frames of the public realm, sociologist Jack Barbalet noted: "emotions are not simply in individual acts . . . but in social interactions more broadly." Jack Barbalet, "Introduction: Why Emotions Are Crucial," in *Emotions and Sociology*, ed. Jack Barlet (Oxford: Blackwell, 2002), 3.

29. Sanghamitra Misra, *Becoming a Borderland: Space and Identity in Colonial Northeastern India* (New Delhi: Routledge, 2011), 15.

30. Claire Ramussen and Michael Brown, "The Body Politic as Spatial Metaphor," *Citizenship Studies* 9, no. 5 (November 2005): 470.

31. Tracy C. Davis, "Theatricality and Civil Society," in *Theatricality*, ed. Tracy C. Davis and Thomas Postlewait (Cambridge: Cambridge University Press, 2003), 130.

32. As Susan Leigh Foster claimed, sense of body is essential in performance: "Choreography, kinesthesia, and empathy function together to construct corporeality in a given historical and cultural moment." Susan Leigh Foster, *Choreographing Empathy: Kinesthesia in Performance* (London and New York: Routledge, 2011), 13.

33. Ramussen and Brown, "Body Politic as Spatial Metaphor," 471–72.

34. N. Yuval-Davis, "Belonging and the Politics of Belonging," *Patterns of Prejudice* 40, no. 3 (2006): 197–214.

1. IMAGINED BORDER CROSSERS ON STAGE

1. The North Korean documentation of the tenth anniversary of its founding is best evidenced in the commemorative photo album *Joseon minjujuui inmin gonghwaguk 1948–1958* (The Democratic People's Republic of Korea). It consists of five major chapters, focusing on different stages of the country's struggle and achievements: 1. The Struggle for National Liberation; 2. The Establishment of the Korean Workers Party and the Republic and Economic Reconstruction in the Postlibera-

tion Era; 3. The War Period; 4. The Postwar Economic Reconstruction and Its Results; 5. Diplomatic Achievements.

2. South Korea in 1958 staged a political propaganda play in the Municipal Theater, which dramatized President Rhee Syngman's efforts to resist Japanese colonizers prior to the liberation in 1945. There were also events called "Korean nights," aimed at foreigners living in South Korea, showcasing traditional Korean cultural performances.

3. Theodore Hughes, *Freedom's Frontier: Literature and Film in Cold War South Korea* (New York: Columbia University Press, 2011), 92.

4. Jinhee Kim, trans., *Korean Drama Under Japanese Occupation* (Paramus: Homa & Sekey Books, 2004), 21.

5. Hanguk geugyesul hakhoe, ed., *Hanguk hyeondae daepyo huigok seonjip* [*Selected representative dramatic works of contemporary Korea*] (Seoul: Worin, 1999), 2:255.

6. Hanguk geugyesul hakhoe, ed., *Hanguk hyeondae daepyo huigok seonjip*, 2:255.

7. Hanguk geugyesul hakhoe, ed., *Hanguk hyeondae daepyo huigok seonjip*, 2:187.

8. Hanguk geugyesul hakhoe, ed., *Hanguk hyeondae daepyo huigok seonjip*, 2:198.

9. Hanguk geugyesul hakhoe, ed., *Hanguk hyeondae daepyo huigok seonjip*, 2:194–95.

10. Hanguk geugyesul hakhoe, ed., *Hanguk hyeondae daepyo huigok seonjip*, 2:205.

11. Hanguk geugyesul hakhoe, ed., *Hanguk hyeondae daepyo huigok seonjip*, 2:254.

12. Five revolutionary operas (*hyeongmyeong gageuk*) are *Pibada* [Sea of blood, premiered in 1971], *Dang ui chamdoen ttal* [True daughter of the party, premiered in 1971], *Kkotpaneun cheonyeo* [Flower girl, premiered in 1972], *Millim a iyagihara* [Oh, tell the forest, premiered in 1972], and *Geumgangsan ui norae* [Song of Geumgang Mountain, premiered in 1973]. Five revolutionary plays (*heongmyeong yeongeuk*), on the other hand, refers to the cycle of stage plays mostly written and produced in the 1980s: *Seonghwangdang* (1978), *Hyeolbun mangukhoe* [The Hague Peace Conference of Disgrace, 1984], *Ttal egeseo on pyeonji* [Letter from the daughter, 1987], *Samin ildang* [Three people, one party, 1988], and *Gyeongchuk daehoe* [Celebratory assembly, 1988].

13. To date, I have not found much information about how the production and circulation of dramas were regulated in North Korea in the 1950s. Theater historian Yi Gang-ryeol notes that in the early 1950s North Korean theater saw the emergence of diverse genres and themes, such as emphasis on comedies and the heroic accomplishments of ordinary people. "North Korean Theater: 1930s to 1960s," in Kim Munhwan, ed., *Bukhan ui yesul* [Art in North Korea] (Seoul: Eulyoo Munhwasa, 1990), 298. We can also infer from the plays published in 1950s North Korea that censorship was much more relaxed than in the following decades. For instance, many amateur journals featuring works by cooperative farm workers, such as *Sseokeulwon*, published short dramas charged with romantic and erotic possibilities among farm workers—a theme that does not come across in the dramas of later years. For more detailed analysis of amateur dramatic works of the 1950s, see Suk-Young Kim, *Illusive Utopia: Theater, Film, and Everyday Performance in North Korea* (Ann Arbor: University of Michigan Press, 2010), 113–15.

14. Louis Althusser, *Lenin and Philosophy and Other Essays*, trans. Ben Brewster (London: New Left Books, 1971), 165.

15. In Japan he was introduced to the so-called *Sprechchor* (a compound of *sprechen* and *chor*, which roughly translates into "chorus of voices"), a theatrical technique developed in Germany in the 1920s. Sin played an active role in introducing the technique to Korea in an article, "*Sprechchor*: A New Form in Theater," published in *Chosun Ilbo* on March 5, 1932. In this article Sin defined *sprechchor* as "the chorus of words." Kim Mido, *Hanguk geundaegeuk ui jaejomyeong* [Rethinking modern Korean drama] (Seoul: Hyeondae Mihaksa, 1995), 212. Those who belonged to the proletarian theater movement welcomed the new technique, but others, especially the members of the Dramatic Art Research Group (*Geugyesul yeonguhoe*), criticized the term for its mechanical translation and the imposition of such foreign dramatic devices onto Korean dramatic tradition. Hanguk geugyesul hakhoe, ed., *Hanguk hyeondae daepyo huigok seonjip*, 1:202.

16. Act 1 consists of six scenes and features the events that take place from 1945 to 1950; act 2 consists of nine scenes and covers three years of the Korean War, from 1950 to 1953; act 3 consists of five scenes and stages the postwar reconstruction efforts in North Korea.

17. Sin Go-song, "Ten Years: Heroic Chronicle" [in Korean], *Joseon Yesul* 9 (1958): 24.

18. Based on my reading of North Korean periodicals, I was not able to confirm that the play was actually produced in the theater.

19. Sin Go-song, "Ten Years," 25.

20. Sin Go-song, "Ten Years," 25.

21. From the contemporary perspective, it is rather refreshing to see that the Soviet Army, not Kim Il-sung, is identified as the liberator of the Korean people.

22. Following the aforementioned narration, Hyeoncheol comes on stage and tells his mother that he has been working all day spreading political propaganda for the Communist Party. When his mother doubts his ability to give speeches in public, he retorts: "Mother, you are underestimating us. Do you think that junior high school students do not know how to talk about the historic significance of land reform?"

23. Sin Go-song, "Ten Years," 46.

24. Sin Go-song, "Ten Years," 48.

25. Sin Go-song, "Ten Years," 33.

26. Sin Go-song, "Ten Years," 33.

27. Kim, *Illusive Utopia*, 114–15.

28. Theodore Hughes, "The Remembered War: Violence, Trauma, Division in Korea" (unpublished manuscript). Cited with permission from the author.

29. Sin Go-song, "Ten Years," 43.

30. Yi Gang-ryeol, "North Korean Theater: 1930s to 1960s," 306.

2. DIVIDED SCREEN, DIVIDED PATHS

1. According to Cumings, the term refers to "self-reliance and independence in politics, economics, defense, and ideology; it first emerged in 1955 as Pyongyang drew away from Moscow, and then appeared full-blown in the mid-sixties as Kim sought a stance independent of both Moscow and Beijing." *Korea's Place in the Sun: A*

Modern History (New York: Norton, 1997), 403. In reality, *juche* came to stand for everything that North Koreans regard as indigenous to the nation and served as an ideological metaphor for North Korea's pure Korean essence vis-à-vis South Korea's tainted national purity marred by the imperial presence of the American military.

2. For more detail on the *Yushin* system, see Cumings, *Korea's Place in the Sun*, 356–63.

3. Even four decades after the tunnels were discovered, North Korea still accuses South Korea of using them to spoil the inter-Korean relationship and elevate tensions in the peninsula. See Sim Cheolyoung, "Bangonghwaguk dobaleun buknamgwangyeui sihantan" [Anti-North Korean provocation is like an explosive to inter-Korean relations], *Rodong Sinmun*, June 7, 2011.

4. Hanguk jeongsin munhwa yeonguwon, *Hanguksa yeonpyo* [Chronicles of Korean history] (Seoul: Dongbang Media, 2004), 676.

5. On August 28, 1974, Kim Yongju, the head of the North Korean side of the Inter-Korean Committee, declared that North Korea would halt dialogues with South Korea in a defiant protest of South Korea's persecution of its dissident Kim Dae-Jung. Kim was living in exile in Tokyo in the early 1970s, but on August 8, 1973, he was kidnapped by South Korean intelligence agents and forcibly brought back to South Korea for trial and imprisonment. For a full declaration by Kim Yongju, see Sindonga editorial board, *North Korea Through Primary Sources, 1945–1998* (Seoul: Donga chulpansa, 1989), 299–302.

6. Sindonga editorial board, *North Korea Through Primary Sources, 1945–1998*, 225.

7. Kim Jongwon and Jeong Jungheon, *A Hundred Years of South Korean Cinema History* [in Korean] (Seoul: Hyeonamsa, 2001), 260.

8. "Filmmakers Documentary Series: Park Sang-ho," a special feature in *The DMZ* DVD, directed by Park Sang-chan (Seoul: Korean Film Archive, 2010).

9. Ibid.

10. Unless otherwise noted, the English translation is taken verbatim from the subtitles of the 1965 film released in DVD format by The Korean Film Archive in 2010.

11. The parallel between *The DMZ* and *Forbidden Games* was pointed out as early as 1965, when the former was released. For instance, the *Donga Ilbo* film critic noted that the "the film evokes the fable-like ambiance of René Clément's *Forbidden Games*." *Donga Ilbo*, December 15, 1965, 4.

12. This translation is taken verbatim from the subtitles of the film, with the exception of "Oh Heavens" in the last two lines (the original translation in the subtitle used "God" instead).

13. *Chosun Ilbo*, December 10, 1965, 4.

14. Sindonga editorial board, *North Korea Through Primary Sources, 1945–1998*, 225.

15. Jisha Menon's work on the dramatic representations of the India–Pakistan partition showcases a similar trope of doubles and twins. See *The Performance of Nationalism* (Cambridge: Cambridge University Press, 2013).

3. Twice Crossing and the Price of Emotional Citizenship

1. Hanguk jeongsin munhwa yeonguwon, *Hanguksa yeonpyo* [Chronicles of Korean history] (Seoul: Dongbang Media, 2004), 700.

2. *Kukmin Ilbo*, January 1, 1990.

3. *Seoul Sinmun*, January 4, 1990.

4. *Hankook Ilbo*, January 5, 1990.

5. It was founded in London in 1945, and the first festival was hosted by Czechoslovakia in July 1947.

6. South Korean policy toward North Korea took a dramatic turn with the introduction of the so-called Sunshine Policy in 1998, in which South Korea actively took the lead in initiating friendly relations between the two Koreas and embracing the North instead of isolating it. Taking its concept from Aesop's fable about a contest between wind and sunshine to make a traveler voluntarily remove his coat, the new policy advocated open dialogue instead of military conflict, mutual understanding instead of mutual accusation.

7. Namhee Lee, "The South Korean Student Movement: Undongkwon as a Counterpublic Sphere," in *Korean Society: Civil Society, Democracy and the State*, 2nd ed., ed. Charles K. Armstrong (New York: Routledge, 2007), 95.

8. See note 2 in the introduction.

9. According to the initial verdict by the South Korean Supreme Court in 1990, Lim was sentenced to fifteen years of imprisonment and suspension of rights. Later the sentence was commuted to five years of imprisonment and suspension of rights. Lim was released in 1992 after a special parole and was rehabilitated in 1999.

10. Although a few female family members of national leaders, such as Gang Banseok (Kim Il-sung's mother) and Kim Jeongsuk (Kim Jong-il's mother), have been canonized, Kim Il-sung, and to a lesser extent, Kim Jong-il are the central figures in defining heroism in North Korea.

11. Jae-gon Hwang, "Gungnip yeonghwa charyeongso ga georeo on gil" [Short history of the National Film Studio], *Joseon Yesul* 9 (1956): 76–79.

12. Arjun Appadurai, "Grassroots Globalization and the Research Imagination," *Public Culture* 12, no. 1 (2000): 7.

13. For detailed background on the 1974 joint declaration, see the introduction to chapter 2.

14. For a more detailed account of how North Korean women's femininity is congealed in the dress code, see Suk-Young Kim, "Dressed to Kill: Women's Fashion and Body Politics in North Korea," *positions: east asia cultures critique* 19, no. 1 (2011): 159–92.

15. The video documents Lim's visit to Kim Il-sung University, Pyongyang Film Institute, Kim Chaek Polytechnical Institute, and Kim Hyong-jik Pedagogical Institute.

16. For a detailed analysis of how the train figures as the agent of reunification, see chapter 4.

17. Upon learning that Lim is a Catholic, the Union of Catholic Priests in Search of Social Justice (Jeongui guhyeon jeongguk sajedan) in South Korea decided to dispatch Father Mun Gyuhyeon to North Korea to protect her and accompany her back to South Korea via the DMZ. Mun flew to North Korea and arrived in Pyongyang on July 25, 1989. This episode shows that the South Korean supporters of Lim also took a paternalistic approach by "protecting" her throughout the journey.

18. Ju Seongha, "Forbidden Seeds That Lim Su-kyung Sowed in North Korea" [in Korean], *DongA.com*, July 1, 2009, http://blog.donga.com/nambukstory/archives/259.

19. For a detailed account of women figures in North Korean cultural tradition, see Kim, *Illusive Utopia*, 205–59.

20. Lim resurfaced in the South Korean media in July 2005 when her nine-year-old son was drowned in Cebu, Philippines, while attending an English summer school. Some South Koreans posted hostile replies to the news report on the conservative right-wing media outlet Chosun.com, stating that Lim deserved this accident for serving as North Korea's propagandistic tool. This resulted in the South Korean police's investigation of twenty-five web users, including a professor, bankers, and business managers, who were predominantly males in their forties; fifteen of them were sentenced to pay a small fine for defamation. The incident testifies to the fact that some South Koreans still hold a very strong sentiment against Lim's visit to North Korea.

21. Jo Jeongjin. "I Defected Because of Lim Su-kyung" [in Korean], *Segye.com*, October 10, 2005, http://blog.segye.com/jjjo101/10382.

22. Ju, "Forbidden Seeds That Lim Su-kyung Sowed in North Korea."

23. Yi Hyeonseok and Kim Seok, "Lim Su-kyung and Hwang Seokyeong Visit North Korea" [in Korean], *Munhwa Ilbo*, August 15, 2001, http://m.munhwa.com/mnews/view.html?no=2001081501030123307002. For a more detailed report on Lim's second visit to Pyongyang in 2001, see: http://cafe452.daum.net/_c21_/bbs_search_read?grpid=1BD4X&fldid=8hdF&contentval=0000Wzzzzzzzzzzzzzzzzzzzzzzzzz&nenc=gKvHNhWfxyVXWunWb19owQoo&fenc=RwpwxNSBuBUo&q=&nil_profile=cafetop&nil_menu=sch_updw (accessed August 8, 2011).

24. Go Jongseok, "Lim Su-kyung," *Hankook Ilbo*, June 22, 2009, http://news.naver.com/main/read.nhn?mode=LSD&mid=sec&sid1=103&oid=038&aid=0002016092.

25. An Byeonguk, "Baek Jiyeon's Interview with Euna Lee" [in Korean], *Hangang Times*, August 5, 2011, http://www.hg-times.com/news/articleView.html?idxno=29650.

26. The translation is directly quoted from the DVD.

27. On different styles of documentary filmmaking and the filmmaker's varying degrees of involvement with the film subject, John Corner suggests that "reactive observationalism operates as the most apparently unmediated recording of actual footage, while proactive observationalism includes a higher degree of choice in what is actually recorded." Jill Nelmes, ed., *An Introduction to Film Studies*, 2nd ed. (London and New York: Routledge, 1999), 214. If we were to place North Korean documentary films along this passive-to-active spectrum of cinematic intervention with the events filmed, North Korean films would be far off the chart that extends the axis of proactive observationalism into messianic interventionism. To borrow Bill Nicholes's expression, North Korean documentary films are created undisputedly in the *"didactic, voice-of God style."* Bill Nicholes, "The Voice of Documentary," in *Movies and Methods*, vol. 2, ed. Bill Nicholes (Berkeley and Los Angeles: University of California Press, 1985), 258. The conventional assumption that documentary films are faithful to reality is subject to critical interrogation, but

it has been revised in North Korea to the degree that documentary films served as a model for making (not faking) reality rather than merely reflecting what has already occurred.

28. I am grateful to Clark Sorensen for pointing out that there is a much larger tendency in South Korea to use kinship terms, such as "grandpas" in this film, to address a disenfranchised social group. For example, elderly comfort women in South Korea are often addressed as "grandmas" in popular media.

29. On July 4, 1972, Kim Il-sung met the head of the South Korean Central Information Agency, Lee Hu-rak, who was dispatched to Pyongyang by the then South Korean President Park Chung-hee to discuss ways of peaceful reunification. The meeting resulted in the Joint Declaration confirming the three principles for Korean reunification, as described in chapter 2. Although the Joint Declaration came as the two Koreas' response to the improvement in U.S.–China relations initiated by President Nixon's visit to China in 1972, in subsequent years, it was appropriated by both sides to strengthen their respective regimes.

30. Claire Ramussen and Michael Brown, "Body Politic as Spatial Metaphor," *Citizenship Studies* 9, no. 5 (November 2005): 470.

31. George Marcus, *The Sentimental Citizen: Emotion in Democratic Politics* (University Park: Pennsylvania State University Press, 2002), 5.

32. Marcus, *Sentimental Citizen*, 7.

33. For more on "intimate publics," see Lauren Berlant, *The Queen of America Goes to Washington City: Essays on Sex and Citizenship* (Durham and London: Duke University Press, 1997); "Intimacy: A Special Issue," *Critical Inquiry* 24, no. 2 (Winter 1998): 281–88.

34. Lauren Berlant, *Female Complaint: The Unfinished Business of Sentimentality in American Culture* (Durham: Duke University Press, 2008), x.

35. Paik Nak-chung, "The Ecological Imagination in Overcoming the Division System," an abbreviated English version of a presentation in Korean at the FRONT DMZ international conference, August 11, 1995, Seoul, Korea.

4. Borders on Display: Museum Exhibitions

1. On February 13, 2013, North Korean state media announced that the North had conducted underground nuclear tests under the leadership of Kim Jung-un, much to the dismay and protests of the international community.

2. For a detailed account of this crisis, see Victor Cha and David Kang, *Nuclear North Korea: A Debate on Engagement Strategies* (New York: Columbia University Press, 2003).

3. Jeon Seongho and Li Chunseong, "Yugiro gyeongnyu yeo tongil ero nodochira" [Let the spirit of the Joint Communique soar up to unification], *Rodong Sinmun*, June 14, 2010.

4. Cheo Cheolsun, "Ginjangsangtae reul gyeokhwasikineun mumohan dobal" [Reckless provocation to worsen tensions in Korea], *Rodong Sinmun*, November 27, 2012.

5. La Seolha, "Angnalhage gamhaengdoeneun bangonghwaguk simnimoryakjeon" [Vicious psychological war against the DPRK], *Rodong Sinmun*, June 17, 2011.

6. Seo Seunguk, "MB 'Jeonjaeng eul duryeowo haeseon jeonjaeng mageul su eo-pda'" [President Lee Myung-bak says one cannot stop war if one is afraid of war], *Joinsmsn.com*, http://article.joinsmsn.com/news/article/article.asp?ctg=10&Total_ID=4848931 (accessed December 17, 2012).

7. Often called the "inventor of video art," Nam June Paik is known for many ground-breaking art installations and performance pieces that incorporate television screens and video technology. His most representative works include *TV Bra for Living Sculpture* (1969), *TV Garden* (1974), *Something Pacific* (1986), and *Electronic Highway: Continental US, Alaska, Hawaii* (1995). For more information on Paik, see Jim Lewis, "Nam June Paik: The Man Who Invented Video Art," *Slate* (February 2, 2006), http://www.slate.com/id/2135349/ (accessed August 1, 2011).

8. Phelan notes that "when writing about the disaster of death it is easy to substitute interpretation for traumas. In that substitution, the trauma is tamed by the interpretative frame and peeled away from the raw 'unthought' energy of the body"; see Peggy Phelan, *Mourning Sex: Performing Public Memories* (New York: Routledge, 1997), 17.

9. Elaine Scarry, *The Body in Pain: The Making and Unmaking of the World* (New York: Oxford University Press, 1985), 4.

10. Paul Virilio, *War and Cinema: The Logistics of Perception*, trans. Patrick Camiller (London: Verso, 1989), 20.

11. Rey Chow, "The Age of the World Target," in *America's Wars in Asia: A Cultural Approach to History and Memory*, ed. Philip West, Steven I. Levine, and Jackie Hilts (New York: M. E. Sharpe, 1998), 208.

12. An earlier version of this section was published as an article entitled "Staging the Cartography of Paradox: The DMZ Special Exhibition at the Korean War Memorial, Seoul," *Theatre Journal* 63 (2011): 381–402.

13. Both plays feature a similar propagandistic story of a man who journeys along the path offered by the communist system in the North and that of the democratic system in the South. The protagonist eventually realizes the fallacy and evil of the former and attempts to settle in the latter.

14. James Der Derian's term was inspired by U.S. President Dwight Eisenhower's term "military-industrial complex," which he introduced in his farewell address on January 17, 1961. The former general warned of "an immense military establishment and a large arms industry," adding that "we must guard against the acquisition of unwarranted influence, whether sought or unsought, by the military-industrial complex." See Norman Solomon, "The Military-Industrial-Media Complex," *Fair.org*, http://fair.org/extra-online-articles/the-military-industrial-media-complex/ (accessed March 25, 2011).

Der Derian takes it one step further by marrying Eisenhower's term with the postmodern disillusionment with media and technology. For a more detailed theoretical context of the MIME-NET, see James Der Derian, *Virtuous War: Mapping the Military-Industrial Media-Entertainment Network*, 2nd ed. (New York: Routledge, 2009), 83–84.

15. Rachel Adams, *Sideshow U.S.A.: Freaks and the American Cultural Imagination* (Chicago: University of Chicago Press, 2001), 127.

16. It is worth noting that an image of then U.S. President Harry Truman, who was equally responsible for the partition of country and the Korean War, is not included. Such an absence clearly underlines the ideological, anticommunist stance of the exhibit's curators.

17. The narrator in the documentary states in a grave voice: "The war annihilated four million local Koreans, which was nearly 20 percent of the population. The recovery from war was nothing short of a miracle, but it is turning into a historical memory for most Koreans nowadays, since only 10 percent of the current South Korean population have experienced the war personally."

18. Chow, "Age of the World Target," 205.

19. Diana Taylor, *Disappearing Acts: Spectacles of Gender and Nationalism in Argentina's Dirty War* (Durham: Duke University Press, 1997), 124.

20. Virilio, *War and Cinema*, 6.

21. Steven C. Dubin, *Displays of Power: Memory and Amnesia in the American Museum* (New York: New York University Press, 1999), 3.

22. Walter Benjamin, "Theories of German Fascism: On the Collection of Essays 'War and Warrior,' Edited by Ernst Jünger," *New German Critique* 17, Special Walter Benjamin Issue (1979): 120.

23. There are many South Korean cultural productions that condemn the North for violating human rights, the musical *Yoduk Story* and the film *Crossing* being arguably the most well known. For a more detailed analysis of the musical, see Suk-Young Kim, "Gulag, the Musical: Performing Trauma in North Korea Through *Yoduk Story*," *TDR: The Drama Review* 52, no. 1 (2008): 118–35. *Crossing* is a 2008 film based on the real-life predicament of North Korean political refugees and economic migrants in China. The film focuses on the story of a father who leaves North Korea in search of food for his family. His eleven-year-old son follows him, only to be permanently separated from the rest of the family.

24. David McCann, "Our Forgotten War: The Korean War in Korean and American Popular Culture," in *America's Wars in Asia*, ed. West, Levine, and Hilts, 65.

25. Jean Baudrillard, *Simulacra and Simulation*, trans. Sheila Faria Glaser (Ann Arbor: University of Michigan Press, 1994), 1.

26. Michel de Certeau, *The Writing of History*, trans. Tom Conley (New York: Columbia University Press, 1988), 64.

27. Walter Benjamin, "The Work of Art in the Age of Its Technological Reproducibility," in *The Work of Art in the Age of Its Technological Reproducibility and Other Writings on Media*, ed. Michael W. Jennings, Brigid Doherty, and Thomas Y. Levin (Cambridge, Mass.: Belknap Press, 2008), 41.

28. Hwang Bong Hyok and Kim Jong Ryol, *DPR Korea Tour* (Pyongyang: Tourist Advertisement Agency, 2002), 62.

29. For an analysis of the museum exhibition, I rely on various web sources, particularly Brian McMorrow's photos posted on http://upload.pbase.com/bmcmorrow /pyongyangmuseum. I am also grateful to Tessa Morris-Suzuki, Leonid Petrov, and other anonymous visitors for sharing their impressions of the museum.

30. Although it is difficult to find any prominent discussions of the DMZ in North Korean literature and media, one can glean from the significant lack that the

DMZ is not a central focus of North Korean national pride, unlike Pyongyang or Baekdu Mountain, which are often glorified as part of the sacred landscape in North Korean revolutionary history. For a more detailed semiotic analysis of national space in North Korea, see chapter 2 in Suk-Young Kim, *Illusive Utopia: Theater, Film, and Everyday Performance in North Korea* (Ann Arbor: University of Michigan Press, 2010).

31. Chris Springer, *Pyongyang: The Hidden History of the North Korean Capital* (Budapest: Entente Bt, 2003), 130.

32. "North Korea Museums: The Victorious Fatherland Liberation War Museum," *KTG: DPRK Tours & Information*, http://www.north-korea-travel.com/north-korea-museums.html.

5. NATION AND NATURE BEYOND THE BORDERLAND

1. A left-wing newspaper, *Hankyoreh*, editorial on May 17, 2010, deplored that the South Korean government had effectively halted all its efforts to pursue cooperative projects with North Korea and also pressured private companies with investments in North Korea to follow suit. Moreover, the South Korean government not only halted food and fertilizer aid but also prevented the private sector from sending any North Korean aid. According to this editorial, the South Korean government spent only 10 percent of its inter-Korean cooperation funds in 2009, whereas during the Sunshine Policy, 70 to 80 percent of the funds were spent on inter-Korean projects. http://www.hani.co.kr/arti/opinion/editorial/421190.html.

2. Editorial by the Tourist Attraction Development Office, "We can never condone the criminal stance against the reopening of tourism in Geumgang Mountain and Gaeseong" [in Korean], *Rodong Sinmun*, March 20, 2010.

3. Song Yeongseok, *Rodong Sinmun*, November 26, 2012.

4. Kim Doyun, "Gyeonggi Province Assembly to Increase Budget for the Sixtieth Anniversary of the DMZ by 700 Million Won, Increasing the Total Budget to1.8 Billion Won" [in Korean], *Yonhap News*, November 26, 2012, http://www.yonhapnews.co.kr/bulletin/2012/11/26/0200000000AKR20121126153000060.HTML?did=1179mhttp://www.yonhapnews.co.kr/bulletin/2012/11/26/0200000000AKR2012112615300060.HTML?did=1179m.

5. Yang Seungjin, "Goseong, Gangwon Province, Where Nature and Men Become One" [in Korean], *Asia Today*, January 3, 2013, http://www.asiatoday.co.kr/news/view.asp?seq=748975.

6. Following the cease-fire in 1953, the Civilian Control Line was set adjacent to the South Korean DMZ area in order to limit civilian access. "In February, 1954, the eighth Army Commander of the U.S. Army established by virtue of his authority an agricultural limitation line by which civilian farming was regulated in order to protect military operations and facilities and for security purposes in the hostile area adjacent to the southern demarcation line of DMZ; it was renamed the civilian control line in June, 1958, when the Korean troops were put in charge of defending the armistice line. This area, lying 5 to 20 kilometers from the southernmost demarcation line, covers a total of 1,528 km² (480 km² for Gyeonggi Province and 1,048

km² for Gangwon Province) and is called Northern District, north of the civilian control line." http://www.korea-dmz.com/en/s/sm/ssm_01_en.asp (accessed May 29, 2012).

7. "PEEP Your DMZ" is the motto used on the official website of Imjingak. PEEP stands for "primary echo experience program." http://peace.ggtour.or.kr/peep-your-dmz.

8. Dean MacCannell, "Tourist Agency," *Tourist Studies* 1 (2001): 31.

9. Kkmankong, "6onyeon heunjeogeul ganjikhan jangdanyeok jeungi gikwancha" [Steam engine at the Jangdan Station embodies traces of six decades], Donghaeng geurigo gong-gam [Accompaniment and confluence, blog], July 5, 2010, http://blog .daum.net/shko1015/7289724.

10. Maxine Feifer, *Going Places: The Ways of the Tourist from Imperial Rome to the Present Day* (London: MacMillan, 1985), 2.

11. Laurie Beth Clark, "Always Already Again: Trauma Tourism and the Politics of Memory Culture," *Encounters* 1 (2010): 65–66.

12. Robert Oppenheim, "Crafting the Consumability of Place: Tapsa and Paenang Yoheang as Travel Goods," in *Consuming Korean Tradition in Early and Late Modernity: Commodification, Tourism, and Performance*, ed. Lauren Kendall (Honolulu: University of Hawai'i Press, 2011), 105.

13. The website for Paju municipal government, http://tour.paju.go.kr/tour/community /postscr/userBbs/bbsView.do?bbs_cd_n=2&bbs_seq_n=11828¤tPage= (accessed May 15, 2011).

14. South Korean policy took a dramatic turn with the introduction of the so-called Sunshine Policy in 1997, in which South Korea actively took the lead in initiating friendly relations and embracing the North instead of isolating it. Taking its name from Aesop's fable about a contest between wind and sunshine to make a traveler voluntarily remove his coat, the new policy advocated open dialogue instead of military conflict, mutual understanding instead of mutual accusation. Former South Korean president Kim Dae-jung, who has been an ardent advocate of the policy, credited the flexibility of the Clinton administration in resolving the 1993 nuclear crisis in North Korea by inviting North Korea to sign the Non-Proliferation Treaty in Geneva in 1994 and thereby realizing the Sunshine Policy. Dae-jung Kim, *Korea and Asia* (Seoul: The Kim Dae-jung Peace Foundation Press, 1994), 36–38. During his presidency (1998–2003), Kim Dae-jung consistently committed himself to the nonhostile approach, in the process of which he went so far as to send secret funds to the North Korean leader Kim Jong-il, which presumably facilitated the summit meeting between the leaders in June 2000. The scandal involving the secret funding erupted at the moment his tenure ended, marring the significant step taken forward in the relationship between the two Koreas as well as defaming Kim Dae-jung's receipt of the 2001 Nobel Peace Prize for his contribution to bringing peace to the Korean Peninsula. Nevertheless, the impact of changes that the Sunshine Policy brought to South Korean society was too significant to be overlooked.

15. Stephen Epstein, "The Axis of Vaudeville: Images of North Korea in South Korean Pop Culture," *Japanfocus.org*, http://japanfocus.org/-Stephen-Epstein/3081.

16. Henri Bergson, "Laughter," in *Comedy*, ed. Wylie Sypher (Baltimore and London: The Johns Hopkins University Press, 1956), 74.

17. Juhn Urry, *The Tourist Gaze*, 2nd ed. (London: Sage, 2002), 1–2.

18. Joseph Roach, *Cities of the Dead: Circum-Atlantic Performance* (New York: Columbia University Press, 1996), 82.

19. Philip Crang, "Performing the Tourist Product," in *Touring Cultures: Transformations of Travel and Theory*, ed. Chris Rojek and John Urry (London and New York: Routledge, 2002), 138.

20. In most tour pamphlets for visitors, Panmunjeom requires a strict dress code that prohibits disrespectful bodily presentation, whereas Imjingak does not have any restrictions. "Panmunjeom Tour Regulations" stipulates the following rules:
 —You must carry your passport on tour day.
 —When you arrive at the conference room, do not touch any equipment such as microphones or flags belonging to the Communist side.
 —Do not speak with, make any gesture toward, or in any way approach or respond to personnel from the other side.
 —Sometimes military or other official considerations prevent entry into the joint security area.
 —Casual clothes such as ripped jeans, sleeveless shirts, miniskirts, short pants, military clothes, and sandals (slippers) are not permitted in the tour area.
 —Shaggy or unkempt hair is not allowed either.
 —Children under ten years of age are not allowed.
 —According to the military situation, the tour can be canceled without notice.
 —According to the USKF regulation, there is a nationality limit.
 —If you cancel on the tour day, 100 [percent] of the tour fee will be charged.
 (DMZ Panmunjeon tour guide pamphlet by Seoul City Tour Co., LTD.)

21. Song Taehyeong, "Shinsegae Paju Outlet 3cheungkkaji 165gae Brand Ppaegok" [Shinsegae Paju Outlet's three-story structure is packed to the gills with 165 brand stores], *Hankyung.com*, http://www.hankyung.com/news/app/newsview.php?aid=2011031761171 (accessed May 4, 2012).

22. The concrete resolutions read: "1. It is the duty of everyone—the nation, various organizations, and the people—to love nature and protect the environment. 2. Beautiful nature and natural resources bearing significant cultural and academic value should be conserved for mankind. 3. Every household, school, and society should educate its members to conserve nature. 4. Natural conservation should take precedence over development. Developmental projects should be carefully pursued in a way that they create harmony with nature. 5. Destruction of nature due to excessive waste and overuse of chemicals should be prohibited. 6. Damaged environments should immediately be restored. 7. Every citizen should maintain a clean environment around them and strive to cultivate lush and beautiful land."

23. "About the DMZ Forum," The DMZ Forum.org, http://www.dmzforum.org/aboutus/about_dmzforum.php.

24. Don Oberdorfer, *Two Koreas: A Contemporary History* (Indianapolis: Basic Books, 1997), 1.

25. Monica Grass, "Vom Eisernen Vorhang zum Grünen Band" [From Iron Curtain to Green Band], *SWR*, http://www.swr.de/swr2/programm/sendungen/leben

/rueckschau/eiserner-vorhang-gruenes-band/-/id=660144/nid=660144/did=8847 032/17zdvsc/ (accessed November 19, 2012).

26. Yi Hae-yong, *DMZ Stories* [in Korean] (Seoul: Nunbit, 2008), 155.

27. Ahn Byungmin, "Reconnection of Railroads Linking the Two Koreas," *Korea Focus* (March–April 1999): 48–49.

28. On April 26, 2002, the North Korean government launched the Arirang Festival to celebrate the 90th birthday of its founding father Kim Il-sung. The festival was conceived as an unprecedented large-scale presentation aimed at staging a breathtaking history of North Korea, from its prenatal struggle for independence to its utopian future. Since its premiere in 2002, the North Korea government has presented an updated version every year. For a more detailed description of the Arirang Festival, see Suk-Young Kim, *Illusive Utopia: Theater, Film, and Everyday Performance in North Korea* (Ann Arbor: University of Michigan Press, 2010), 277–93.

29. Associated Press, "Trains Make Historic Run Across Korean DMZ," NBCNews. com, http://www.msnbc.msn.com/id/18711246/ (accessed March 14, 2009).

30. The interviewee requested anonymity. Interviewed on May 22, 2007, Washington, D.C.

31. I would like to thank Semi Oh and Viren Murthy for their insights on how Imjingak differs from other DMZ tourist sites in South Korea.

32. The peaceful perception of Imjingak was shattered in October 2012 when the League for Democracy in North Korea (Bukhan minjuhwa chujin yeonhaphoe), a nonprofit community organized by a group of North Korean defectors who have settled in South Korea, declared that they would send to North Korea pamphlets criticizing its leadership succession by a balloon from the Altar for Remembering Lost Homelands in Imjingak. The North Korean state responded immediately on October 19, 2012, that in the event the pamphlets were to be sent, they would launch attacks on Imjingak. Given the potential for military attacks, on October 22, 2012, the South Korean government prohibited civilian entry to Imjingak until the situation settled. This is a rare incident where Imjingak became a site of escalating inter-Korean tension rather than a symbol of inter-Korean kinship and peaceful reconciliation.

33. Clark, "Always Already Again," 67.

34. The Geumgang Mountain tour was launched as a joint venture between the North Korean government and the South Korean Hyundai-Asan Corporation when inter-Korean relations ameliorated in the late 1990s. More than one million South Korean civilians were able to visit the North side of the DMZ, but the area they could visit was limited to a special tourist zone mainly featuring scenic views of the Geumgang Mountains and the eastern shoreline. Contact with the North Korean people was strictly limited to well-trained tour guides who carefully monitored every move of the South Korean tourists. The venture lasted only a decade, coming to a close in 2008 with the deteriorating inter-Korean relationship. For a more detailed account of this tourism project, see Kim, *Illusive Utopia*, chap. 5.

35. The term "cross-border tourism" is frequently used by many scholars and tourist organizations to designate tourist activities that are enabled by crossing a state or regional border. For instance, Mexican scholars Tomás J. Cuevas-Contreras and

Isabel Zizaldra-Hernández use the term "cross-border tourism network" to describe invigorating regional borderland tourism by involving a broader social network and alliances to enable a vibrant flow of tourists between El Paso, Texas, USA, and Ciudad Juárez, Mexico. http://www.esade.edu/cedit/pdfs/papers/pdf4.pdf.

36. Andrew F. Wood succinctly summarizes the quintessential features of post-tourism: "For the post-tourist, ambivalence serves as a reminder: 'Don't get too excited. This is not real.' Performing ambivalence calls for a certain detached cool, a gaze that does not linger too lengthily upon once site or another, a knowing smile that does not exude joy but rather a sense of irony." "'What Happens [in Vegas]': Performing the Post-Tourist Flaneur in 'New York' and 'Paris,'" *Text and Performance Quarterly* 25, no. 4 (2005): 322.

37. Kim, *Illusive Utopia*, 266.

38. Beijing-based Koryo Tour, U.S.-based Asia-Pacific Travel, and Spain-based KTG are the most visible companies bringing Western tourists to the North Korean side of the DMZ, whereas there are many more agencies catering to foreigners hoping to visit the DMZ from the South Korean side.

39. SAYA, "Projects," http://www.sayarch.com/category/projects/.

40. "North Korean Explaining the Armistice (DPRK)," YouTube video, 3:37, posted by "nilov71," August 25, 2012, http://www.youtube.com/watch?v=oeNDtdXgXqM&feature=plcp.

41. Such a comparative lack of claims of victory and political tension makes foreigners' visits to the North side of the DMZ less tense than visiting from the South side through a USO tour. Participants on the tour of the DMZ from both sides claim that visiting the North Korean side was a "relaxing" experience (Hazel Smith) and that the DMZ museum is practically empty (Leonid Petrov). David Field mentioned that visitors to the DMZ from South Korea are bound to feel that they are entering a danger zone, whereas visiting from the North side is more relaxed.

42. Associated Press, "U.S. Envoys Return from North Korea with Remains of 6 American Soldiers from the Korean War," *FOXNews.com*, April 11, 2007, http://www.foxnews.com/story/0,2933,265186,00.html.

43. Kim Cheolhwan, "Sorrowful Memories of Those Who Perished in North Korea" [in Korean], *Gukbang Ilbo*, May 21, 2012, http://www.mnd.go.kr/mndMedia/mndNew/mndNew_1/20120521/1_-19425.jsp?topMenuNo=1&leftNum=17.

44. Hyojadong Chunbali, "Gukgun yuhae songhwan" [Repatriation of South Korean soldiers' remains, blog], May 27, 2012, http://blog.daum.net/lcs5801/8739364.

45. Woo Yeongsik, "Yeoksa ui irony Paju 'Jeokgunmyoji' reul gada," *Yonhap News*, http://www.yonhapnews.co.kr/bulletin/2011/06/17/0200000000AKR20110617049200060.HTML (accessed November 13, 2012).

46. Associated Press, "South Korea's 'Enemy Cemetery' Neglected," SFGate.com, July 26, 2012, http://www.sfgate.com/world/article/South-Korea-s-enemy-cemetery-neglected-3739433.php#photo-3245112.

47. Ibid.

WORKS CITED

Adams, Rachel. *Sideshow U.S.A.: Freaks and the American Cultural Imagination.* Chicago: University of Chicago Press, 2001.

Ahn, Byung-min. "Reconnection of Railroads Linking the Two Koreas." *Korea Focus* (March-April 1999): 38–52.

Althusser, Louis. *Lenin and Philosophy and Other Essays.* Trans. Ben Brewster. London: New Left Books, 1971.

An, Byeong-uk. "Baek Ji-yeon, buk eongnyu Euna Lee interview 'tongil ui kkot Lim Su-kyung aneunya?'" [Baek Ji-yeon's interview with Euna Lee]. *Hangang Times,* August 5, 2011.

Andreas, Peter. *Border Games: Policing the U.S.–Mexico Divide.* Ithaca: Cornell University Press, 2009.

Appadurai, Arjun. "Grassroots Globalization and the Research Imagination." *Public Culture* 12, no. 1 (2000): 1–19.

Barbalet, Jack. "Introduction: Why Emotions Are Crucial." In *Emotions and Sociology,* ed. Jack Barbalet, 1–9. Oxford: Blackwell, 2002.

Baudrillard, Jean. *Simulacra and Simulation.* Trans. Sheila Faria Glaser. Ann Arbor: University of Michigan Press, 1994.

Benjamin, Walter. "Theories of German Fascism: On the Collection of Essays 'War and Warrior,' Edited by Ernst Jünger." *New German Critique* 17, Special Walter Benjamin Issue (1979): 120–28.

——. "The Work of Art in the Age of Its Technological Reproducibility." In *The Work of Art in the Age of Its Technological Reproducibility and Other Writings on Media,* ed.

Michael W. Jennings, Brigid Doherty, and Thomas Y. Levin, 19–55. Cambridge, Mass.: Belknap Press, 2008.

Bergson, Henri. "Laughter." In *Comedy*, ed. Wylie Sypher, 61–190. Baltimore and London: The Johns Hopkins University Press, 1956.

Berlant, Lauren. *Female Complaint: The Unfinished Business of Sentimentality in American Culture*. Durham: Duke University Press, 2008.

——. "Intimacy: A Special Issue." *Critical Inquiry* 24, no. 2 (Winter 1998): 281–88.

——. *The Queen of America Goes to Washington City: Essays on Sex and Citizenship*. Durham and London: Duke University Press, 1997.

Baudrillard, Jean. *Simulacra and Simulation*. Trans. Sheila Faria Glaser. Ann Arbor: University of Michigan Press, 1994.

Breen, Michael. *Kim Jong-il: North Korea's Dear Leader*. Singapore: Wiley, 2004.

Buzo, Adrian. *The Guerilla Dynasty: Politics and Leadership in North Korea*. Boulder: Westview Press, 1999.

Carlson, Marvin. *The Haunted Stage: The Theatre as Memory Machine*. Ann Arbor: University of Michigan Press, 2003.

Cha, Victor and David Kang. *Nuclear North Korea: A Debate on Engagement Strategies*. New York: Columbia University Press, 2003.

Cheng, Anne Anlin. *The Melancholy of Race: Psychoanalysis, Assimilation, and Hidden Grief*. Oxford: Oxford University Press, 2001.

Chow, Rey. "The Age of the World Target." In *America's Wars in Asia: A Cultural Approach to History and Memory*, ed. Philip West, Steven I. Levine, and Jackie Hilts, 205–20. New York: M. E. Sharpe, 1998.

Clark, Laurie Beth. "Always Already Again: Trauma Tourism and the Politics of Memory Culture." *Encounters* 1 (2010): 65–74.

Crang, Philip. "Performing the Tourist Product." In *Touring Cultures: Transformations of Travel and Theory*, ed. Chris Rojek and John Urry, 137–54. London and New York: Routledge, 2002.

Cumings, Bruce. *Korea's Place in the Sun: A Modern History*. New York: Norton, 1997.

Davis, Tracy C. "Theatricality and Civil Society." In *Theatricality*, ed. Tracy C. Davis and Thomas Postlewait, 127–55. Cambridge: Cambridge University Press, 2003.

de Certeau, Michel. *The Writing of History*. Trans. Tom Conley. New York: Columbia University Press, 1988.

Der Derian, James. *Virtuous War: Mapping the Military-Industrial Media-Entertainment Network*. 2nd ed. New York: Routledge, 2009.

The DMZ. DVD. Directed by Park Sang-ho. 1965; Seoul: Korean Film Archive, 2010.

Dubin, Steven C. *Displays of Power: Memory and Amnesia in the American Museum*. New York: New York University Press, 1999.

Epstein, Stephen. "The Axis of Vaudeville: Images of North Korea in South Korean Pop Culture." http://japanfocus.org/-Stephen-Epstein/3681.

Feifer, Maxine. *Going Places: The Ways of the Tourist from Imperial Rome to the Present Day*. London: MacMillan, 1985.

"Filmmakers Documentary Series: Park Sang-ho." A special feature in *The DMZ* DVD. Directed by Park Sang-chan. Seoul: Korean Film Archive, 2010.

Foster, Susan Leigh. *Choreographing Empathy: Kinesthesia in Performance.* London and New York: Routledge, 2011.

Go, Jong-seok. "Lim Su-kyung." *Hankook Ilbo,* June 22, 2009. http://news.naver.com /main/read.nhn?mode=LSD&mid=sec&sid1=103&oid=038&aid=0002016092.

Grass, Monica. "Vom Eisernen Vorhang zum Grünen Band" [From Iron Curtain to Green Band]. *SWR.* http://www.swr.de/swr2/programm/sendungen/leben/rueckschau /eiserner-vorhang-gruenes-band/-/id=660144/nid=660144/did=8847032/17zdvsc/ (accessed November 19, 2012).

Grinker, Roy Richard. *Korea and Its Futures: Unification and the Unfinished War.* New York: St. Martin's Press, 1998.

Hanguk geugyesul hakhoe, ed. *Hanguk hyeondae daepyo huigok seonjip* [Selected representative dramatic works of contemporary Korea]. 2 vols. Seoul: Worin, 1999.

Hanguk jeongsin munhwa yeonguwon, *Hanguksa yeonpyo* [Chronicles of Korean history]. Seoul: Dongbang Media, 2004.

Hicks, Emily. *Border Writing: The Multidimensional Text.* Minneapolis: University of Minnesota Press, 1991.

Ho, Elaine Lynn-Ee. "Constituting Citizenship Through the Emotions: Singaporean Transmigrants in London." *Annals of the Association of American Geographers* 99, no. 4 (2009): 788–804.

Hughes, Theodore. *Freedom's Frontier: Literature and Film in Cold War South Korea.* New York: Columbia University Press, 2011.

——. "The Remembered War: Violence, Trauma, Division in Korea." Unpublished manuscript.

Hwang, Bong Hyok and Kim Jong Ryol. *DPR Korea Tour.* Pyongyang: Tourist Advertisement Agency, 2002.

Hwang, Jae-gon. "Gungnip yeonghwa charyeongso ga georeo on gil" [Short history of the National Film Studio]. *Joseon Yesul* 9 (1956): 76–79.

Hyojadong Chunbali. "Gukgun yuhae songhwan" [Repatriation of South Korean soldiers' remains, blog]. May 27, 2012. http://blog.daum.net/lcs5801/8739364.

Jeon, Seongho and Li Chunseong. "Yugiro gyeongnyu yeo tongil ero nodochira" [Let the spirit of Joint Communique soar up to unification]. *Rodong Sinmun,* June 14, 2010.

Jeong, Yeonbi. "Gangwon DMZ 60junyeon hongbo hanchang" [Gangwon province advertises the sixtieth anniversary of the DMZ]. *Segye Yeohaeng Sinmun,* November 23, 2012.

Jo, Jeong-jin. "Lim Su-kyung ttaemune mangmyeonghaetda" [I defected because of Lim Su-kyung]. *Segye.com,* October 10, 2005. http://blog.segye.com/jjjo101/10382.

Ju, Seong-ha. "Lim Su-kyung i bukhan e ppuryeotdeon geumdan ui yeolmaedeul" [Forbidden seeds that Lim Su-kyung sowed in North Korea]. *DongA.com,* July 1, 2009. http://blog.donga.com/nambukstory/archives/259.

Kim, Cheolhwan, "Buk eseo nun gameun dongji saenggakhamyeon gaseum apa" [Sorrowful memories of those who perished in North Korea]. *Gukbang Ilbo,* May 21, 2012.

Kim, Dae-jung. *Korea and Asia.* Seoul: The Kim Dae-jung Peace Foundation Press, 1994.

Kim, Doyun. "Gyeonggi Province Assembly to increase budget for the sixtieth anniversary of the DMZ by 700 million won, increasing the total budget to reach 1.8 billion won." [In Korean.] *Yonhap News,* November 26, 2012.

Kim Jongwon and Jeong Jungheon. *A Hundred Years of South Korean Cinema History*. [In Korean.] Seoul: Hyeonamsa, 2001.

Kim, Jinhee, trans. *Korean Drama Under Japanese Occupation*. Paramus: Homa & Sekey Books, 2004.

Kim, Mido. *Hanguk geundaegeuk ui jaejomyeong* [Rethinking modern Korean drama]. Seoul: Hyeondae Mihaksa, 1995.

Kim, Munhwan, ed. *Bukhan ui yesul* [Art in North Korea]. Seoul: Eulyoo Munhwasa, 1990.

Kim, Suk-Young. "Dressed to Kill: Women's Fashion and Body Politics in North Korea." *positions: east asia cultures critique* 19, no. 1 (2011): 159–92.

——. "Gulag, the Musical: Performing Trauma in North Korea Through *Yoduk Story*." *TDR: The Drama Review* 52, no. 1 (2008): 118–35.

——. *Illusive Utopia: Theater, Film, and Everyday Performance in North Korea*. Ann Arbor: University of Michigan Press, 2010.

——. "Staging the Cartography of Paradox: The DMZ Special Exhibition at the Korean War Memorial, Seoul." *Theatre Journal* 63 (2011): 381–402.

Kkmankong. "6onyeon heunjeogeul ganjikhan jangdanyeok jeungi gikwancha" [Steam engine at the Jangdan Station embodies traces of six decades] from Donghaeng geurigo gong-gam [Accompaniment and confluence, blog]. http://blog.daum.net/shko1015/7289724.

La, Seolha. "Angnalhage gamhaengdoeneun bangonghwaguk simnimoryakjeon" [Vicious psychological war against the DPRK]. *Rodong Sinmun*, June 17, 2011.

Leary, Virginia. "Citizenship, Human Rights, and Diversity." In *Citizenship, Diversity, and Pluralism: Canadian and Comparative Perspectives*, ed. Alan C. Cairns, John C. Courtney, Peter MacKinnon, Hans J. Michelmann, and David E. Smith, 247–64. Montreal: McGill-Queen's Press, 2000.

Lee, Namhee. "The South Korean Student Movement: Undongkwon as a Counterpublic Sphere." In *Korean Society: Civil Society, Democracy and the State*, 2nd ed., ed. Charles K. Armstrong, 95–120. New York: Routledge, 2007.

Lewis, Jim. "Nam June Paik: The Man Who Invented Video Art." *Slate*, February 2, 2006. http://www.slate.com/id/2135349.

MacCannell, Dean. "Tourist Agency." *Tourist Studies* 1 (2001): 23–37.

Marcus, George. *The Sentimental Citizen: Emotion in Democratic Politics*. University Park: Pennsylvania State University Press, 2002.

Martin, Bradley. *Under the Loving Care of the Fatherly Leader*. New York: St. Martin's Press, 2004.

McCann, David. "Our Forgotten War: The Korean War in Korean and American Popular Culture." In *America's Wars in Asia: A Cultural Approach to History and Memory*, ed. Philip West, Steven I. Levine, and Jackie Hilts, 65–83. New York: M. E. Sharpe, 1998.

Menon, Jisha. *The Performance of Nationalism*. Cambridge: Cambridge University Press, 2013.

Misra, Sanghamitra. *Becoming a Borderland: Space and Identity in Colonial Northeastern India*. New Delhi: Routledge, 2011.

Moon, Seungsook. *Militarized Modernity and Gendered Citizenship in South Korea*. Durham: Duke University Press, 2005.

Nelmes, Jill ed. *An Introduction to Film Studies.* 2nd ed. London and New York: Rout-
ledge, 1999.

Nicholes, Bill. "The Voice of Documentary." In *Movies and Methods,* vol. 2, ed. Bill
Nicholes. Berkeley and Los Angeles: University of California Press, 1985.

Nyers, Peter. "Introduction: Why Citizenship Studies." *Citizenship Studies* 11, no. 1
(February 2007): 1–4.

Oberdorfer, Don. *Two Koreas: A Contemporary History.* Indianapolis: Basic Books,
1997.

Oppenheim, Robert. "Crafting the Consumability of Place: Tapsa and Paenang Yohe-
ang as Travel Goods." In *Consuming Korean Tradition in Early and Late Modernity:
Commodification, Tourism, and Performance,* ed. Lauren Kendall, 105–26. Honolulu:
University of Hawai'i Press, 2011.

Paik, Nak-chung. "The Ecological Imagination in Overcoming the Division System."
An abbreviated English version of a presentation in Korean at the FRONT DMZ
International Conference, August 11, 1995, Seoul, Korea.

——. "The Idea of a Korean National Literature Then and Now." *positions* 1, no. 3 (Win-
ter 1993): 553–80.

——. "Korea and the United States: The Mutual Challenge," Presentation at the sympo-
sium "America, Asia, and Asian Americans." The University of Chicago Center for
East Asian Studies, November 18, 1991.

Phelan, Peggy. *Mourning Sex: Performing Public Memories.* New York: Routledge, 1997.

Ramussen, Claire and Michael Brown. "The Body Politic as Spatial Metaphor." *Citi-
zenship Studies* 9, no. 5 (November 2005): 469–84.

Roach, Joseph. *Cities of the Dead: Circum-Atlantic Performance.* New York: Columbia
University Press, 1996.

Scarry, Elaine. *The Body in Pain: The Making and Unmaking of the World.* New York:
Oxford University Press, 1985.

Seo, Seunguk. "MB 'Jeonjaeng eul duryeowo haeseon jeonjaeng mageul su eopda'"
[President Lee Myung-bak says one cannot stop war if one is afraid of war]. *Joinsmsn.
com.* http://article.joinsmsn.com/news/article/article.asp?ctg=10&Total_ID=4848931
(accessed December 17, 2012).

Sim Cheolyoung,."Bangonghwaguk dobaleun buknamgwangyeui sihantan" [Anti-
North Korean provocation is like an explosive to the inter-Korean relations]. *Rodong
Sinmun,* June 7, 2011.

Sin, Go-song. "Ten Years: Heroic Chronicle." [In Korean.] *Joseon Yesul* 9 (1958).

Sindonga editorial board. *North Korea Through Primary Sources, 1945–1998.* [In Korean.]
Seoul: Donga chulpansa, 1989.

Song, Taehyeong. "Shinsegae Paju Outlet 3cheungkkaji 165gae Brand Ppaegok" [Shin-
segae Paju Outlet's three story structure is packed to the gills with 165 brand stores].
Hankyung.com. http://www.hankyung.com/news/app/newsview.php?aid=2011031761171
(accessed May 4, 2012).

Springer, Chris. *Pyongyang: The Hidden History of the North Korean Capital.* Budapest:
Entente Bt, 2003.

Suh, Dae-sook. *Kim Il-sung: The North Korean Leader.* New York: Columbia University
Press, 1988.

Taylor, Diana. *Disappearing Acts: Spectacles of Gender and Nationalism in Argentina's Dirty War*. Durham: Duke University Press, 1997.

Tourist Attraction Development Office. "We can never condone the criminal stance against reopening of tourism in Geumgang Mountains and Gaeseong." [In Korean.] *Rodong Sinmun*, March 20, 2010.

Urry, John. *The Tourist Gaze*. 2nd ed. London: Sage, 2002.

Virilio, Paul. *War and Cinema: The Logistics of Perception*. Trans. Patrick Camiller. London: Verso, 1989.

Wood, Andrew F. "'What Happens [in Vegas]': Performing the Post-Tourist Flaneur in 'New York' and 'Paris.'" *Text and Performance Quarterly* 25, no. 4 (2005): 315–33.

Yi, Gang-ryeol. "North Korean Theater: 1930s to 1960s." [In Korean.] In *Bukhan ui yesul* [Art in North Korea], ed. Kim Mun-hwan, 285–307. Seoul: Eulyoo Munhwasa, 1990.

Yi, Hae-yong. *DMZ Stories*. [In Korean.] Seoul: Nunbit, 2008.

Yi, Hyeon-seok and Kim Seok. "Lim Su-kyung, Hwang Seokyeong ssi bangbuk" [Lim Su-kyung and Hwang Seokyeong visit North Korea]. *Munhwa Ilbo*, August 15, 2001. http://m.munhwa.com/mnews/view.html?no=2001081501030123307002.

Yuval-Davis, N. "Belonging and the Politics of Belonging." *Patterns of Prejudice* 40, no. 3 (2006): 197–214.

INDEX